Au

Tr

Acces

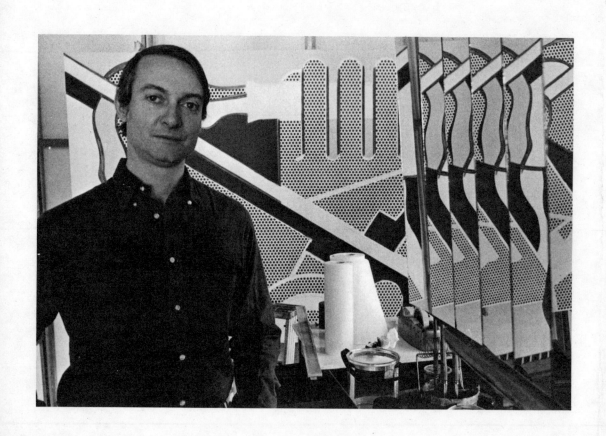

Documentary Monographs
in Modern Art
general editor: Paul Cummings

Roy Lichtenstein

edited by
John Coplans

Allen Lane The Penguin Press

Frontispiece: Roy Lichtenstein in his studio, 1967.

ACKNOWLEDGMENTS

The author wishes to thank the institutions, publishers, and publications listed below for granting permission to reprint: Harry N. Abrams, Inc., New York; *Artforum,* New York; *Art News,* New York; *Arts Magazine,* New York; E. P. Dutton & Co., Inc., New York: Gemini G.E.L., Los Angeles; Gabriele Mazzotta Editore S.R.L., Milan; *Studio International,* Inc., London; and The Tate Gallery, London.

PHOTO CREDITS

Ferdinand Boesch
Rudolf Burckhardt
R. D. Burmeister
Gianfranco Gorgoni
Eric Pollitzer
Renate Ponsold
Nathan Rabin
Photo Shunk-Kender
Nick Sheidy
Frank J. Thomas

The Leo Castelli Gallery, New York, generously provided the majority of the illustrations for the book.

First published in the United States of America in 1972 by
Praeger Publishers, Inc., New York

First published in Great Britain in 1973 by
Allen Lane The Penguin Press
74 Grosvenor Street, London W1

ISBN 0 7139 0379 1

Printed in the United States of America

contents

Contents

list of illustrations

TEXT ILLUSTRATIONS

introduction, biographical notes, chronology of imagery and art

Introduction

Until recently, the history of American painting has been concerned with delineating the changing shape of the American consciousness within stylistic forms that originated in Europe. Yet at the same time, in the search to intersect art with life and felt experience, the American use of imagery has of necessity been distant from its European origins and has persistently revealed distinctly American overtones. To the sophisticated eye of John Ruskin in 1856, the disparity between the European original and the American counterpart was sufficient to provoke a complaint about the ugliness of American painting (a transgression, paradoxically, that a more enlightened generation of American painters a hundred years later consciously sought to emulate). But in matters of culture, and especially painting, Europe led and America followed. American painting looked out-of-date, clumsy, naïve and homespun—an altogether maimed version of its model.

To the vanguard painters in New York in the 1940's and '50's, who formulated Abstract Expressionism and thereby lifted American painting out of its provincial status, the essence of their challenge lay in nullifying the traditional impotence of American artists in the face of European superiority. To break the stranglehold of European art became the overriding task. A process of absorption and denial opened painting at its most meaningful level to the American experience. Disavowal became transmuted into a source of regenerative vitality, a procedure not uncommon in modern art. The rejection of European sophistication of touch in favor of painterly spontaneity and directness (often equated by epigones with painting in a numb, brutal, or ugly manner) opened the way to a viable expression of the American consciousness.

Inevitably, however, the radicality of one generation required refurbishing by another, and the question once thought answered by the Abstract Expressionists was reasserted in Pop art, which once more raised the issue of the American identity—this time, however, in figurative painting.[1] And if the Abstract Expressionists enforced the issue of an American identity by exploiting the expressive potential of paint itself, the Pop artists, in contrast, made ugly and brutal American images and thrust them down the throat of the public. Roy Lichtenstein, Claes Oldenburg, and Andy Warhol project a range of imagery from the very heart of the American civilization, an imagery so powerful, so persuasive, and so different from the European experience that the result appeared as outrageous to the viewer as had the thought of Jackson Pollock's picking up a can of commercial paint and throwing the contents over the canvas.

Inherent to the imagery of Pop art, and particularly of Lichtenstein's painting, is a built-in challenge to the exclusiveness of European traditions. Lichtenstein's images menace sacrosanct values and in a remarkable way expand our consciousness of civilization and culture. His art is a reminder that the goals of civilization and art as we face them in America are mutually incompatible; through imagery derived from the contemporary American vernacular, he exposes the true relationship of one to the other, and to reality. Lichtenstein stated in an early interview, "I want my images to be as critical, as threatening, and as insistent as possible." Asked "About what?" he replied, "As visual objects, as paintings, not as critical comments about the world." But, as Nicolas Calas so correctly asserts, "Only a work which touches upon a myth whose validity is accepted could be threatening."[2] Thus, in Lichtenstein's "reproductions" of Monet, Cézanne, Picasso, and Mondrian—the giants of European art—he punctures the myth of their invulnerability once more; not, however, by the long-drawn-out battle for mastery so typical of the older generation of American painters, but by absorbing the European old masters in one stroke by parody. Lichtenstein converts their images into vernacular forms reminiscent of the comics and thereby re-creates the workings of a consumer civilization, with its built-in capacity to coarsen everything it touches. He further rams home his point by painting, for example, his vulgarized version of a Picasso still life (*Still-Life,* 1964) on plastic—a cheap, synthetic industrial material with a glossy and sanitary surface.

Lichtenstein's drive to adapt his art to a more popular, more immediately accessible iconography reflective of contemporary life is long standing and derives from a consistent interest in the use of a purely American symbolic subject matter. He remarks that from 1951 onward his images were "mostly reinterpretations of those artists concerned with the opening of the West, such as Remington, with a subject matter of cowboys, Indians, treaty signings, a sort of Western official art in a style broadly influenced by modern paintings." In a 1954 review of a one-man exhibition, Fairfield Porter discerningly intuited the manner in which the painting Lichtenstein was then doing prefigured his Pop style:

He uses the modern manner that is at hand. He retains . . . the child's way of using things . . . for the purposes for which they were not intended. The sophisticated manner is applied to the corny. . . . He notices relationships that are not supposed to be noticed. . . . He transforms the meaning of things through his private and irreverent imagination.[3]

Between 1957 and 1961, Lichtenstein abandoned figuration for Abstract Expressionism. To viably merge pictorial and formal energy with an American iconography, however, demanded the invention of a completely new style. In the comics, an American invention, Lichten-

stein found his inspiration. Vernacular in imagery and derived from the heart of the culture, the comics persuasively reveal American civilization in its most uninhibited form. Moreover, the comic image is endemic to the consciousness of the vast majority of Americans, and in spite of their varying origin and background, it has stimulated a shared awareness that is almost wholly independent of race, creed, age, or sex.[4]

Central to Lichtenstein's art is his use of stereotyped situations. The comic images painted between 1961 and 1965, which are abstracted from the original narrative context, reveal by skillful selection standard modes of behavior of the average American adult. Lichtenstein's use of irony is formidable and includes the rendition of violent emotion in a mechanical style. His images look as prepackaged as a cliché; the events depicted appear to be crucial, but their critical quality is only sham. In revealing the trite situations of everyday life, his images also point up a consistent absence of crisis in so-called dramatic situations, emphasizing that everyday American life is composed of petty people enamored of petty problems—of people continuously preoccupied with taking care of themselves. The men and women Lichtenstein selects to depict are trapped in stupid situations, vassals of a system beyond their everyday control. His art points up the constant irritation of life in an advanced consumer society, of the accumulation of intolerable situations that finally makes the texture so unbearable.

Lichtenstein's rendition of images derived from the comics is blatant: They are without ambiguity, forthright in preserving the style of the original. The situations depicted are not without humor, and even tragedy finally dissolves into farce. Many images focus upon romantic love or the mock heroics of men at war. Lichtenstein's lovers and heroes are full of pathos and at the same time, ironically, fully exposed in their shallowness. They reveal themselves to be programmed: Each responds to a given situation with standard modes of behavior typical of the American culture, whether it is the girl who has quarreled with her lover and is about to tearfully drown (*Drowning Girl*, 1963) or the pilot who has shot down his comrade by mistake (*Tex!*, 1962). The viewer ultimately discovers his own indifference to the imminent death of the girl or the agonizing situation of the surviving pilot. Problems he should care a great deal about suddenly appear ridiculous. This capacity to trigger in the viewer a realization of his own disquieting lack of concern is part of the content of Lichtenstein's paintings—skillfully structured double entendre.

Lichtenstein's use of lettering in the comic images is extensive and permits him to generalize experience, yet to load it with a specifically charged sentiment. The balloons and captions play an important iconographic role except in situations that are obvious and therefore require no further elucidation. The use of words makes the imagery concrete

and points up what the viewer might miss or fail to perceive by not immediately catching the intended irony. A viewer would certainly understand the consternation of the girl on the telephone if the painting *Oh, Jeff . . . I Love You Too, But* (1964) had no lettering, but the inclusion of the encapsulated legend "Oh, Jeff, I love you too, but . . ." immediately throws the image into a romantic context of unrequited passion. In a rare exception, the irony takes the form of an "in" joke. *Mr. Bellamy* (1961) depicts a uniformed naval officer; a "think" balloon is captioned: "I am supposed to report to a Mr. Bellamy. I wonder what he is like." Mr. Bellamy refers to Richard Bellamy, at that time director of the Green Gallery, an avant-garde New York gallery well known for first exhibiting the work of many important young artists.

It would not suffice for Lichtenstein's intended irony simply to title his paintings in a more traditional way. This can be clearly seen in the painting *Cold Shoulder* (1963) in which the lower part of the balloon is shaped like a series of icicles; though the girl is saying "hullo," the use of the icicle shapes indicates that in reality she means "goodbye." Thus, the letters do not as much repeat what is going on as expand, extend, or explain the meaning of the depicted situation. Furthermore, Lichtenstein not only treats the balloons as a communication device but also uses them as aesthetic elements. The balloons are therefore important as shape. Lichtenstein follows the conventions of the comics in his usage: A think balloon (usually indicated by a series of bubbles that connect it to the "thinker") encapsulates unspoken thoughts, a narrative balloon encloses spoken words. But Lichtenstein never mixes the two forms together in one painting, as the comics do.

Though lettering is extensively used in Cubist collage, Lichtenstein is the only painter in the history of Western art (apart from Warhol, who used words in a few early paintings) to concentrate so exclusively upon the integration of words and figurative images in a narrative way. Strange that it is so unique a contribution considering the long history of word usage in calligraphic form in Oriental art. It is also ironical that Lichtenstein's inspiration derives not from a form of high art but the pulp comics.

A curious facet of Lichtenstein's painting is that once he began quoting cartoon images, he found it necessary to work his way out of the very clumsiness he originally sought. There are two early phases to his cartoon work—the first, in which he accedes to the vulgarity of the comic image, and a second, wherein object replaces subject and in which he begins to probe his means and thereby transforms his style. In the first phase, the images are densely and softly composed and, though he more or less "quotes" the facture of the comics, the impulse to classicize his paintings by building form out of standard pictorial parts (inherent in the comic technique and subject treatment) is only implied

Roy Lichtenstein

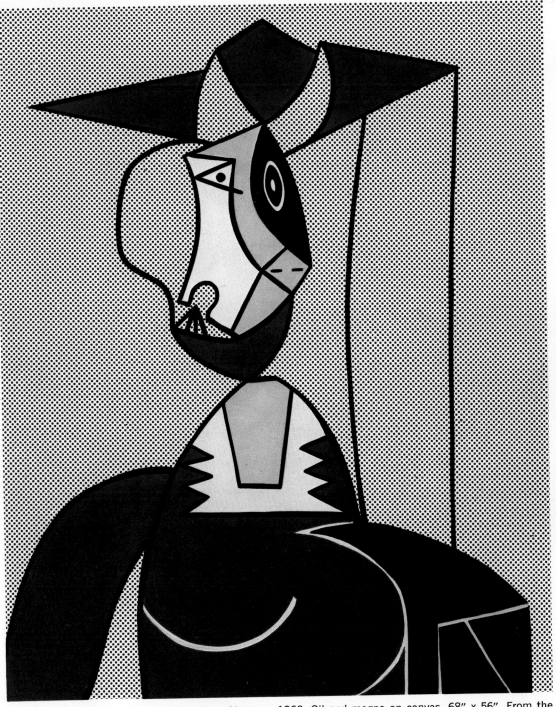

I. *Femme au Chapeau*, 1962. Oil and magna on canvas, 68" x 56". From the collection of Mr. and Mrs. Burton Tremaine, Meriden, Connecticut.

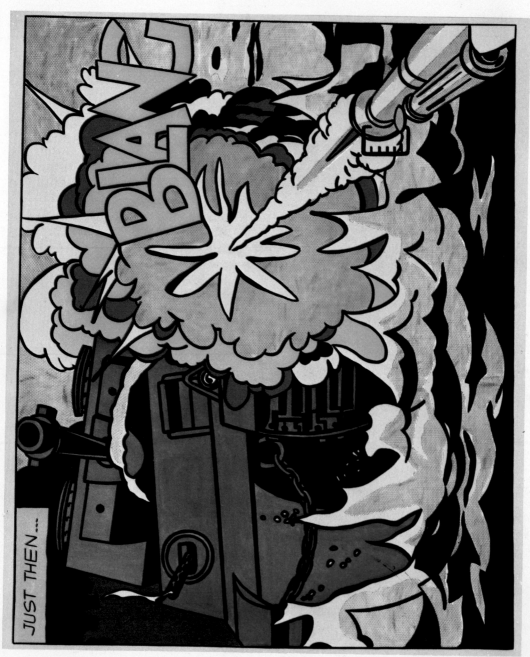

II. *Live Ammo* (*Blang*), 1962. Third of five panels. Oil on canvas, 68″ x 80″. Collection Bruno Bischofberger, Zürich.

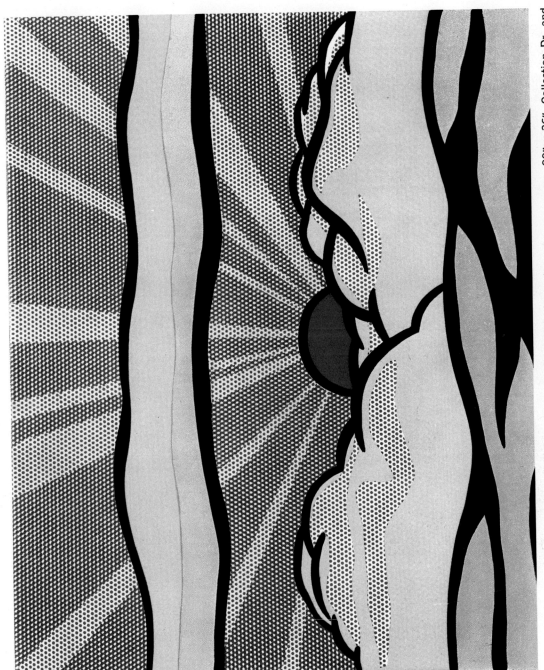

III. *Dawning*, 1964. Oil and magna on canvas, 30″ x 36″. Collection Dr. and Mrs. Eugene A. Eisner, Scarsdale, New York.

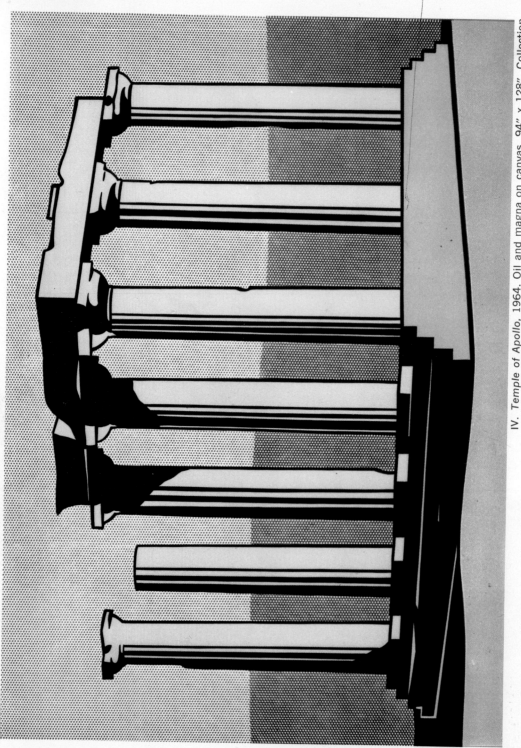

IV. *Temple of Apollo*, 1964. Oil and magna on canvas, 94" x 128". Collection Mr. and Mrs. Robert Rowan.

or loosely carried out. Lichtenstein began to clarify his vision and means in 1962, when he dropped color altogether for the use of rigorous black-and-white images of objects derived mainly from advertising art. In his search for a revised lexicon of form, he chose simple objects—a golf ball (*Golf Ball*, 1962), a man's sock (*Sock*, 1962), a piece of fabric before and after the reweaving of a cigarette burn (*Like New*, 1962), an automobile wheel and tire (*Tire*, 1962). In his second phase, purging his imagery of all sentimentality, by emphasizing the diagrammatic, Lichtenstein brought to bear his experience as an engineering draftsman; he created with a cold factuality and lack of idealization a series of almost melodramatic images of modern life. Inexpensive, mass-produced objects are ironically presented as things of beauty in their own right, and carried into this new reality by an exaggerated degree of isolation and magnification, as if in close-up view. The objects float in the center of the field in a flat, undefined space. The banality of the objects themselves and their very anonymity is married to a rigorous sense of abstraction—a new architecture of boldness and clarity defined by the starkness and simplicity of the parts.

Lichtenstein has stated: "The meaning of my work is that it's industrial, that's what all the world will soon become. Europe will be the same way soon, so it won't be American; it will just be universal." Emphasis on the technological—and also the built-in capacity of an industrial civilization not only to extend itself infinitely but also to reshape culture—led Lichtenstein to formulate a style in which the component parts and the precision of finish of the painting ironically apes the subject matter. Though in fact each work is completely dependent on Lichtenstein's own sure and meticulous touch for its vitality and painterly sophistication, the process of facture is concealed and the painting's appearance simulates the anonymous and mechanical finish of machine-made objects.

Obviously, Mondrian and Léger provide a precedent for this development: Mondrian, perhaps inadvertently, by having standardized his formal elements into simplified component parts, including the primary spectrum of color that Lichtenstein uses; and Léger by his overt interest in the mechanization of painting, which—as a result of a highly deliberate system of preplanning—included the stripping down of his vocabulary to component and interchangeable parts, as well as the use of a machinelike precision of finish. The idea, of course, of a painting's being completely planned in advance is a classical one. But Léger's and Lichtenstein's usage is reflective of a different intent, that of stylistically mirroring mechanical standardization and repetition.

Lichtenstein often enlarges his sketches and transfers them onto the canvas by using a projector. The art world overlooked, or was forgetful of, this classical European method of organizing a painting because of

Abstract Expressionism's compulsion for spontaneity, and accused Lichtenstein of degrading high art by importing the techniques of commercial art into painting. In actuality, however, it is not so much the preplanning as the high degree of manipulation in the process of paint application and continuous adjustments that lead to a compelling unification of the shapes and the pictorial field in a Lichtenstein painting.

Lichtenstein's assertive use of Benday dots to enhance the mechanical look of his art, similar to his use of words in narrative sequence, imprints his paintings with his own unique identity. In the painting of a woven piece of cloth before and after repair (*Like New*, 1962), the image is almost exclusively built with Benday dots: Subject, object, and technique are formally unified. The Benday dots become a recognizable and sophisticated component of Lichtenstein's painting, and in the later paintings of landscapes as well as in the haystacks and the Rouen Cathedral series, the images are impacted in a surface of colored, overlapped dots. Thus, the dots, in replacing dabbed brush marks, become a metaphor of mechanization and plenitude. The superimposition of the dots in a well-regulated overlapping pattern in any given area creates in the interstices a variety of different white textures and optical patterns, which Lichtenstein employs as an ironic reference to optical art and, perhaps even indirectly, to the compulsive practice of the Pointillists. In those paintings devoid of black arabesque outlines the demarcation of one shape from another is achieved by lineally grouping the dots and changes of color. The dots are applied through a screen, often by an assistant (a further reminder of the classical studio process), and the superimposition and impingement of one color upon another causes pronounced optical color interaction.

In contrast to both his earlier comic-strip paintings and his more recent paintings, Lichtenstein's centralized images of objects in black and white (1962–63) look extremely formalistic; they represent an apparently necessary compositional experiment that Lichtenstein finally dropped (but not without extending the method to include images in color of various foodstuffs—a piece of dressed meat, a wedge of pie, a hot dog, and so on). It is the diagrammatic aspect rather than the use of color in these works that visually persuades. The formal discoveries inherent in this group of paintings led to the two provocative images quoting Cézanne: *Man with Folded Arms* and *Portrait of Madame Cézanne* (both 1962). Both images derive from outline diagrams by Erle Loran explaining Cézanne's compositional methods.[5] The drawings fascinated Lichtenstein, if for no other reason than the attraction of outlining a Cézanne when the artist himself had noted that the outline escaped him. To make a diagram by isolating the woman out of the context of the painting seemed to Lichtenstein to be such an over-

simplification of a complex issue as to be ironical in itself. To be sure, all of Lichtenstein's images pre-exist in a flat form and are therefore "reproductions of reproductions," but by making paintings of these two images Lichtenstein raised a host of critical issues concerning what is a copy, when can it be a work of art, when is it real and when fake, and what are the differences. Lichtenstein's attitude was as startling to the art audience as Warhol's paintings of soup cans, which provoked similar questions; both artists challenged the art establishment—Warhol by ironically humanizing mass-produced products, and Lichtenstein by de-humanizing a masterpiece.

The highly magnified close-up view crucial to the formal qualities of the black-and-white object paintings was extended by Lichtenstein into the comic images he painted thereafter. He intensified the emotive charge of his images by fusing object and narrative, simplified color, and a high degree of image cropping. This paring away of the unessential led Lichtenstein to a sharper confrontation with the outside world, to a wider range and sharper focus in his use of stereotype. Because of his interest in revealing habit patterns Lichtenstein, unlike Léger, never paints a whole figure—and has not since his earliest paintings. It is not that Lichtenstein avoids painting the whole figure because it is too complex but, rather, that the whole figure is *too specific, too anecdotal* for his purpose. Too much detail weakens the focus and the power of the image to immediately and recognizably signal the desired content. Thus, Lichtenstein crops away until he gets to the irreducible minimum and compresses into the format the exact cliché he desires to expose. Lichtenstein's technique is similar to his imagery: He reduces his form and color to the simplest possible elements in order to make an extremely complex statement. In short, he uses a reductive imagery and a reductive technique for their sign-carrying potential.

In comparison with the earlier comic images, Lichtenstein's later images of women (beginning in 1963) look hard, crisp, brittle, and uniformly modish in appearance, as if they all came out of the same pot of makeup. They cry more often, and the tears seem not only to be larger but to well at slighter provocation. The hair becomes a strong compositional element, rippling and contorting rhythmically in decorative arabesques around the masklike faces. Lichtenstein's recent use of color is strong, assertive, and clear. Apart from black and white, his palette consists almost entirely of the Mondrianesque primaries of red, yellow, and blue (and very occasionally green); however, Lichtenstein rarely uses more than two colors in combination, and the black lines surrounding or crisply dividing the forms significantly magnify hue. Very often a head is cropped to such an extent that the hair flows outside the borders of the format, as, for instance, in *Sleeping Girl* (1964). In other paintings of women, the hands are used for qualities of gestural ex-

pressiveness, to reinforce the iconography of the image, sometimes by enhancing the sense of pathos or the sense of helplessness of the woman's defeat in the face of a given situation.

Lichtenstein's use of heavily cropped hands in isolation dates from 1961, when he completed several finished drawings of hands in action performing various tasks. These hands become surrogates of the human body, signaling information by their actions—as, for example, in a frontal view of a hand threateningly pointing an extended index finger, in which the foreshortened view of the thumbnail and the finger look like two eyes within an angry head (*Finger Pointing,* 1961). Others reveal a cropped hand treating a cropped and naked foot (*Foot Medication,* 1962), and two cropped hands outlining the shape of a foot for mail-order shoes (*Mail Order Foot,* 1961). In many of the comic-strip paintings executed in 1962 and thereafter, the object and the detached hand are united in cropped images (sometimes with a consumer item) performing a household task (*Spray,* 1962), or as in two images of impending violence: the cropped and a gloved hand of a Western gunman about to draw a holstered pistol (*Fastest Gun,* 1963), and an even more reduced and cropped-away image of a curled finger about to pull the trigger of a pistol (*Trigger Finger,* 1963).

An interesting facet of Lichtenstein's art is that many of his images exist as finished drawings, complete in themselves. The drawings are of two types: finished works that are not necessarily extended into paintings and sketches that are developed into either drawings or paintings. Lichtenstein is concerned with the development of an image independent of technique. Thus, an image will surface in a painting, drawing, print, or sculpture, and it will not necessarily be repeated in another medium —it is the delineation of the image itself that is of peculiar fascination to Lichtenstein.

Although the comic format presents stereotypes of subconscious desires and yearnings, and reeks of erotic fantasies and anxieties, Lichtenstein's dispassionate treatment cools the imagery to such an extent that his art is peculiarly devoid of surrealist qualities. In contrast, Claes Oldenburg dilates the eroticism of his already erotic subject matter; his art is tied to Abstract Expressionism and Surrealism, and he uses scale as a surrealist device. Oldenburg's art is about sexuality, but Lichtenstein's aseptic treatment renders his images asexual. Andy Warhol's scale, like Oldenburg's, tends toward the environmental, and by constant repetition (as in the Brillo boxes) it implies great expanse without the use of a large format. Lichtenstein's does not. Both Warhol and Oldenburg are typically alienated existential artists. Everything Warhol paints is autobiographical; his work is as much about himself as the culture. Lichtenstein's art, however, is devoid of direct personal feelings; his style is anti-the-artist-as-hero; thus, he reflects society rather than

Roy Lichtenstein

directly mirroring his own anxieties. Nor is Lichtenstein's style anonymous, as is so often claimed.[6] It is as full of character as Pollock's; only Lichtenstein's seemingly mechanical technique is anonymous. Nevertheless, Lichtenstein, Oldenburg, and Warhol do share one marked trait; an irrepressible vein of humor—a sense of the absurd, even—that threads their choice of imagery: Oldenburg takes cognizance of the constant reference to London's River Thames as an open sewer by proposing to anchor opposite the Houses of Parliament a sculpture of a giant ball cock; Warhol impudently fills a gallery with replicas of Brillo boxes; Lichtenstein makes a painting of an Abstract Expressionist brushstroke in 1966 that looks like a piece of bacon, provoking thereby the obvious thought of "bringing home the bacon."

Though Lichtenstein has evolved out of American art, his painting is formally the product of European art, a distinctly American subject matter notwithstanding. He still acknowledges the framing edge as the controlling compositional device, and modulates his forms to the canvas; he crops compositionally and works in a relatively small size. True, there are large paintings—the ruins of a temple (*Temple of Apollo*, 1964), the Egyptian pyramids (*The Great Pyramid*, 1969), as well as a large brushstroke (*Yellow and Green Brushstrokes*, 1966) and several large modular modern paintings—but on the whole, he only works at mural scale when the subjects are larger. The impressiveness of the monuments, for instance, would be undermined if they were painted in a small size. Thus, large paintings are more the exception than the rule in Lichtenstein's work. What counts is that Lichtenstein composes internally (the way artists have composed with the edge throughout the history of European painting), that he is interested in balance rather than symmetry, and that he generally uses a hard-soft, left-right manner of equalizing forms. His principal drive is toward internal balance and completeness within the picture frame, and the size of his paintings tends to be fairly ordinary except for a few essays into monumentality. Though a few of his works are on plastic or enameled metal, Lichtenstein uses a traditional technique, and his habit of progressing from the rough sketch to the finished work (and his use of assistants) is entirely European.

For Lichtenstein to have carried off his art despite a traditional approach, and to have done so without wavering, represents an extraordinary challenge successfully met. Again, part of his strength is that he worked in oil on canvas, without drawing upon a new technique such as the silkscreen process employed by Warhol. Nor was Lichtenstein strongly influenced by Jasper Johns or Robert Rauschenberg, who from the beginning were basically assemblagists and involved in all manner of collage techniques. Lichtenstein is a serious, intellectual painter who instead wants to revolutionize painting within its traditional media. Of

course, both Rauschenberg and Johns fed into the art ambience a common everyday imagery, but Lichtenstein's ties to these artists are more reflective of shared culture than influence. Only one painting (and its two variations), the school composition book (*Compositions*, 1964), appears to be related formally with Johns. Yet, given its chronological position in Lichtenstein's development, the connection seems to be the result of coincidence rather than influence, despite Johns's precedence in his paintings of the American flag. On the other hand, having had his art described so consistently as a direct response to Johns's influence may have led Lichtenstein to make a painting that ironically and openly reflects Johns's art, as he has done on occasion with other contemporaries.

Unlike Warhol, who explicitly acknowledges the influence of Duchamp, Lichtenstein can only have been influenced by Duchamp in a convoluted way. The series of paintings of the backs of canvases (variously numbered *Stretcher Frames with Cross Bar* and *Stretcher Frame*, 1968) are obviously a Duchampian gesture but arise out of Duchamp's general influence in New York rather than a direct influence. Moreover, the canvas backs are much more characteristic of Lichtenstein's mode of mockery through the use of a public image than of Duchamp, whose irony is private and arcane. Lichtenstein's iconography is always forceful and striking; his imagery is one of signposts and not at all esoteric. Culturally, Lichtenstein's images are at the same level as the Seven Wonders of the World—pure stereotypes. The painting of an empty desert landscape with a fragment of a classical column cropped to the left edge (*Landscape with Column*, 1965) is beautifully abstract. Its imagery and irony, however, are direct and immediately refer the viewer to art history and the extraordinary claims based on remote, battered, and tiny fragments from the past; the image laughs at archaeology, too.

Throughout Lichtenstein's art there is a discernible mixture of metaphor: His art oscillates with contradictory activities and references. Several of the brushstroke paintings, which whimsically mock the Abstract Expressionist style, recall de Kooning's art. The background of the label in the school composition book and its fragmented black-and-white forms obviously refer to Pollock; the form of the waves in *Drowning Girl* are reconstructed to recall Hokusai as well as the biomorphic forms of Arp and Miró; the cluster of semicircular marks on the face of the subject of *Golf Ball* echo Mondrian's plus-and-minus drawings. But in Lichtenstein's references to the art of the 1930's, he reworks a style in depth. The original thirties style hovers between pure abstraction and figuration. In parodying the style, Lichtenstein first expunges every specific reference to a particular artist's work and reconstructs it in a general way with the intention of exposing its idiomatic character. Thus, Lichtenstein's "thirties" paintings are extremely varied;

they swing from what appears to be outright abstraction in some paintings to a parody in others of the style's overt amalgam of man and machine. Though the images have been absorbed and converted, they ironically appear to be more characteristic of the thirties style than a genuine work of the epoch.

Lichtenstein cannot be considered an abstract painter. His "abstract" thirties-style paintings are re-creations in much the same manner as his "fake" Mondrian (*Non Objective I,* 1964), except that they are more distant from the originals. Accordingly, it is necessary for the viewer to recognize Lichtenstein's parody of the Modern style and realize that the style itself is the subject and not abstract art. Similarly, though the Mirror paintings, many of which mimic round or ovoid mirror shapes and the reflective surface of mirror glass, are abstract (in the sense that all the internal parts are composed abstractly and look abstract), they are nevertheless mirrors and must be so recognized. Lichtenstein, it would seem, is not willing to paint an abstract painting; he is primarily a subject painter who refuses to work without a seen image. Still, part of the fascination of his art is the remarkable quality of abstractness adhering to the paintings *despite* his imagery.

Lichtenstein's body of sculpture is small, for he works in three-dimensional form only from time to time. His sculptures of explosions (*Desk Explosion,* 1965, and *Explosion II,* 1966) are flat and consist of overlapping planes of enameled steel. They derive from the painting of a similar image, *Varoom* (1963), which in turn is an isolated fragment of an explosion taken from the cartoon war images. Lichtenstein's intent is to give—again, in an ironic manner—permanent shape to ephemeral form. Another series consists of monolithic columns of piled coffeecups. In these sculptures he creates an image of used restaurant ware, transforming what is crude, dirty, and messy into something pristine and beautiful. The cups are polychromed in what seems to be a highly contradictory fashion; the superimposition of dots and shadows is based on the stereotype manner used by commercial artists to represent shadows and highlights on highly reflective surfaces. Thus, the sculptures simultaneously reflect the presence and absence of light in a natural and illusionistic manner. A later body of sculpture dating from 1967 is in the thirties style. Mainly of brass and glass, the forms are linear, open, and diagrammatic. Though these sculptures are three dimensional, they primarily employ profile rather than volume and play upon the highly conceptual mode of contemporary sculpture.

Lichtenstein enforces the degree of abstraction when there is no obvious quantity of social comment inherent in a work, and generally it can be said the more abstract his imagery, the weaker the iconographic charge. The charge is low in the thirties sculpture and in the landscapes, both of which are without the raw human emotions and situations so

central to Lichtenstein's art. These are neither as powerful nor as successful as many of his images, though perhaps they are more subtle. Composition becomes critical when no sense of irony is held in abeyance or is absent, and the most successful landscapes—those capable of riveting the attention—are compositionally the best.

Lichtenstein very rarely relies on formal qualities alone to carry a painting except in his late paintings of mirrors and the backs of canvases. These two series, as well as many of the thirties Modern-style paintings, reflect Lichtenstein's growing ability to work viably after having absorbed the over-all development of sixties art, by working with modular units, the shaped canvas, and serial imagery. Perhaps the biggest change of all is Lichtenstein's recent desire to employ a mute image. The Mirrors no doubt derive from his interest in thirties furniture, but he works very intuitively by continually experimenting with images: The shadows of the bars appeared to be the only part of the canvas-back pictures he could successfully manipulate to any degree, but the fracturing of light on the surface of a mirror proved to be an extraordinarily adaptable and manipulatable form, rich in potential. In view of the degree of refinement that has taken place more recently in his art, it is possible the Mirrors would have been less successful had Lichtenstein painted them in 1965, at the time of his first use of reflections in his coffeecup sculptures. The Coffeecups are too closely related to the comic-strip and advertising images and consequently project the crudity so essential to his art at that time. In Lichtenstein's recent work, there is evidence of a marked degree of change, flexibility, and subtlety, partly as a consequence of sixties painting itself, partly as a result of his own internal development.

Lichtenstein's art is compellingly open to the modern experience and the twentieth-century social landscape. Pop art as a style and Lichtenstein's art in particular operate in an uncharted iconographic territory —a new world without rules and guides. Up to the seventeenth century, the iconographic limits of art were closely defined and the artists were free to function only within the limits of a given text. The world is Lichtenstein's text; there are no circumscribed patterns for his art to follow, nor any defined borders. Fortunately, Lichtenstein is an open person; he seeks and takes from everywhere according to necessity. His imagery is public, overtly of life and daily experience, its only restriction the necessity to be large in its cultural horizons or limits to succeed. Because of his openness, Lichtenstein's art is very experimental; yet it has, however, an obvious mainstream.

Lichtenstein's art reveals a wonderful sense of design, composition, and abstraction. These qualities, allied to an interest in making an art that people can understand—of realism, social ideas, and even vulgarity —expose our world in a remarkably straightforward way and reflect

Roy Lichtenstein

many of the manners, morals, and attitudes of our culture. But, though Lichtenstein deals with mass attitudes, it is the man himself, his individualism combined with a quiet and serious need to portray the truth, that makes his art unique and of major consequence.

Notes to Introduction

1. It is only in the painting of another, younger generation of abstract artists, particularly Frank Stella and Kenneth Noland, that American artists began to work in a sophisticated nonobjective style without direct European influence or naïve American overtones.
2. Nicolas Calas, "Roy Lichtenstein: Insight Through Irony," *Arts Magazine* 44, no. 1 (September–October, 1969): 29.
3. Fairfield Porter, "Lichtenstein's Adult Primer," *Art News* 52, no. 9 (March, 1954): 18.
4. For an estimate of this audience, see Pierre Couperie and Maurice C. Horn, *A History of the Comic Strip* (New York: Crown, 1968), pp. 147–53.
5. Erle Loran, *Cézanne's Composition* (Berkeley and Los Angeles: University of California Press, 1946).
6. The anonymous appearance of Lichtenstein's style has often misled the critics, including this writer.

1923–38	Born New York City. Parents of middle-class background. Happy, normal, and uneventful home life and childhood, though somewhat shy and withdrawn in personality. Attended Franklin High School, New York. Art not taught as part of curriculum. In junior year, began drawing and painting in oils as a hobby at home. Became interested in jazz, particularly the blues and dixieland. Attended jazz concerts and sought out the masters at the Apollo Theater, Harlem, and at various jazz clubs on 52nd Street, out of which grew an interest in painting portraits of jazz musicians, often depicted playing instruments. Paintings also influenced by reproductions of Picasso's Blue and Rose periods.
1939	During last year of high school, enrolled in summer art classes at the Art Students League under Reginald Marsh. Student work consisted of immediate and loosely rendered sketches of the vernacular New York scene with a preference for subject matter derived from Coney Island, the Bowery, carnival scenes, and boxing matches. Also painted directly from the model.
1940–42	Graduated from high school and decided to major in art. Given the emphasis on regional painting at the Art Students League, found no compelling reason to study in New York and therefore enrolled in the School of Fine Arts, Ohio State University, one of the few painting schools outside of New York that provided studio courses and a degree in fine arts. Strongly influenced at Ohio State by Professor Hoyt L. Sherman, an artist with an intense interest in the psychology of vision and the significance of illusion to the organization of seeing. Freely expressionist works from the model and still life.
1943–45	Drafted U.S. Army. Served in Europe (England, France, Belgium, Germany). Many drawings from nature in wash, pencil, and crayon. After cessation of hostilities, posted from Germany to Paris and briefly studied French language and civilization at Cité Universitaire.
1946–48	Demobilized U.S.A. (January, 1946) and returned to Ohio State University to continue art studies under G.I. Bill. Graduated B.F.A. (June, 1946). Entered graduate program

Roy Lichtenstein

and hired as instructor. Painted mainly geometric abstractions followed by Cubist-oriented semi-abstract paintings influenced by Braque, Klee, and late Picasso.

1949–50 Graduated M.F.A. Ohio State University (1949), continued teaching. Exhibited in various group shows at Chinese Gallery, New York (1949). First one-man show at Ten Thirty Gallery, Cleveland (1949).

1951 First one-man show at Carlebach Gallery, New York, of paintings, lithographs, etchings, and assemblages. Moved to Cleveland. For the next few years worked intermittently as an engineering draftsman for Republic Steel and various other engineering corporations and continued painting.

1952 One-man show at John Heller Gallery, New York.

1953 One-man show at John Heller Gallery.

1954 Birth of first son, David Hoyt Lichtenstein. One-man show at John Heller Gallery.

1956 Birth of second son, Mitchell Wilson Lichtenstein.

1957 Appointed assistant professor of art, New York State University, Oswego. One-man show at John Heller Gallery.

1958 One-man show at Condon Riley Gallery, New York. Abstract Expressionist paintings.

1960 Appointed assistant professor, Douglas College, Rutgers University, New Jersey. Moved to Highland Park, New Jersey. Rich texture of conversations with Allan Kaprow (also teaching at Rutgers) on contemporary culture and art, especially in relationship to happenings, environments, and Kaprow's interest in American consumer culture. Attended several happenings as a spectator and met Robert Watts, Claes Oldenburg, Jim Dine, Robert Whitman, Lucas Samaras, and George Segal, which revived his interest in proto-Pop imagery.

1961 Began first Pop paintings. In autumn left several of the new paintings with Leo Castelli Gallery, New York. On a second visit to the gallery a few weeks later saw for the first time similar images painted by Andy Warhol. First sale of new work to Irving Blum, Billy Klüver, and Ileana Sonnabend. Invited to exhibit at the Ferus Gallery, Los Angeles.

1962 One-man show at Leo Castelli Gallery. Participated in *The New Paintings of Common Objects* (organized by Walter Hopps) at the Pasadena Art Museum, the first museum ex-

hibition to focus upon the emergence of Pop art on the East and West coasts.

1963 Included in *Six Painters and the Object* (organized by Lawrence Alloway) at The Solomon R. Guggenheim Museum, New York. One-man shows at Leo Castelli Gallery; Ileana Sonnabend Gallery, Paris; Ferus Gallery; Il Punto Gallery, Turin. Moved studio from New Jersey to Broad Street, New York. Granted a year's leave of absence from Rutgers University.

1964 Resigned from faculty of Rutgers to devote full time to painting. One-man shows at Leo Castelli and Ferus galleries.

1965 Moved studio to 26th Street, New York. One-man shows at Leo Castelli Gallery and Ileana Sonnabend.

1966 Moved studio to the Bowery. Exhibited at the United States Pavilion, 33d Venice Biennale (with Helen Frankenthaler, Ellsworth Kelly, and Jules Olitski). One-man exhibition at Cleveland Museum of Art.

1967 One-man show at Leo Castelli Gallery. Exhibition at Contemporary Arts Center, Cincinnati. Retrospective exhibition of work from 1961 to 1967 (organized by John Coplans) at Pasadena Art Museum, which subsequently traveled to the Walker Art Center, Minneapolis, Stedelijk Museum, Amsterdam. Appointed Regents Professor, University of California, Irvine.

1968 Married Dorothy Herzka. Retrospective continued at The Tate Gallery, London; Kunsthalle, Bern; and Kestner-Gesellschaft, Hannover. One-man show at Irving Blum Gallery, Los Angeles.

1969 Retrospective exhibition of work from 1961 to 1969 (organized by Diane Waldman) at The Solomon R. Guggenheim Museum, which subsequently traveled to Nelson Gallery of Art, Kansas City; Seattle Art Museum, Columbus Gallery of Fine Arts; Museum of Contemporary Art, Chicago. One-man show at Irving Blum Gallery. Exhibited in *New York Painting and Sculpture: 1945–1970* at The Metropolitan Museum of Art, New York.

1970 Painted four large murals of brushstrokes for College of Medicine, Düsseldorf University. Elected to the American Academy of Arts and Sciences.

1971 One-man shows at Leo Castelli and Irving Blum galleries.

1972 One-man show at Leo Castelli Gallery.

Chronology of Imagery and Art

Numbers in brackets following drawing references are catalogue numbers assigned in Roy Lichtenstein: Drawings and Prints *(Introduction by Diane Waldman). New York: Chelsea House, 1969.*

1949–50 Began to introduce into his work broad references to Americana, particularly a Western subject matter derived from paintings of Indian treaties, cowboys, and so on, originating with such artists as Frederic Remington and Charles Willson Peale but within a Cubist structure. Working mostly in oils, sometimes in pastel; treatment of subject matter gradually became more expressionistic with looser brushwork.

1951 Assemblages exhibited in first New York one-man show consisted of found wood and metal objects wired or riveted together (hammer handles, rasps, latches, and so on, sometimes including carved wooden parts); used to create an imagery of horses, knights in armor, Indians, handled within a broad Cubist structure. Paintings similar in subject matter but hovering between Cubism and Expressionism.

1952–55 Lost interest in imagistic assemblage and concentrated on paintings with an American subject matter. Occasional forays into expressionist, abstract, painted wood constructions (including pieces of string and canvas).

1956 Made proto-Pop lithograph of a ten-dollar bill, the rectilinear shape of the bank note extending from edge to edge of the image.

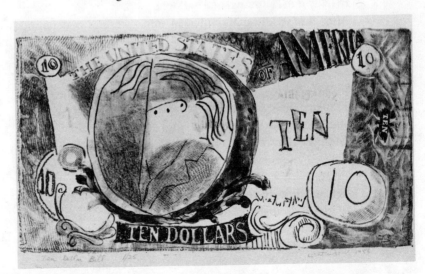

Ten Dollar Bill, 1956. Lithograph. Collection the artist.

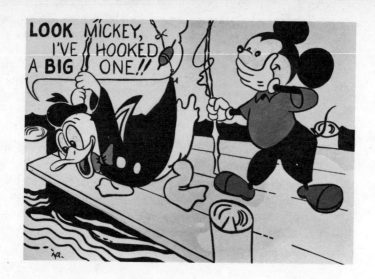

Look Mickey, 1961. Oil on canvas, 48" x 60". Collection the artist.

1957–60 Began painting in a nonfigurative Abstract Expressionist style. Occasional drawings including a proto-Pop subject matter (Mickey Mouse, Donald Duck, Bugs Bunny, and other Disney-style imagery).

1961 Approximately six paintings of recognizable characters from comic-strip frames (Popeye, Wimpy, Bugs Bunny, Donald Duck, Mickey Mouse, and so on) directly and loosely drawn on the canvas and painted with conventional artists' materials (oil on canvas) with minor changes in color and form from the original cartoon; executed in a large scale (*Look Mickey*, 48 × 60 inches). First use of Benday dots, lettering, and balloons.

1961–71 After this series, images divided into paintings and finished drawings, very often without overlap of subject matter and without preliminary sketches of any kind. Early Pop paintings reveal evidence of much penciling in. To a large extent this ceased late in 1963 with his adoption of the projection technique and led to the development of pencil sketches suitable for projection, often with touches of color. Unlike the more finished black-and-white drawings, these rough sketches were always conceived as possible paintings but sometimes not painted. Nor, until much later, were these sketches thought to have "artistic" value; thus, many were destroyed or abandoned.

Several paintings and drawings of images often cropped

Roy Lichtenstein

from comic strips include visual symbols of sensations: the sound of a telephone ringing in *Ring-Ring* (1961); sounds of knocking on a door and vibrations of pounding in *Knock, Knock* (1961), drawing [61–2]; a halo representing the sparkling condition of a jacket after dry cleaning in *Man with Coat* (1961) and drawing 1 [61–6].

Thereafter, images divided into several fairly clear categories, though not without some overlap; often worked on simultaneously and therefore lack a distinct chronological order of development. Isolation of images against a white or simulated Benday dotted ground and the occasional use of severe crop began. Isolated use of tondo shape, as in *Cat* (1962), an old-masters format more thoroughly explored in all its variety of shape in the various images of 1970. Beginning of the use of the diptych, a traditional religious format ironically subsumed into consumer imagery as in *Like New* (1962), which consists of two hinged panels. This image is one of the few instances of image overlap in a painting and drawing [62–6]. Both the painting and the drawing reflect early interest in reductive art exploited in his later Mondrian, landscape, stretcher bar, modern, and frieze paintings.

Although cropped images of hands, and sometimes legs or feet, performing various tasks do not necessarily represent a clear-cut category, there is a very special focus on them throughout the work that follows: *Finger Pointing* (1961)

Ring-Ring, 1961. Oil on canvas, 24″ x 16″. Collection Dr. Ivan C. Karp.

Knock, Knock, 1961. Ink on paper, 20¼″ x 19¾″. Collection Mr. and Mrs. Michael Sonnabend.

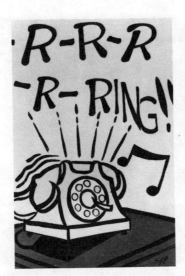

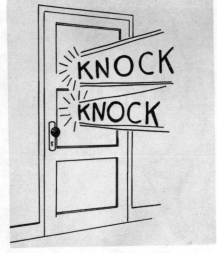

and drawing [61–1]—a coated and cuffed wrist leading to a centrally positioned clenched hand with a finger pointed threateningly: *Trigger Finger* (1963)—a closely cropped image depicting a curled finger about to pull the trigger of a gun. The cool rendition of imminent violence is taken a step further in the felt banner (and drawing [64–5]) *Pistol,* a close-up frontal view of an isolated hand holding a smoking revolver. Several two-handed images exist: *The Ring* (1962) depicts a male hand slipping a diamond engagement ring on a girl's finger; *Handshake* (1961), two isolated hands clamped in friendship, is also an ironic comment on labor and management. (This image, permuted with slight variation three times over, was adopted for the poster of Lichtenstein's first one-man show at Leo Castelli Gallery in 1962, the earliest of many subsequent posters and poster prints.) Several images reveal a hand performing a routine task: cleaning—*Sponge* (1962); operating a spray can—*Spray* (1962); medicating a foot—*Foot Medication* (1962) and drawing [62–2]; measuring a stockinged foot for shoes— *Mail Order Foot* (1961) and drawing [61–12]. A few images exist of cropped legs and feet in action: *Step-on Can with Leg* (1961), another hinged diptych, depicts a woman's leg operating an open and closed, decorated kitchen garbage can (also drawings [61–7] and [61–8]); in *Flatten . . . Sandfleas* (1962) a booted foot kicks an attacker's hand

Left: *Finger Pointing,* 1961. Ink on paper, 30″ x 22½″. Private collection. Right: *Handshake,* 1961. Oil on canvas, 32″ x 48″. Collection Dr. Umberto Agnelli.

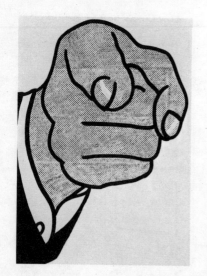

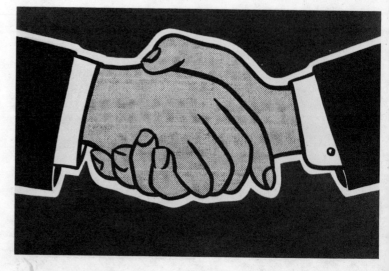

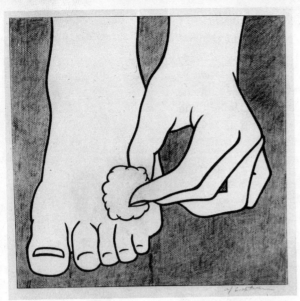 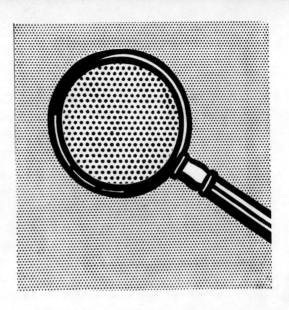

Left: *Foot Medication*, 1962. Pencil and frottage, 18½″ x 18¾″. Collection Dr. James Holderbaum. Right: *Magnifying Glass*, 1963. Oil on canvas, 16″ x 16″. Collection Mr. Pier Luigi Pero.

holding a knife. In the later images of sophisticated girls, hands are often used near the framing edge, as surrogate of the body, to create areas of smaller rhythmical formal elements as well as to reinforce the emotional quality of the iconography. In *Nurse* (1964) the hand is raised in a gesture of alarm; in *Happy Tears* (1964) the cropped fingers enhance the poignancy of the image.

Principal Categories of Imagery

Advertising imagery (1961–64) Several early images derived from advertisements are tentative in treatment and paint handling. In *Bathroom* and *Kitchen Range* (both 1961), as well as other images, the color and drawing, and the imagery are less crisply treated than later. *Black Lily* (never exhibited) and *Black Flowers* (both 1961) are from a seed catalogue or advertisement, but the images have undergone considerable adaptation and reveal a more expressionist tendency than the cooler images that follow.

Generally, the imagery deriving from advertisement is extremely disparate, though very often linked by homemaking and consumerism: cooking—*Roto Broil* and *Kitchen*

Range (both 1961); dry cleaning—*Man with Coat* (1961) and drawing [61–6]; before and after repair of clothing—*Like New* (1962) and drawing [62–6]; cleaning—*The Refrigerator* and *Sponge* (both 1962); bathing—*Women in Bath,* drawing [63–1]. *Magnifying Glass* (1963) is an invented image in which the lens considerably magnifies the over-all ground of small Benday dots. *Girl with Ball* (1961) obviously derives from a holiday advertisement.

Common objects (1961–64) Black-and-white close-up views of common industrial or manufactured objects with flat or shaded areas often animated with Benday dots, the shape tautly delineated in crisp black outline with the image floating centrally on the ground. Among the earliest paintings is *Electric Cord* (1961). The range of objects depicted includes furniture—*Couch* (1961) and drawing [61–3], *Piano* (1961) and drawing [61–4]; wearing apparel—*Keds* (1961), including a slightly later drawing of 1962 [62–1] with the sneaker image reversed and in enlarged close-up view, *Zipper* (1962) and drawing [62–5], *Sock* (1962); small objects exceptionally magnified in scale—*Golf Ball* (1962), *The Ring* (1962). Sometimes, however, an exceptionally large object is rendered at a scale approximating life size, as in *Tire* (1962), a three-quarter view of an automobile wheel with hub cap, tire, and a geometrically rendered tire tread.

Although the majority of these images are painted with the white ground of the paper or canvas left untouched, a few are positioned on an all-over ground of Benday dots: *Ball of Twine* (1963), and a slightly dissimilar drawing of the same title and year [63–9]; *Duridium* (1964), a razor blade, the one and only example of the use of the airbrush technique.

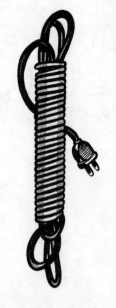

Electric Cord, 1961. Oil on canvas, 28″ x 18″. Collection Mr. and Mrs. Leo Castelli, New York.

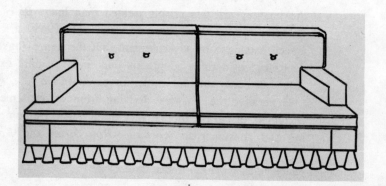

Couch, 1961. Ink on paper, 19¾″ x 23¼″. Collection Mr. and Mrs. Michael Sonnabend.

Including the very early lithograph *Ten Dollar Bill* (1956), several works exist with the image shape and rectilinear format positioned in a one-to-one relationship: *On* (1962)—a light switch and surrounding plate—and the three slightly different *Compositions* (all 1964) showing the front cover of a school composition book.

Foodstuffs (1961–66) The images of foodstuffs originate in two earlier paintings taken from advertisements: *Roto Broil* (1961), which has the frying element at the top piled with chickens (taken from a packaging carton), and *Kitchen Range* (1961), in which the open oven reveals racks of four various foods (at the top, pudding, fruit pie; at the bottom, roast, muffins). The foodstuff paintings reflect standard American methods of commercially representing food: *Turkey* and *Cherry Pie* (both 1961), *Standing Rib* and *Ice Cream Soda* (both 1962), *Hot Dog* and *Hot Dog with Mustard* (1963). The drawings begin in 1962—*Turkey* [62–8], *Baked Potato* [62–9, 62–10], *Cup of Coffee* [62–11] and continue *Bread and Jam* [63–3], *Sandwich and Soda* [64–3]. Ironically, the last image related to foodstuffs is *Tablet* [66–2], which depicts an indigestion tablet dissolving in a glass of water.

Comic strip (1961–65) The comic images divide into three principal categories: (1) war and violence, (2) science fiction, and (3) love and romance. In the comic-strip paintings, balloons and a wide variety of lettering of different weight, color, and design become formally and aesthetically integrated as major components of the imagery.

War and violence (1962–63) The war paintings, like the original comic images from which they derive, are rendered in movielike close-up and consist of two major subdivisions: aerial combat—*Blam, Tex!* (both 1962), and *Bratatat* (1963 and drawing [62–13]); land warfare—*Blaang* and *Scared Witless* (both 1962), images deriving from one painting conceived and executed in five panels, *Live Ammo* (1962). This five-paneled work was subsequently split into three single panels and one diptych. In its original form, *Live Ammo* depicts war by land and by air, and, though compositionally linked, the narrative element is ambiguous. *Whaam I* (1963), on the other hand, is a diptych with a clearly linked pictorial narrative, and *As I Opened Fire*

(1964) is a triptych connected by both a verbal narrative and movement in time.

In the majority of the war images there is an intense focus on symbols of flaming explosions, the trajectory of bullets and projectiles, and the sounds and the actions of violence and battle, particularly in the design of the lettering. Elements from these paintings provide the imagery of the later explosion paintings and sculptures.

With the exception of a solitary painting of sea warfare, *Torpedo . . . los!* (1963), which depicts a scarred German submarine captain at a battle station, all the war paintings are linked by the depiction of a generalized American subject obvious to the viewer.

Science fiction (1963–64) The science fiction images are few in number and selectively linked by a choice of subject matter representing technology gone mad and the lunatic fringe of scientists: *Image Duplicator, Mad Scientist* (both 1963), and *Eccentric Scientist* (1964).

Love and romance (1961–65) The earlier images, particularly *The Engagement Ring* (1961), *The Kiss III, Eddie Diptych, Masterpiece* (all 1962), *In the Car* (1963), and *Tension* (1964), consist of two figures, the majority being a boy and a girl connected by romantic dialogue and action. However, *Eddie Diptych* depicts a mother and a daughter,

Mad Scientist, 1963. Oil on canvas, 50" x 60". The Ludwig Collection, Wallraf-Richartz Museum, Cologne.

The Kiss III, 1962. Oil on canvas, 64" x 48". Collection Dwan Gallery, Los Angeles.

and Eddie is referred to only in the lettered panel. *Eddie Diptych* and *We Rose Up Slowly* (1964), another diptych, are two paintings in which the dialogue becomes the sole visual content of the hinged left-hand panels. Generally, the earlier the imagery the less significant the degree of crop: *Girl at Piano* (1962) and *I Know . . . Brad* (1963) are both three-quarter-length, single images of lovelorn girls situated within different settings. *Kiss with Cloud* (1964) is a bridge image between love and romance and the landscape.

1964–65: The first thematically linked paintings of girls' heads. Such is the similarity of the stylistic treatment and formal qualities in these images that they obviously represent a single series.

Lettering (1962) Though, as noted, there is a diverse and

Art, 1962. Oil on canvas, 36" x 68". Collection Gordon Locksley.

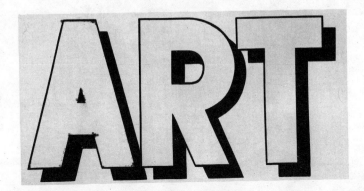

extensive use of lettering throughout the range of work up to 1965, four images exist with large geometricized words on a flat ground as the sole content: *Art, In,* and two drawings entitled *10¢,* of 1962—[62–7], and an uncatalogued version.

Adaptations of paintings by famous artists (1961–69) The idea of using a closely linked subject matter within a unified style of treatment is obviously suggested in the various paintings deriving from modern masters. *Man with Folded Arms* and *Portrait of Madame Cézanne* (both 1962) are quotations of outline diagrams by Erle Loran explaining Cézanne's compositional methods and are similar in the linear, black-and-white handling of the imagery. Of the paintings deriving from Picasso—*Femme au Chapeau* (1962), *Femme dans un Fauteuil, Femme d'Alger, Woman with Flowered Hat* (all 1963), *Still Life* (1964)—and three from Mondrian—*Non-Objective I, II,* and *III* (all 1964)—though obviously and recognizably images of work by these artists, are caricatured in the comic style. *George Washington* (1962)—drawing [62–14] and the oil painting of the same subject—is reminiscent of Gilbert Stuart's portrait, but in actuality the image derives from a linecut adaptation published in a Hungarian-language newspaper and is the only instance of reference to an American old master.

Thus, choice of subject matter and standardization of the fictional treatment loosely connects these paintings as a se-

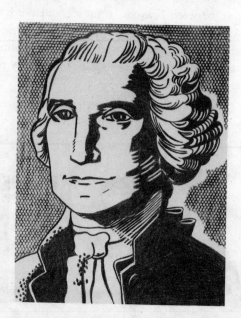

George Washington, 1962. Pencil on paper, 18¾" x 14½". Collection Mr. and Mrs. Ned Owyang.

ries. The Haystack and Cathedral paintings and prints of 1969, however, are thematically and formally structured by the use of serial imagery. The Cathedral series is not only linked by standardized imagery and formal components but also by identical canvas size and, for the first time, the use of three or more separate canvases within a set. (Note: The first Cathedral painting, somewhat different in size but similar in other respects, is an isolated image not belonging to any set.)

Ceramic sculpture (1965) Although three-dimensional, the ceramic polychrome sculptures of girls' heads are connected to the 1964–65 series of paintings of girls' heads. Rendered at a one-to-one scale with the originals and made in the same material, the black-and-white sculptures of crockery, in their vulgarity and decoration, also relate to the comics.

Landscapes (1964–65) The landscape images include various elements such as clouds, skies, sea, land, sun, and moon. These paintings vary between a high degree of representativeness, as *Gullscape, Sussex,* and *Sinking Sun* (all 1964), and almost completely abstract images that play upon the field painting of the 1960's—especially *Seascape* (1964), in which the upper band of the sky and the lower band of the land are treated as similar elements. Many of the more abstract paintings are without black lines; the image is

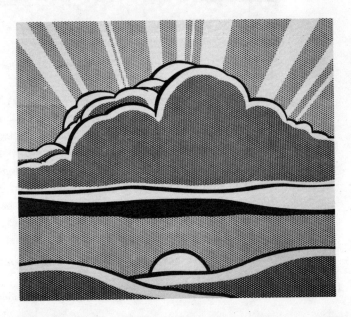

Sinking Sun, 1964. Oil and magna on canvas, 68″ x 80″. Collection Ms. Brooke Hayward Hopper.

formed in its entirety from linear and massed groupings of dots. In addition, many paintings reveal a high degree of optical interplay among the various overlapping colored dots and the white ground. In this series, there is also an unusual use of various plastic materials to produce ambivalent optical effects. Some incorporate an external lighting system and some, electric motors to give various kinetic effects. *Atomic Explosion* (1966) is a small painting (14 × 16 inches) of a large event. *Landscape with Setting Sun,* a

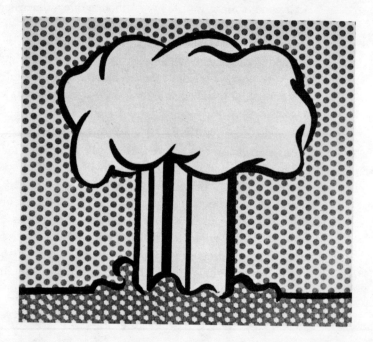

Atomic Explosion, 1966.
Oil on canvas, 14″ x 16″.
Collection the artist.

drawing [64–40], is one of many small sketches made for this series.

Remains of monumental architecture (1964–69) The various paintings of classical ruins and temples—*Temple of Apollo* (1964), *Temple II* (1965), and particularly the image of a decayed and isolated classic column in *Landscape with Column* (1965)—are an offshoot of the landscape series. The monumentality of the architecture in *Temple of Apollo* (1964) and of the various images of the Egyptian pyramids—for example, *The Great Pyramid* (1969)—demand and receive a much larger format than usual.

Brushstrokes (1965–66) The varied brushstroke series of

Roy Lichtenstein

paintings represents a classical rendition of an expressionist subject matter. The brushstrokes are a generalized, invented image. The images were arrived at by applying loaded brushstrokes of black Magna color upon acetate, allowing the paint to shrink on the repellent surface and to dry, and then overlapping the sheets to find a suitable image, which was finally projected onto a canvas and redrawn. Two unexhibited paintings of drips (or biomorphic blotches of paint rendered at a large scale on simulated graph paper with

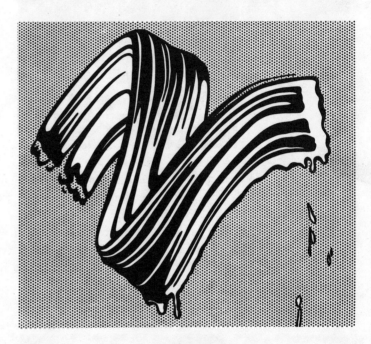

White Brushstroke I, 1965. Oil and magna on canvas, 48″ x 56″. Collection Mr. Irving Blum.

colored horizontal and vertical lines) also exist—*White Drip on Red and Black Graph* and *Yellow and White Drip on Graph* (both 1966). Never exhibited.

Explosions (1965–66) Paintings, many reliefs, and freestanding enameled sculptures of explosions. The hard surface lends concreteness to what, in its original form, is an amorphous and ephemeral phenomenon. The fact that even the freestanding sculptures consist of decidedly two-dimensional, glossy polychrome elements heightens the synthetic quality of these images.

Modern paintings (1966–70) The Modern paintings represent a highly diversified body of work mixing abstraction

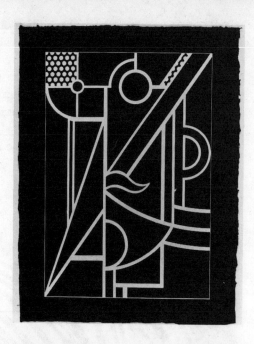

Modern Head No. 3, 1969–70. Embossed linocut print. 24½″ x 18½″. Collection Gemini G.E.L., Los Angeles.

and representation to an extraordinary degree and ending with totally abstract and semi-abstract images in 1969 and 1970, interspersed with sculptures in brass, wood, glass, and marble, as well as a diverse range of imagery in multiples and graphics. The Modern paintings derive in style from Art Deco and WPA mural painting. Many of the paintings

Mirror, 1970. Oil and magna on canvas, 24″ diameter. Private collection.

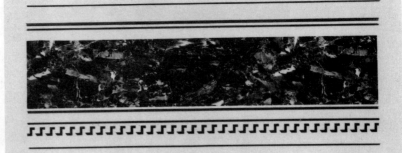

Frieze, 1971. Pencil and Contac paper on paper, 28″ x 41″. Collection Leo Castelli Gallery, New York.

explore a modular format of from two to nine panels in various arrangements with the same image invariably repeated on all panels. The modern images are numerically the largest series.

Mirrors (1970–71) Paintings of round, oval, and rectilinear, single and multipaneled vertical images of the reflective surface of mirrors. Extremely abstract, varied in color and formal treatment, they include the extensive use of graduated dots. These images derive from catalogues and newspaper advertisements of mirrors but are refined reinterpretations without the vulgar overtones of the original commercial art. The images are, in fact, first suggested in *Magnifying Glass* (1963).

Friezes (1971) Highly reductive and austerely treated black-and-white horizontal images of entablatures, derived from photographs taken by the artist of nineteenth-century neoclassical New York office buildings. The images can be considered as an extension and distillation of architectural details first used in the 1964 paintings of classical ruins. The forms consist entirely of black shadows conventionally cast by strong upper-left illumination freely invented from photographs. They are large pencil drawings centered on white paper and a number of long, horizontal paintings in black on a white ground varying in length from ten to eighteen feet.

‖ interviews

An Interview with Roy Lichtenstein *John Coplans*

John Coplans: *How did you paint prior to your current style?*

Roy Lichtenstein: Mostly reinterpretations of those artists concerned with the opening of the West, such as Remington, with a subject matter of cowboys, Indians, treaty signings, a sort of Western official art in a style broadly influenced by modern European painting. From 1957 onward my work became nonfigurative and Abstract Expressionist. In the latter part of this body of work I used loosely handled cartoon images. In the summer of 1961 I made a complete break into my current work.

What triggered this jump?

I am not sure what particularly influenced the change, especially as I have always had this interest in a purely American mythological matter.

Then, what gave you the idea of using an impersonal industrial technique?

Using a cartoon subject matter in my later paintings, some of which I was getting from bubble gum wrappers, eventually led to simulating the same technique as in the originals. The early ones were of animated cartoons, Donald Duck, Mickey Mouse, and Popeye, but then I shifted into the style of cartoon books with a more serious content such as "Armed Forces at War" and "Teen Romance."

Did you find any difficulty in handling the subject matter in an impersonal way?

It was very difficult not to show everything I knew about a whole tradition. It was difficult not to be seduced by the nuances of "good painting." The important thing, however, is not the technique but the unity of vision within the painter himself. Then you don't have to worry if everything you "know" will be in the painting.

What was the real crisis that precipitated your clean break with the past?

Desperation. There were no spaces left between Milton Resnick and Mike Goldberg.

Did the work of Johns or Rauschenberg provide you with any insights at that time?

Although I recognize their great influence now, I wasn't as aware at that time. I was more aware of the Happenings of Oldenburg, Dine, Whitman, and Kaprow. I knew Kaprow well; we were colleagues at Rutgers. I didn't see many Happenings, but they seemed concerned with the American industrial scene. They also brought up in my mind the whole question of the object and merchandising.

From *Artforum* 2, no. 4 (October, 1963).

In your reply you seem to imply that the Happenings were more important to you than Johns or Rauschenberg. Why?

Although the Happenings were undoubtedly influenced by Johns and Rauschenberg, an Oldenburg Fried Egg is much more glamorized merchandise and relates to my ideas more than Johns's beer cans. I want my images to be as critical, as threatening, and as insistent as possible.

About what?

As visual objects, as paintings—not as critical commentaries about the world. Of course this is all in retrospect. At the beginning I wasn't sure exactly what I was doing, but I was very excited about, and interested in, the highly emotional content yet detached, impersonal handling of love, hate, war, etc., in these cartoon images.

One of the main criticisms of your work is that you don't significantly transform the material you use.

The closer my work is to the original, the more threatening and critical the content. However, my work is entirely transformed in that my purpose and perception are entirely different. I think my paintings are critically transformed, but it would be difficult to prove it by any rational line of argument.

What Is Pop Art? *G. R. Swenson*

G. R. Swenson: *What is Pop art?*

Roy Lichtenstein: I don't know—the use of commercial art as subject matter in painting, I suppose. It was hard to get a painting that was despicable enough so that no one would hang it—everybody was hanging everything. It was almost acceptable to hang a dripping paint rag, everybody was accustomed to this. The one thing everyone hated was commercial art; apparently they didn't hate that enough either.

Is Pop art despicable?

That doesn't sound so good, does it? Well, it *is* an involvement with what I think to be the most brazen and threatening characteristics of our culture, things we hate but which are also powerful in their impingement on us. I think art since Cézanne has become extremely romantic and unrealistic, feeding on art; it is utopian. It has had less and less to do with the world, it looks inward—neo-Zen and all that. This is not so much a criticism as an obvious observation. Outside is the world; it's there. Pop art looks out into the world; it appears to accept its environment, which is not good or bad, but different—another state of mind.

From *Art News* 62, no. 7 (November, 1963).

"How can you like exploitation?" "How can you like the complete mechanization of work?" "How can you like bad art?" I have to answer that I accept it as being there, in the world.

Are you anti-experimental?

I think so, and anti-contemplative, anti-nuance, anti-getting-away-from-the-tyranny-of-the-rectangle, anti-movement and -light, anti-mystery, anti-paint-quality, anti-Zen, and anti all of those brilliant ideas of preceding movements which everyone understands so thoroughly.

We like to think of industrialization as being despicable. I don't really know what to make of it. There's something terribly brittle about it. I suppose I would still prefer to sit under a tree with a picnic basket rather than under a gas pump, but signs and comic strips are interesting as subject matter. There are certain things that are usable, forceful, and vital about commercial art. We're using those things—but we're not really advocating stupidity, international teen-agerism, and terrorism.

Where did your ideas about art begin?

The ideas of Professor Hoyt Sherman [at Ohio State University] on perception were my earliest important influence and still affect my ideas of visual unity.

Perception?

Yes. Organized perception is what art is all about.

He taught you "how to look"?

Yes. He taught me how to go about learning how to look.

At what?

At what doesn't have anything to do with it. It is a process. It has nothing to do with any external form the painting takes; it has to do with a way of building a unified pattern of seeing. In Abstract Expressionism the paintings symbolize the idea of ground-directedness as opposed to object-directedness. You put something down, react to it, put something else down, and the painting itself becomes a symbol of this. The difference is that rather than symbolize this ground-directedness I do an object-directed appearing thing. There is humor here. The work is still ground-directed; the fact that it's an eyebrow or an almost direct copy of something is unimportant. The ground-directedness is in the painter's mind and not immediately apparent in the painting. Pop art makes the statement that ground-directedness is not a quality that the painting has because of what it looks like. This tension between apparent object-directed products and actual ground-directed processes is an important strength of Pop art.

Antagonistic critics say that Pop art does not transform its models. Does it?

Transformation is a strange word to use. It implies that art transforms. It doesn't, it just plain forms. Artists have never worked with the model—just with the painting. What you're really saying is that an artist

like Cézanne transforms what we think the painting ought to look like into something he thinks it ought to look like. He's working with paint, not nature; he's making a painting, he's forming. I think my work is different from comic strips—but I wouldn't call it transformation; I don't think that whatever is meant by it is important to art. What I do is form, whereas the comic strip is not formed in the sense I'm using the word; the comics have shapes but there has been no effort to make them intensely unified. The purpose is different, one intends to depict and I intend to unify. And my work is actually different from comic strips in that every mark is really in a different place, however slight the difference seems to some. The difference is often not great, but it is crucial. People also consider my work to be anti-art in the same way they consider it pure depiction, "not transformed." I don't feel it is anti-art.

There is no neat way of telling whether a work of art is composed or not; we're too comfortable with ideas that art is the battleground for interaction, that with more and more experience you become more able to compose. It's true, everybody accepts that; it's just that the idea no longer has any power.

Abstract Expressionism has had an almost universal influence on the arts. Will Pop art?

I don't know. I doubt it. It seems too particular—too much the expression of a few personalities. Pop might be a difficult starting point for a painter. He would have great difficulty in making these brittle images yield to compositional purposes. Interaction between painter and painting is not the total commitment of Pop, but it is still a major concern—though concealed and strained.

Do you think that an idea in painting—whether it be "interaction" or the use of commercial art—gets progressively less powerful with time?

It seems to work that way. Cubist and Action Painting ideas, although originally formidable and still an influence, are less crucial to us now. Some individual artists, though—Stuart Davis, for example—seem to get better and better.

A curator at the Modern Museum has called Pop art fascistic and militaristic.

The heroes depicted in comic books are fascist types, but I don't take them seriously in these paintings—maybe there is a point in not taking them seriously, a political point. I use them for purely formal reasons, and that's not what those heroes were invented for. Pop art has very immediate and of-the-moment meanings which will vanish—that kind of thing is ephemeral—and Pop takes advantage of this "meaning," which is not supposed to last, to divert you from its formal content. I think the formal statement in my work will become clearer in time. Superficially, Pop seems to be all subject matter, whereas Abstract Expressionism, for example, seems to be all esthetic.

54 Roy Lichtenstein

I paint directly—then it's said to be an exact copy, and not art, probably because there's no perspective or shading. It doesn't look like a painting *of* something, it looks like the thing itself. Instead of looking like a painting *of* a billboard—the way a Reginald Marsh would look—Pop art seems to be the actual thing. It is an intensification, a stylistic intensification of the excitement which the subject matter has for me; but the style is, as you said, cool. One of the things a cartoon does is to express violent emotion and passion in a completely mechanical and removed style. To express this thing in a painterly style would dilute it; the techniques I use are not commercial, they only appear to be commercial—and the ways of seeing and composing and unifying are different and have different ends.

Is Pop art American?

Everybody has called Pop art "American" painting, but it's actually industrial painting. America was hit by industrialism and capitalism harder and sooner, and its values seem more askew. I think the meaning of my work is that it's industrial, it's what all the world will soon become. Europe will be the same way, so it won't be American; it will be universal.

Oldenburg, Lichtenstein, Warhol: A Discussion
Bruce Glaser

The following discussion was broadcast over radio station WBAI in New York in June, 1964. The transcript was edited for publication in September–October, 1965.

BRUCE GLASER: Claes, how did you arrive at the kind of image you are involved with now? Did it evolve naturally from the things you were doing just before?

CLAES OLDENBURG: I was doing something that wasn't quite as specific as what I'm doing now. Everything was there, but it was generalized and in the realm of imagination, let's say. And, of course, an artist goes through a period where he develops his "feelers" and then he finds something to attach them to, and then the thing happens that becomes the thing that he wants to be or say.

So I had a lot of ideas about imaginary things and fantasies which I experimented with in drawings, sculptures, and paintings in every conceivable way I could. Through all this I was always attracted to city culture because that's the only culture I had. Then around 1959, under the influence of the novelist Céline and Dubuffet, I started to work with

From *Artforum* 4, no. 6 (February, 1966).

city materials and put my fantasy into specific forms. Then, under the influence of friends like Jim Dine and Roy Lichtenstein and Andy [Warhol] and all these people, the images became even more specific. But I can go back to my earlier work and find a toothpaste tube or a typewriter, or any of the things that appear in my present work, in more generalized forms.

GLASER: You mention that some of the other artists who work with Pop imagery had some effect on you. Yet it is often said by advocates of Pop art that it arose spontaneously and inevitably out of the contemporary milieu without each Pop artist's having communication about, or even awareness of, what other Pop artists were doing. Are you suggesting something contrary to this?

OLDENBURG: There is always a lot of communication between artists because the art world is a very small one and you can sense what other people are doing. Besides, America has a traditional interest in Pop culture. In Chicago, where I spent a lot of time, people like June Leaf and George Cohen were working very close to a Pop medium in 1952. George Cohen used to go to the dime store and buy all the dolls he could find and other stuff like that. Even though he used them for his own personal image there has always been this tendency.

Also, in California, where I've spent some time, the tradition of getting involved with Pop culture goes way back. But I don't think the particular subject matter is as important as the attitude. It's a deeper question than just subject matter.

GLASER: Roy, how did you come upon this imagery?

ROY LICHTENSTEIN: I came upon it through what seems like a series of accidents. But I guess that maybe they weren't completely accidental. Before I was doing this I was doing a kind of Abstract Expressionism, and before that I was doing things that had to do with the American scene. They were more Cubist and I used early American paintings by Remington and Charles Willson Peale as subject matter.

But I had about a three-year period, just preceding this, in which I was doing only abstract work. At that time I began putting hidden comic images into those paintings, such as Mickey Mouse, Donald Duck, and Bugs Bunny. At the same time I was drawing little Mickey Mouses and things for my children and working from bubble gum wrappers, I remember specifically. Then it occurred to me to do one of these bubble gum wrappers, as is, large, just to see what it would look like. Now I think I started out more as an observer than as a painter, but, when I did one, about half way through the painting I got interested in it as a painting. So I started to go back to what I considered serious work because this thing was too strong for me. I began to realize that this was a more powerful thing than I had thought and it had interest.

Now, I can see that this wasn't entirely accidental. I was aware of

56 Roy Lichtenstein

other things going on. I had seen Claes's work and Jim Dine's at the "New Forms, New Media" show (Martha Jackson Gallery, 1960), and I knew Johns, and so forth. But when I started the cartoons I don't think that I related them to this, although I can see that the reason I felt them as significant was partly because this kind of thing was in the air. There were people involved in it. And I knew Happenings. In fact, I knew Allan Kaprow, who was teaching with me at Rutgers. Happenings used more whole and more American subject matter than the Abstract Expressionists used. Although I feel that what I am doing has almost nothing to do with environment, there is a kernel of thought in Happenings that is interesting to me.

GLASER: How did you get involved with Pop imagery, Andy?

ANDY WARHOL: I'm too high right now. Ask somebody else something else.

GLASER: When did you first see Andy's work?

LICHTENSTEIN: I saw Andy's work at Leo Castelli's about the same time I brought mine in, about the spring of 1961. And I hear that Leo had also seen Rosenquist within a few weeks. Of course, I was amazed to see Andy's work because he was doing cartoons of Nancy and Dick Tracy and they were very similar to mine.

GLASER: Many critics of Pop art are antagonistic to your choice of subject, whether it be a comic strip or an advertisement, since they question the possibility of its having any philosophical content. Do you have any particular program or philosophy behind what you do?

OLDENBURG: I don't know, and I shouldn't really talk about Pop art in general, but it seems to me that the subject matter is the least important thing. Pop imagery, as I understand it, if I can sever it from what I do, is a way of getting around a dilemma of painting and yet not painting. It is a way of bringing in an image that you didn't create. It is a way of being impersonal. At least that is the solution that I see, and I am all for clear definitions.

I always felt, for example, that Andy was a purist kind of Pop artist in that sense. I thought that his box show was a very clear statement and I admire clear statements. And yet again, maybe Andy is not a purist in that sense. In art you could turn the question right around and the people that are most impersonal turn out to be the most personal. I mean, Andy keeps saying he is a machine and yet looking at him I can say that I never saw anybody look less like a machine in my life.

I think that the reaction to the painting of the last generation, which is generally believed to have been a highly subjective generation, is impersonality. So one tries to get oneself out of the painting.

GLASER: In connection with this I remember a show of yours at the Judson Street Gallery in 1959 which reflected your interest in Dubuffet, and that work clearly had a very personal touch. Your drawings and

objects then were not made in the impersonal way that Roy uses a stencil or Andy a silkscreen.

LICHTENSTEIN: But don't you think we are oversimplifying things? We think the last generation, the Abstract Expressionists, were trying to reach into their subconscious, and more deeply than ever before, by doing away with subject matter. Probably very few of those people really got into their subconscious in a significant way, although I certainly think the movement as a whole is a significant one. When we consider what is called Pop art—although I don't think it is a very good idea to group everybody together and think we are all doing the same thing—we assume these artists are trying to get outside the work. Personally, I feel that in my own work I wanted to look programmed or impersonal but I don't really believe I am being impersonal when I do it. And I don't think you could do this. Cézanne said a lot about having to remove himself from his work. Now this is almost a lack of self-consciousness and one would hardly call Cézanne's work impersonal.

I think we tend to confuse the style of the finished work with the method through which it was done. We say that because a work looks involved, as though interaction is taking place, significant interaction is really taking place. And when a work does not look involved, we think of it merely as the product of a stencil or as though it were the same comic strip from which it was copied. We are assuming similar things are identical and that the artist was not involved.

But the impersonal look is what I wanted to have. There are also many other qualities I wanted to have as an appearance. For example, I prefer that my work appear so literary that you can't get to it as a work of art. It's not that I'm interested in confounding people but I do this more as a problem for myself. My work looks as if it is thought out beforehand to such a degree that I don't do anything but put the color on. But these are appearances and they are not what I really feel about it. I don't think you can do a work of art and not really be involved in it.

GLASER: You are lessening the significance of appearances, but appearances can hardly be dismissed as a reflection of your intentions.

LICHTENSTEIN: But part of the intention of Pop art is to mask its intentions with humor.

GLASER: Another thing; one may say he wants to make a work of art that is not self-conscious and that he doesn't want to give the appearance of a self-conscious work of art, but it doesn't matter whether you use an industrial method or whether you use a method that emphasizes the artist's hand. Whatever the case may be, we assume that if the artist has been working for any length of time he will acquire a certain lack of consciousness in the way he uses that particular method. As a result, consciousness, or the lack of it, becomes less of an issue.

58 Roy Lichtenstein

OLDENBURG: I think we are talking of impersonality as style. It's true that every artist has a discipline of impersonality to enable him to become an artist in the first place, and these disciplines are traditional and well known—you know how to place yourself outside the work. But we are talking about making impersonality a style, which is what I think characterizes Pop art, as I understand it, in a pure sense.

I know that Roy does certain things to change his comic strips when he enlarges them, and yet it's a matter of the degree. It's something that the artist of the last generation or, for that matter, of the past would not have contemplated.

LICHTENSTEIN: I think that's true. I didn't invent the image and they wanted to invent the image.

OLDENBURG: That's right. And Andy is the same with his Brillo boxes. There is a degree of removal from actual boxes, and they become an object that is not really a box. In a sense they are an illusion of a box, and that places them in the realm of art.

GLASER: Would you say that this particular ambiguity is the unique contribution of Pop art, or is it the subject matter?

OLDENBURG: Subject matter is certainly a part of it. You never had commercial-art apples, tomato cans, or soup cans before. You may have had still life in general, but you never had still life that had been passed through the mass media. Here, for the first time, is an urban art which does not sentimentalize the urban image but uses it as it is found. That is something unusual. It may be one of the first times that art focuses on the objects that the human being has created or played with, rather than on the human being. You have had city scenes in the past but never a focus on the objects the city displays.

GLASER: Is it fair to say that it is only to the subject matter that Pop art owes its distinction from other movements, and that there are relatively few new elements of plastic invention in your work?

LICHTENSTEIN: I don't know, because I don't think one can see things like plastic invention when one is involved.

OLDENBURG: If I didn't think that what I was doing had something to do with enlarging the boundaries of art, I wouldn't go on doing it. I think, for example, the reason I have done a soft object is primarily to introduce a new way of pushing space around in a sculpture or painting. And the only reason I have taken up Happenings is because I wanted to experiment with total space or surrounding space. I don't believe that anyone has ever used space before in the way Kaprow and others have been using it in Happenings. There are many ways to interpret a Happening, but one way is to use it as an extension of painting space. I used to paint but I found it too limiting, so I gave up the limitations that painting has. Now I go in the other direction and violate the whole idea of painting space.

But the intention behind this is more important. For example, you might ask what is the thing that has made me make cakes and pastries and all those other things. Then, I would say that one reason has been to give a concrete statement to my fantasy. In other words, instead of painting it, to make it touchable, to translate the eye into the fingers. That has been the main motive in all my work. That's why I make things soft that are hard and why I treat perspective the way I do, such as with the bedroom set, making an object that is a concrete statement of visual perspective. But I am not terribly interested in whether a thing is an ice cream cone or a pie or anything else. What I am interested in is that the equivalent of my fantasy exists outside of me, and that I can, by imitating the subject, make a different kind of work from what has existed before.

GLASER: What you say is very illuminating. How does this fit in with your intentions, Roy?

LICHTENSTEIN: Well, I don't think I am doing the same thing Claes is doing. I don't feel that my space is anything but traditional, but then I view all space as traditional. I don't dwell on the differences in viewing space in art history. For example, I can see the obvious difference between Renaissance and Cubist painting but I don't think it matters. The illusion of three-dimensional space is not the basic issue in art. Although perspective as a scientific view of nature was the subject matter of Renaissance art, that perspective is still two-dimensional. And I think that what Cubism was about was that it does not make any difference, and they were restating it, making a formal statement about the nature of space, just as Cézanne had made another formal statement about the nature of space. So I would not want to be caught saying that I thought I was involved in some kind of spatial revolution. I am interested in putting a painting together in a traditional but not academic way. In other words, I am restating the idea of space because the form is different from the forms that preceded me.

I think, like Claes, I am interested in objectifying my fantasies and I am interested in the formal problems more than the subject matter. Once I have established what the subject matter is going to be, I am not interested in it any more, although I want it to come through with the immediate impact of the comics. Probably the formal content of Pop art differs from Cubism and Abstract Expressionism in that it doesn't symbolize what the subject matter is about. It doesn't symbolize its concern with form but rather leaves its subject matter raw.

GLASER: Claes, I want to find out a bit more about the nature of Dubuffet's influence on you which we mentioned before. Your early work seemed to explore the same areas of primitive art and expression of the subconscious that he is interested in.

OLDENBURG: Yes, that's true, but mainly Dubuffet is interesting because

Roy Lichtenstein

of his use of material. In fact, that is one way to view the history of art, in terms of material. For example, because my material is different from paint and canvas, or marble or bronze, it demands different images and it produces different results. To make my paint more concrete, to make it come out, I used plaster under it. When that didn't satisfy me I translated the plaster into vinyl, which enabled me to push it around. The fact that I wanted to see something flying in the wind made me make a piece of clothing, or the fact that I wanted to make something flow made me make an ice cream cone.

GLASER: I think it may even be fair to say that Dubuffet's work is one of the main precedents for Pop art insofar as he was interested in banal and discredited images. And as you say, he worked with common or strange materials such as dirt and tar, or butterfly wings, to create his new imagery.

Now, I would like to pick up something else we were talking about before, namely the possible implications of style in regard to Roy's work. I have had the feeling in looking at some of your paintings that they have more affinities with certain current styles of abstract art than with other kinds of Pop art. Your clearer, direct image, with its hard lines and its strong impact relate you to artists such as Al Held, Kenneth Noland, or Jack Youngerman. Because of these connections, discounting subject matter, I wondered whether you might be involved in some of the same stylistic explorations they are.

LICHTENSTEIN: Yes, I think my work is different from theirs and no doubt you think so too, but I also think there is a similarity. I am interested in many of these things, such as showing a similarity between cartooning and certain artists. For example, when I do things like explosions, they are really kinds of abstractions. I did a composition book in which the background was a bit like Pollock or Youngerman. Then, I also have done the Picasso and Mondrians, which were obviously direct things, but they are quite different in their meaning than the other less obviously related analogies to abstract painting. I like to show analogies in this way in painting, and I think of them as abstract painting when I do it. Perhaps that is where the deeper similarity lies, in that once I am involved with the painting I think of it as an abstraction. Half the time they are upside down, anyway, when I work.

WARHOL: Do you do like what Claes does with vinyl ketchup and french-fried potatoes?

LICHTENSTEIN: Yes, it's part of what you do, to make something that reminds you of something else.

OLDENBURG: This is something I wonder about. I know I make parodies on artists, as with vinyl ketchup forms which have a lot of resemblance to Arp, but why? I wonder why we want to level these things. Is it part of the humbling process? Maybe it is because I have

always been bothered by distinctions—that this is good and this is bad and this is better, and so on. I am especially bothered by the distinction between commercial and fine art or between fine painting and accidental effects. I think we have made a deliberate attempt to explore this area, along with its comical overtones. But, still, the motives are not too clear to me as to why I do this.

LICHTENSTEIN: Nor with me either, nor even why I say I do it.

OLDENBURG: I don't want to use this idea as an instrument of ambition or facetiousness or anything like that. I want it to become work. But I am never quite sure why I am doing it.

GLASER: There is a question in my mind as to whether much of the subject of Pop art is actually satirical. I have felt so many times that the subject matter and the technique are, indeed, an endorsement of the sources of Pop imagery. It is certainly true that there are some satirical elements in this work, but apparently that doesn't concern you too much. I wonder, then, whether you are not saying that you really like this banal imagery.

LICHTENSTEIN: I do like aspects of it.

OLDENBURG: If it was just a satirical thing there wouldn't be any problem. Then we would know why we were doing these things. But making a parody is not the same thing as a satire. Parody in the classical sense is simply a kind of imitation, something like a paraphrase. It is not necessarily making fun of anything, rather it puts the imitated work into a new context. So I see an Arp and I put that Arp into the form of some ketchup, does that reduce Arp or does it enlarge the ketchup, or does it make everything equal? I am talking about the form and not about your opinion of the form. The eye reveals the truth that the ketchup looks like an Arp. That's the form the eye sees. You do not have to reach any conclusions about which is better. It is just a matter of form and material.

LICHTENSTEIN: In the parody there is the implication of the perverse and I feel this in my own work even though I don't mean it to be that, because I don't dislike the work that I am parodying. The things that I have apparently parodied I actually admire, and I really don't know what the implication of that is.

GLASER: There is an ambiguity here too, part endorsement, part satire.

OLDENBURG: Anyhow, there is something very beautiful in putting art back into the present world and breaking down the barriers that have been erected for the appreciation of art. Nevertheless, I would like to say that I have a very high idea of art. I am still romantic about that. This process of humbling it is a testing of the definition of art. You reduce everything to the same level and then see what you get.

LICHTENSTEIN: I am very interested in a thing that seems to happen in the visual arts more than anywhere else. There is the assumption

Roy Lichtenstein

by some people that similar things are identical. If you were to do the same thing in music and play something that sounded like a commercial, it would be very hard to vary it from the commercial or not have it immediately obvious that you are "arting" it somehow, or making it aesthetic. Your only alternative would be to play this thing—whatever it is—the simple tune, as is. If you did anything to it, it would immediately be apparent, and this is not true in the visual arts. Maybe this is one reason why this sort of thing has not been done in music. Although it has had parallels in which commercial material is used, it is always obviously transformed.

GLASER: You are saying that one of the purposes of the subject matter of Pop art is to confuse the spectator as to whether the advertisement, comic strip, or movie-magazine photograph is really what it seems to be.

LICHTENSTEIN: This is true. In my own work there is a question about how much has been transformed. You will discover the subjects really are if you study them, but there is always the assumption that they are the same, only bigger.

GLASER: Well, even if there is a transformation, it is slight, and this has given rise to the objection that Pop art has encroached on and plundered the private pleasure of discovering interest in what is ordinarily mistaken as banal subjects. For example, if one privately enjoyed aspects of the comics, today one finds this pleasure made public in the galleries and museums.

LICHTENSTEIN: I am crying.

WARHOL: Comic strips now give credit to the artist. They say "art by." Comic books didn't give credit in the past.

OLDENBURG: It would be interesting to study the effect of this on the average commercial artist who still remains a problem child. He is generally trying to figure out who he is and what he is doing. Maybe this will make them do more crazy things. I don't know.

WARHOL: Commercial artists are richer.

GLASER: That is a difference too. But I am more interested in the problems that come up in regard to your interest in popular imagery. For example, with you, Claes, if at one time you saw in this material the possibility of exploring some kind of fantastic world, what you actually have done is to take the world of popular imagery and use it to a point where it is now becoming commonplace in museums and seen and talked about by cultured people, by critics and collectors. Your imagery no longer has any clear relationship to the public that the original popular image had, and the implication of this is that you may, in fact, have abandoned a very vital connection with a very large but visually naïve public.

OLDENBURG: We did not establish that my art had any clear relation to the public in the first place. I think the public has taken it for its own

uses, just as it takes everything you do for its own uses. You can't legislate how the public is going to take your art.

GLASER: You did say that you were still interested in the idea of high art?

OLDENBURG: I am interested in distinguishing the artist as a creator from certain other people. If I make an image that looks very much like a commercial image, I only do it to emphasize my art and the arbitrary act of the artist who can bring it into relief somehow. The original image is no longer functional. None of my things have ever been functional. You can't eat my food. You can't put on my clothes. You can't sit in my chairs.

GLASER: Traditional art is like that too. You can't eat a still life.

OLDENBURG: But they haven't been so physical, nor so close to you so that they looked as if you could eat them or put them on or sit in them.

WARHOL: But with your bedroom set, you can sleep in it.

OLDENBURG: You can sleep in it on my terms. But to get back to the idea of high art, I believe there is such a profession as being an artist and there are rules for this, but it is very hard to arrive at these rules.

GLASER: What is your feeling about the audience that reacts to Pop art? Did you ever think that with such imagery you might be able to reach a larger audience, or do you want the same traditional art audience?

LICHTENSTEIN: When you are painting you don't think of the audience, but I might have an idea of how an audience would see these paintings. However, I don't think that Pop art is a way of reaching larger groups of people.

GLASER: Some commentators, having noticed the greater popularity and reception of Pop art, have said that this is so because it is representational rather than abstract.

LICHTENSTEIN: I don't think Pop has found any greater acceptance than the work of the preceding generation.

OLDENBURG: There is a sad, ironic element here which almost makes me unhappy. I have done a lot of touring in this country and abroad for Pop shows and Happenings, deliberately, to learn how people feel about this outside of New York. There is a disillusionment that follows. When you come to a town they think you are going to be something like the Ringling Brothers. They expect you to bring coke bottles and eggs and that they are going to eat it and like it, and so on. But then, when they find that you are using different things you begin to grate on them.

WARHOL: Yes, but the wrong people come, I think.

OLDENBURG: But I hate to disillusion anybody, and you find people becoming disillusioned because it turns out to be just the same old thing —Art.

GLASER: Andy, what do you mean by the wrong people coming?

Roy Lichtenstein

WARHOL: The young people who know about it will be the people who are more intelligent and know about art. But the people who don't know about art would like it better because it is what they know. They just don't think about it. It looks like something they know and see every day.

OLDENBURG: I think it would be great if you had an art that could appeal to everybody.

WARHOL: But the people who really like art don't like the art now, while the people who don't know about art like what we are doing.

GLASER: Then, you do believe that the public is more receptive to Pop art than to Abstract Expressionism?

WARHOL: Yes. I think everybody who likes abstract art doesn't like this art, and they are all the intelligent and marvelous people. If the Pop artists like abstract art it is because they know about art.

GLASER: The criticism of Pop art has been that it reflects a growing tendency toward neoconservatism that is apparent in certain areas of American life. On the most superficial level, reference is made to its turning away from abstraction and back to the figure. But on a more serious level, objections are raised about what seems to be the negation of humane qualities which the more liberal segments of our society, rightly or wrongly, claim as their special preserve. Superficially, one can point to the fact that you use industrial processes in making your work and deny the presence of the artist's hand. There is also Andy's statement, "I wish I were a machine."

LICHTENSTEIN: This is apolitical. For that matter, how could you hook up abstraction with liberal thinking? Probably most artists may be more liberal politically. But Pop art doesn't deal with politics, although you may interpret some of Andy's paintings, such as those with the police dogs or the electric chairs, as liberal statements.

OLDENBURG: Andy, I would like to know, when you do a painting with a subject matter such as this, how do you feel about it? In the act of setting it up the way you do, doesn't that negate the subject matter? Aren't you after the idea of the object speaking for itself? Do you feel that when you are repeating it the way you do, that you are eliminating yourself as the person extracting a statement from it? When I see you repeat a race riot I am not so sure you have done a race riot. I don't see it as a political statement but rather as an expression of indifference to your subject.

WARHOL: It is indifference.

GLASER: Isn't it significant that you chose that particular photograph rather than a thousand others?

WARHOL: It just caught my eye.

OLDENBURG: You didn't deliberately choose it because it was a "hot" photograph?

WARHOL: No.

OLDENBURG: The choice of these "hot" subjects and the way they are used actually bring the cold attitude more into relief.

GLASER: Perhaps in dealing with feelings in such a way one may be exploring new areas of experience. In that case it would hardly be fair to characterize Pop art as neoconservative. It might be more worthwhile to consider its deliberating quality in that what is being done is completely new.

Conversation with Lichtenstein *Alan Solomon*

Alan Solomon: *How do you feel about being considered a Pop artist?*

Roy Lichtenstein: Well, I don't think I mind being called a Pop artist. I think it will stick regardless of what later names are given to it. I think it reflects the feeling of the kind of work I do, and it fits me fairly well. I think we're living in a society that to a large extent is "Pop." It's one of the facets of present society which is new and hasn't existed before. I think in that way the name is somewhat significant.

I'm interested in portraying a sort of anti-sensibility that pervades the society and a kind of gross oversimplification. I use that more as style than as actuality. I really don't think that art can be gross and over-simplified and remain art. I mean, it must have subtleties, and it must yield to aesthetic unity, otherwise it's not art. I think that it's really a kind of conceptual rather than a visual style which maybe permeates most art being done today, whether it's geometric or whatever. Whereas Abstract Expressionism was rather loose and would yield to whatever sensibility the artist had about the work and his sensitivity to color, to position, to emphasis, and so forth. Much of what is done today, in Pop and in other styles, apparently does not yield to the influence of the other parts of the work and does not in a way *seem* to be involved in sensitivity to the aesthetic problem. Although it really is. I think that may be the underlying point of today's art. I think Pop is a particular facet of that. Pop deals with using commercial subject matter, and sensitivity usually, or at least the kind of commercial subject matter that I use. It's that sort of anti-sensibility and conceptual appearance of the work that interests me and is my subject matter.

Do you have other things to say about your attitude toward our society and the idea of anti-sensibility?

I think that there's something very harsh about the society and something rather deadening about—oh, half-minute in-depth news broadcasts and things like that which have more fanfare and more ad-

Originally taped as a television interview. The edited version reprinted here was first published in *Fantazaria* 1, no. 2 (July–August, 1966).

vertising than they have news. And the kind of drawing that goes along with commercial art, the kind of education that advertising seems to give the viewer or listener, is very insensitive. At the same time there's something very energetic about it. I don't know what kind of an effect this oversimplification has brought about, but most of our communication, somehow or other, is governed by advertising, and they're not too careful about how they tend to instruct us. I think that may or may not have a deadening effect on the minds of people. I'm really not sure. One would think that it would, but at the same time almost everybody seems to see through it and not really care what the message is; sort of laugh at it but still buy the product regardless of what you think of the advertising. But it has made, in a way, a new landscape for us—billboards and neon signs and all this stuff that we're very familiar with, literature and television, radio. So that almost all of the landscape, all of our environment, seems to be made up partially of a desire to sell products. This is the landscape that I'm interested in portraying. I'm not alone in doing this. There have been other people who have been preoccupied by the commercial landscape.

I personally care about the society, but I don't think my art is involved in it. (The social consequences of the society are important to me, but I don't think my art deals with this.) I think it merely portrays it. One would hardly look at my work and think that it wasn't satirical, I think, or that it made no comment. But I don't really think that I'm interested in making a social comment. I'm using these aspects of our environment which I talked about as subject matter, but I'm really interested in doing a painting. No doubt this has an influence on my work somehow, but I'm not really sure what social message my art carries, if any. And I don't really want it to carry one. I'm not interested in the subject matter to try to teach society anything, or to try to better our world in any way.

But you are bringing a certain psychological state of mind to the work. Doesn't that have something to do with your feelings about our society?

Yes, I do bring a state of mind about the society to the work but I don't know that I can really say what that is. I think it's probably the lack of sensibility, the lack of refinement; the kind of immediate, not contemplative answer that society keeps giving us. I think this aspect is what I try to get into my work—as an appearance. I'm not interested in promoting it, but it's a stylistic appearance that I want my work to have. It gives a kind of brutality and maybe hostility that is useful to me in an aesthetic way.

What do you see in the art you draw upon, and what do you make out of it that's meaningful to you?

Well, I think the thing that I find in commercial art—in the new

world outside largely formed by industrialism or by advertising—is the energy and the impact that it has, and the directness and a kind of aggression and hostility that comes through it. I don't mean that industrialization is attempting to be hostile. That's not the point. But the aggressiveness is aggressive to the point of hostility, I think. It's this kind of thing which forms or crystallizes into a kind of style which is very demanding, energetic, [and] so forth, to me. It has a lot to do with the conceptualization of art rather than the visual. Conceptualization in a way means oversimplification, and I'm concerned very much with apparent oversimplification. I think art maybe has been concerned with this for quite a while. Mondrian may be looked at as being concerned with this, and Miró. It doesn't mean that the art is oversimplified; but it's a kind of stylistic development.

This doesn't really answer what I'm asking. Because, for example, when you do a "Mondrian" it's not the simplification that you're concerned with. You do something very strange to it.

When I do a "Mondrian" or a "Picasso" it has, I think, a sort of sharpening effect because I'm trying to make a commercialized Picasso or Mondrian or a commercialized Abstract Expressionist painting, let's say. At the same time I'm very much concerned with getting my own work to be a work of art, so that it has a sort of rebuilding aspect to it also. So, it's completely rearranged; it has become commercialized because the style that I switch it into is one of commercialization. At the same time I recognize that this is only a mode or a style, and it's not the truth of my own work because my work is involved with organization. I don't want it to appear to be involved in this. But the result that I work toward is one of creating a new work of art which has other qualities than the Picasso or the Mondrian or the Abstract Expressionist painting.

I realize that you don't want to talk about what your work means; it can't or it shouldn't be talked about. Still, there's something you have not said about your own sensibility; you see these things in a certain way, you want to say something about it. Can you discuss your involvement in a new way of seeing and feeling, in a new sensibility?

The sensibility that I'm trying to bring is apparent anti-sensibility, but it is a new sensibility. I think that's the important part of it! It's a modern sensibility. Instead, say, of thick and thin paint, which might be the European sensibility, I'm using flat areas of color opposed to dotted areas, which imitate Benday dots in printing, and become an industrialized texture rather than what we're familiar with as a paint texture. So that in juxtaposing two kinds of commercial textures, I'm really involved in a relationship between textures in this instance, as well as color and the other things; but it's a modern industrial texture and it's not one

Roy Lichtenstein

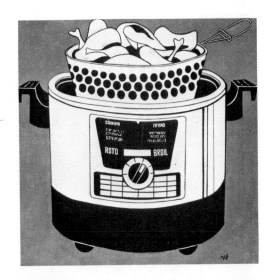

1. *Roto Broil*, 1961. Oil on canvas, 68½″ x 68½″. Collection Mr. and Mrs. Leonard Asher.

2. *Mr. Bellamy*, 1961. Oil on canvas, 56½″ x 42½″. Collection Vernon Nikkel.

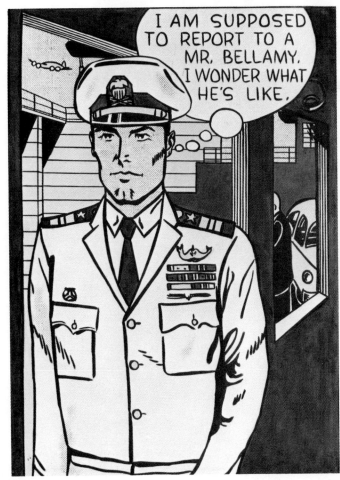

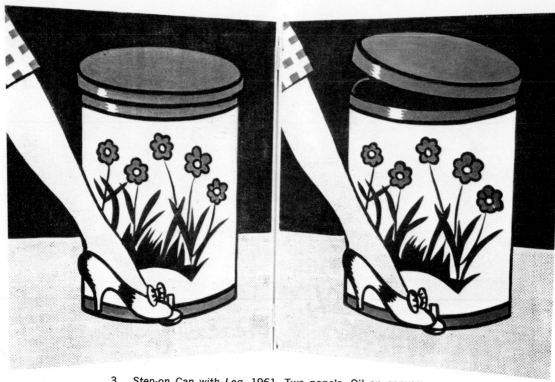

3. *Step-on Can with Leg,* 1961. Two panels. Oil on canvas,
 32½" x 53". Collection Robert Fraser.

4. *Washing Machine,* 1961. Oil on canvas, 56½" x 68½".
 Collection Mr. Richard Brown Baker.

5. *I Can See the Whole Room and There's Nobody in It*, 1961. Oil on canvas, 48" x 48". From the collection of Mr. and Mrs. Burton Tremaine, Meriden, Connecticut.

6. *The Kiss*, 1962. Oil on canvas, 80" x 68". Collection Mr. Ralph T. Coe.

7. *Scared Witless*, 1962. Oil on canvas, 68" x 68".
Private collection.

8. *The Refrigerator*, 1962. Oil on canvas,
68" x 56". Collection Mr. and Mrs. Peter
Brant.

9. *The Ring*, 1962. Oil on canvas, 48" x 70". Collection Mr. J. M. Rossi,
Paris.

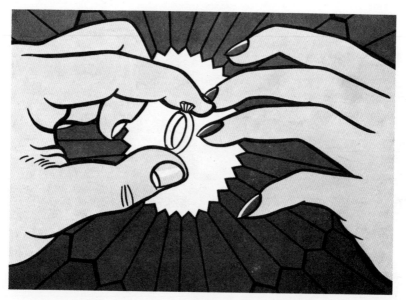

THE EXHAUSTED SOLDIERS, SLEEP-
LESS FOR FIVE AND SIX DAYS AT A
TIME, ALWAYS HUNGRY FOR DECENT
CHOW, SUFFERING FROM THE TROPICAL
FUNGUS INFECTIONS, KEPT FIGHTING!

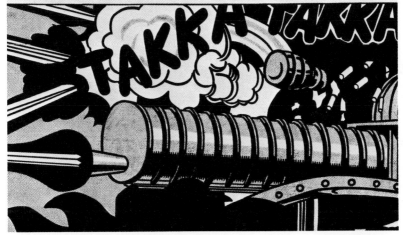

10. *Takka Takka*, 1962. Oil on canvas, 56" x 68". The Ludwig Collection, Wallraf-Richartz Museum, Cologne.

11. *Live Ammo*, 1962. First and second of five panels. Oil on canvas, 68" x 56" and 68" x 36". Collection Mr. and Mrs. Morton Neumann.

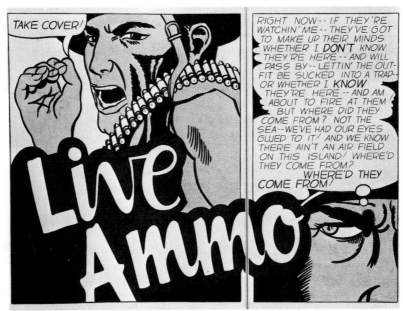

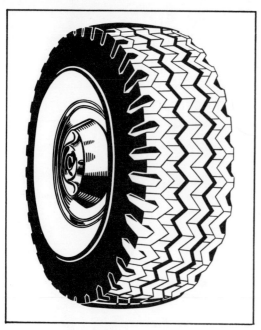

12. *Tire*, 1962. Oil on canvas, 68" x 56". Private collection.

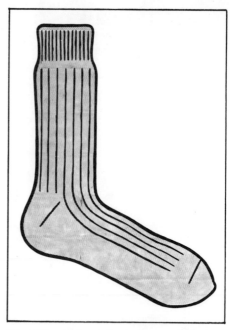

13. *Sock*, 1962. Oil on canvas, 48" x 36". Collection Dr. Peter Ludwig.

14. *Portrait of Madame Cézanne*, 1962. Magna on canvas, 68" x 56". Collection Mr. Irving Blum.

15. *Man with Folded Arms*, 1962. Oil on canvas, 70" x 48". Collection Count Panza di Biumo.

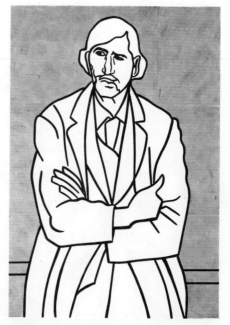

16. *Like New*, 1962. Two panels. Oil on canvas, 36" x 56". Collection Mr. Robert Rosenblum.

17. *Spray*, 1962. Oil on canvas, 36" x 68". Collection Galerie Rudolf Zwirner, Cologne.

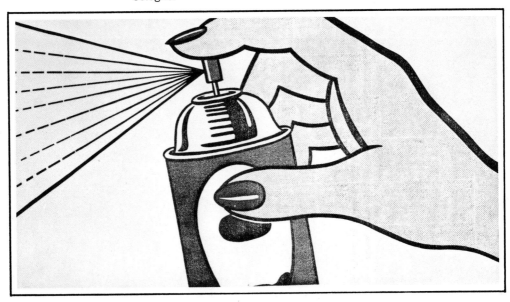

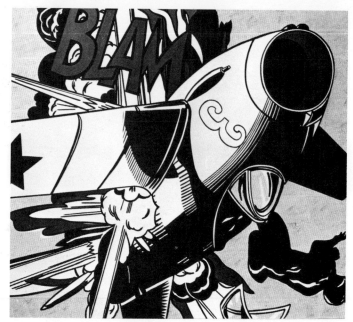

18. *Blam,* 1962. Oil on canvas, 68" x 80". Collection Mr. Richard Brown Baker.

19. *Tex!,* 1962. Oil on canvas, 68" x 80". Private collection.

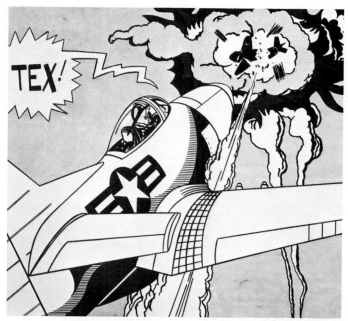

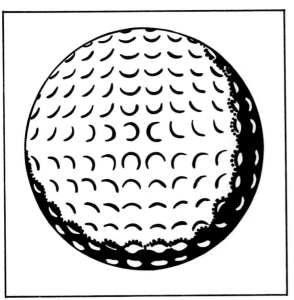

20. *Golf Ball,* 1962. Oil on canvas, 32″ x 34″. Collection Mr. and Mrs. Melvin Hirsch.

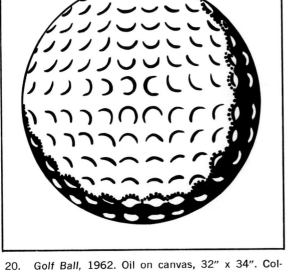

21. *The Ring,* 1962. Oil on canvas, 18″ x 18″. Collection Mr. James Speyer.

22. *Sponge,* 1962. Oil on canvas, 68″ x 56″. Collection Mr. Gian Enzo Sperone.

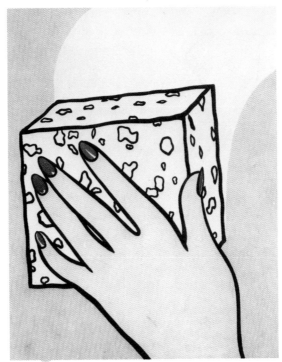

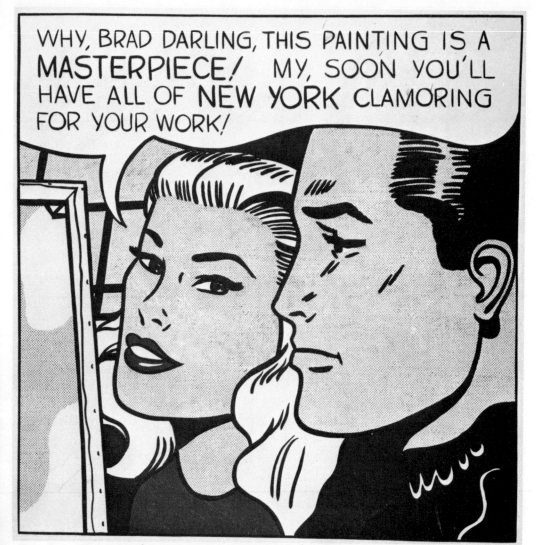

23. *Masterpiece*, 1962. Oil on canvas, 54" x 54". Collection Mr. and Mrs.
Melvin Hirsch.

24. *Eddie Diptych*, 1962. Oil on canvas, 44″ x 52″. Collection Mr. and Mrs. Michael Sonnabend.

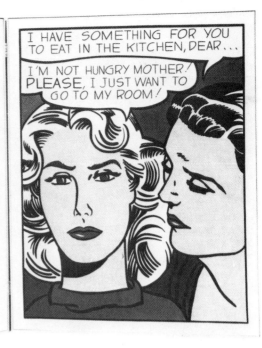

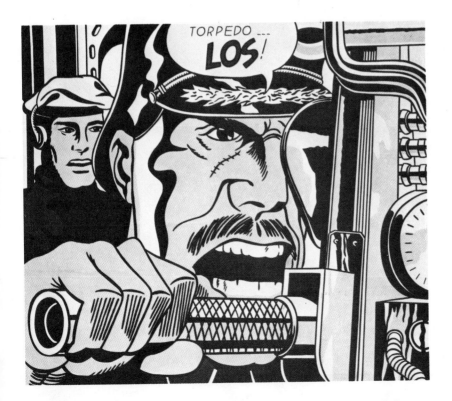

25. *Torpedo . . . los!*, 1963. Oil on canvas, 68″ x 80″. From the collection of Mr. and Mrs. Robert B. Mayer.

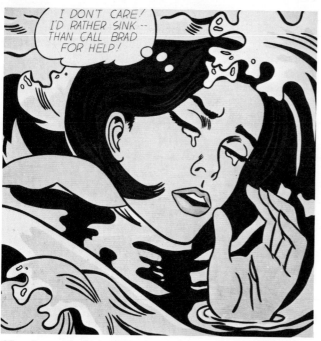

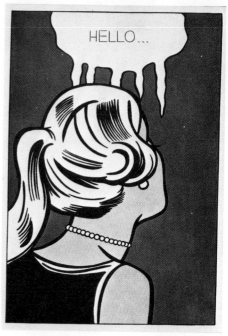

26. *Drowning Girl*, 1963. Oil on canvas, 68" x 68". Collection Mr. and Mrs. C. B. Wright.

27. *Cold Shoulder*, 1963. Magna on canvas, 68" x 48". Collection Mr. Robert Halff and Mr. Carl W. Johnson, Beverly Hills, California.

28. *Ball of Twine*, 1963. Magna on canvas, 40" x 36". Collection Karl Ströher, Hessischen Landesmuseum, Darmstadt.

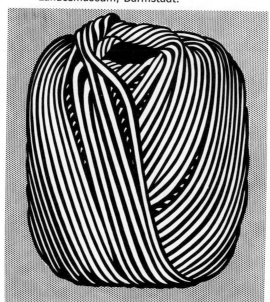

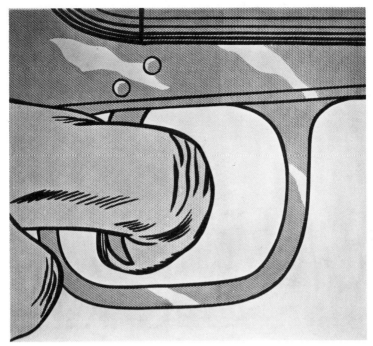

29. *Trigger Finger*, 1963. Oil and magna on canvas, 36" x 40".
Collection Mr. and Mrs. Robert A. Rowan.

30. *Fastest Gun*, 1963. Oil on canvas, 36" x 68". Collection L. M.
Asher Family.

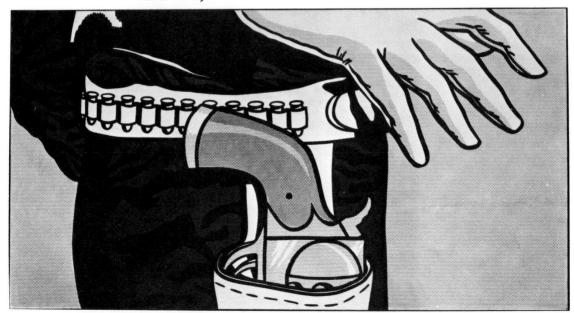

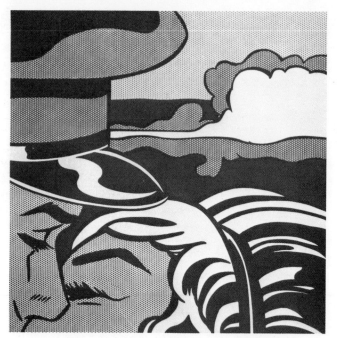

31. *Kiss with Cloud*, 1964. Oil and magna on canvas, 60" x 60". Collection Mr. Irving Blum.

32. *Femme d'Alger*, 1963. Oil on canvas, 80" x 68". Collection Mr. and Mrs. Peter Brant.

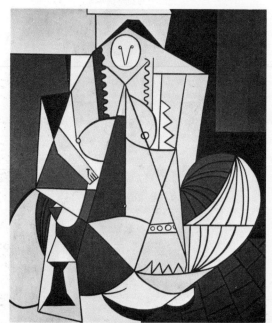

33. Drawing for *Kiss V*, 1964. Colored pencil on paper, 5¾″ x 6″. Collection Ms. Linda Stewart.

34. Untitled, 1964. Pencil and colored pencil on paper, 4½″ x 11″. Collection Mr. Charles Cowles.

35. *O.K. Hot-Shot*, 1963. Oil and magna on canvas, 80″ x 68″. Collection Mr. Remo Morone.

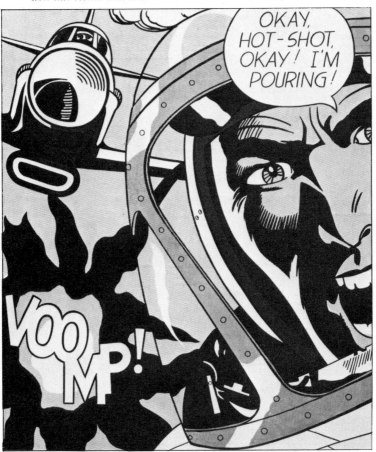

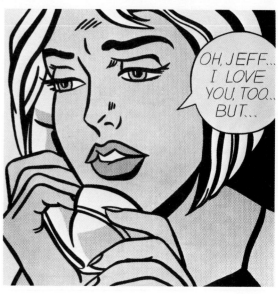

36. *Frightened Girl*, 1964. Oil on canvas, 48″ x 48″. Collection Mr. Irving Blum.

37. *Oh, Jeff . . . I Love You Too, But*, 1964. Acrylic on canvas, 48″ x 48″. Collection Harry N. Abrams Family, New York.

38. *Still-Life*, 1964. Magna on plexiglass, 48″ x 60″. Collection Mr. and Mrs. Leo Castelli.

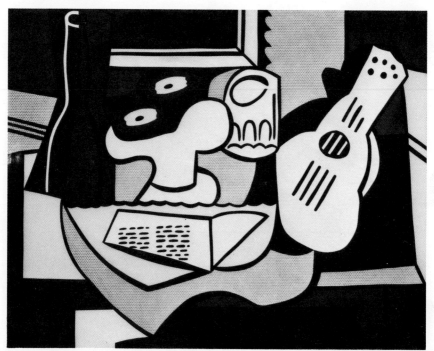

that is nostalgic or that refers back to European painting or American painting up to now. It has its own mode, its own sensibility.

Well, what is the quality of feeling that you bring to bear on this new sensibility? You talk about it technically; you talk about three-dimensional texture and so forth. There is something else, right? You want to create certain kinds of feelings.

Yes. One, I think, is a hard steely quality which seems to be an antiseptic quality, a commercial painting quality, perhaps a sort of data information quality which has been suggested as belonging to the dots, particularly the way I am doing them now, which is a little bit different from the way I did them when I was more strictly imitating industrial printing. Now the dots have become something else, I think, other than that. All of these qualities are more brutal, more antiseptic, and more present-day.

Why do you want to be brutal and antiseptic?

Well, I don't think it makes too much difference what the quality of a painting is. It can be beautiful, serene, it can be lovely, charming, it can be very aggressive, it can be anything. But I think that whatever approach one uses, one ought to go as far as one can with it in order to make it have as much impact as possible. And I think the one that I've chosen—I've no idea why, because I haven't always painted this way—seems to lead toward a kind of brutal and antiseptic quality.

How do you feel about the New York environment?

I've lived in Ohio and upstate New York and so forth, and there's a lot of America which seems to be composed almost entirely of industrial sludge, or advertising or builders' houses, or the prosaic, the banal, and very uninteresting. I think New York itself is extremely interesting and it has all of these commercial aspects also, but it has a tremendous mixture of things. I don't think that it's at all the typical city in America. I'm not so sure that Pop art is entirely American. It is entirely American in the sense that there's more industrialization here than there is anywhere else. But I think that the effects of industrialization are seen in many parts of the world.

How do you find your images?

To find subject matter for the work, I look through comic books for the cartoon works, also somewhat for the landscapes. For the war pictures and teen-romance pictures and things like that, I go through comic books looking for material which seems to hold possibilities for painting, both in its visual impact and the impact of its written message, which I rarely make up. I don't think I'd be capable of making them up. I try to take messages which are kind of universal or, in a way, either completely meaningless or so involved that they become ludicrous.

Talking with Roy Lichtenstein *John Coplans*

John Coplans: *How do you do your paintings?*

Roy Lichtenstein: I just *do* them. I do them as directly as possible. If I am working from a cartoon, photograph, or whatever, I draw a small picture—the size that will fit into my opaque projector—and project it onto the canvas. I don't draw a picture in order to reproduce it—I do it in order to recompose it. Nor am I trying to change it as much as possible. I try to make the minimum amount of change. Although sometimes I work from two or three different original cartoons and combine them, I go all the way from having my drawing almost like the original to making it up altogether. It depends on what it is. Anyway, I project the drawing onto the canvas and pencil it in and then I play around with the drawing until it satisfies me. For technical reasons I stencil in the dots first. I try to predict how it will come out. Then I start with the lightest colors and work my way down to the black line. It never works out quite the way I plan it because I always end up erasing half of the painting, redoing it, and redotting it. I work in Magna color because it's soluble in turpentine. This enables me to get the paint off completely whenever I want so there is no record of the changes I have made. Then, using paint which is the same color as the canvas, I repaint areas to remove any stain marks from the erasures. I want my painting to look as if it has been programmed. I want to hide the record of my hand.

Do you like to do everything by hand in your painting?

Yes. I like to have full control, but I don't care if this control is obvious. For example, I am very happy when the factory takes my painting and makes an edition of enamels on steel. This is what I actually do: I do a full-sized cartoon on paper for the enamel people with acrylic color. They cut stencils from my cartoon and make an edition of perhaps six enamels. I have done it once and I am very happy that the six enamels all come out beautifully in the factory technique. I like the style of industrialization, but not necessarily the fact. I am not against industrialization, but it must leave me something to do.

Incidentally, were you a commercial artist at any time of your life?

No, although I have done some industrial design, but that had more to do with engineering and drafting.

Did this have any influence on your painting?

Yes. I used to do paintings with drafting and radio symbols in them. Probably the exacting requirements of drafting have had some influence on my work. It helped me to organize and simplify.

In your early work, that is in 1962, you seemed to be very aware of

From *Artforum* 5, no. 9 (May, 1967).

what you were up to. There is tremendous diversity of imagery. Were you plugging holes?

Yes. The first show was very diverse. I did the *Roto-Broil; The Engagement Ring;* a round picture *Cat* (which I got from a cat-food package); the *Golf Ball,* which was a single object in black and white; *In,* which was just letters; and *Soda,* which was blue and white. I like the idea of blue and white very much because a lot of commercial artists use it to get a free color. Blue does for black as well; it is an economic thing. So I liked the idea of an apparent economic reason for making one color work as two colors. Sometimes commercial artists use blue lines with yellow or two colors overlapped in a certain way to look like three colors. Using a configuration which has arisen because of economic expediency—I like that! Of course, when these things are done in painting it has another meaning because, obviously, they are not expedient. That has its humor, but it also has other aspects in that a form has been developed that is recognizable to the society. I mean that *this* is a picture of a girl, *that* is a picture of a light cord and it becomes an easily identifiable thing, but this kind of portrayal is so unreal when compared with the actual object. This is something that interests me, plus the fact that these portrayals are taken for *real.* I mean, in the same way that a frankfurter looks nothing like the cartoon of it—there are no black lines, dots, or white highlights on the original. In the picture the form becomes a purely decorative abstract object which everyone instantly recognizes as a frankfurter. It becomes a very exaggerated, a very compelling symbol that has almost nothing to do with the original. It has partly to do with the economics of printing, partly to do with the gross vision of the artist. It is very compelling for reasons that have nothing to do with art.

What about the limited range of color you use?

At the beginning I picked out four contrasting colors that would work together in a certain way. I wanted each one as complete in its own way as it could be—a kind of purplish-blue, a lemon-yellow, a green that was between the red and blue in value (I don't use it too much because it is an intermediate color), a medium-standard red, and, of course, black and white.

You don't vary these colors?

No, and if they have varied it's because different manufacturers' products are varied. I use color in the same way as line. I want it oversimplified—anything that could be vaguely red becomes red. Actual color adjustment is achieved through manipulation of size, shape, and juxtapositions.

Which of your images are invented from the start?

The explosions, landscapes, and brushstrokes. The heads usually come from one or two photographs.

What led you to do the temples?

A Greek restaurant I went to has a wall with repeatedly stenciled Parthenons. The wall was red with the Parthenons sprayed on through a stencil with silver paint. Because of the obviously "hokey" quality of the silver paint, and the very quick method of reproducing the Parthenons by spraying an image through a stencil, it is like a "Modern Times" duplication of a masterpiece. I tried to do that by making a stencil and spraying through it, but somehow it just didn't have the style of the restaurant mural. I think my stencil was too intricate. Anyway, I'm not very sure what it was, but the original had a quality that was perfect in its environment. Later, because I have been working in a cartoon style, I decided to do a cartoon of it.

Where did the George Washington image come from?

It is a woodcut version of one of Gilbert Stuart's portraits of Washington which I saw in a Hungarian national newspaper.

What about the various common objects you painted, for example, the ball of twine, etc.?

I think that in these objects, the golf ball, the frankfurter, and so on, there is anti-Cubist composition. You pick an object and put it on a blank ground. I was interested in non-Cubist composition. The idea is contrary to the major direction of art since the early Renaissance, which has more and more symbolized the integration of "figure" with "ground."

What led you to the landscapes which, incidentally, seem to be very optical?

Well, partly it was a play on Optical art. But optical materials might be used in commercial art or in display; you use an optical material to make a sky, because the sky has no actual position—it's best represented by optical effects.

And the sunsets?

Well, there is something humorous about doing a sunset in a solidified way, especially the rays, because a sunset has little or no specific form. It is like the explosions. It's true that they may have some kind of form at any particular moment, but they are never really perceived as defined shape. Cartoonists have developed explosions into specific forms. That's why I also like to do them in three dimensions and in enamel on steel. It makes something ephemeral completely concrete.

Where did you get the image for the engagement ring?

It was actually a box in a comic book. It looked like an explosion.

Did you find or invent the brushstroke image?

Although I had played on the idea before, it started with a comic-book image of a mad artist crossing out, with a large brushstroke "X," the face of a fiend that was haunting him. I did a painting of this. The painting included the brushstroke "X," the brush, and the artist's hand.

Then I went on to do paintings of brushstrokes alone. I was very interested in characterizing or caricaturing a brushstroke. The very nature of a brushstroke is anathema to outlining and filling in as used in cartoons. So I developed a form for it, which is what I am trying to do in the explosions, airplanes, and people—that is, to get a standardized thing—a stamp or image. The brushstroke was particularly difficult. I got the idea very early because of the Mondrian and Picasso paintings, which inevitably led to the idea of a de Kooning. The brushstrokes obviously refer to Abstract Expressionism.

You have never been particularly interested in a sequence of images as in the comics?

No, although I have done a few linked-panel cartoons. There was one five-panel series that got broken up. I thought of it as two diptychs and a single painting in the middle linking them up. It was a five-panel sequence, but a sort of mysterious sequence as though you had walked into the middle of a soap opera. Although you couldn't really figure out what was going on, the story had a cohesiveness.

What gave you the idea of using war imagery?

At that time I was interested in anything I could use as a subject that was emotionally strong—usually love, war, or something that was highly charged and emotional subject matter. Also, I wanted the subject matter to be opposite to the removed and deliberate painting techniques. Cartooning itself usually consists of very highly charged subject matter carried out in standard, obvious, and removed techniques.

Why did you particularly choose a diagram from Erle Loran's book on Cézanne as a basis for a painting?

The Cézanne is such a complex painting. Taking an outline and calling it "Madame Cézanne" is in itself humorous, particularly the idea of diagraming a Cézanne when Cézanne said, "the outline escaped me." There is nothing wrong with making outlines of paintings. I wasn't trying to berate Erle Loran, because when you talk about paintings you have to do something, but it is such an oversimplification trying to explain a painting by A, B, C, and arrows, and so forth. I am equally guilty of this. *The Man with Folded Arms* is still recognizable as a Cézanne in spite of the fact it is a complete oversimplification. Cartoons are really meant for communication. You can use the same forms, almost, for a work of art.

How do you relate to the Picasso paintings?

They were intriguing to do for some reason which I think I can talk about to some extent. First of all, a Picasso has become a kind of popular object—one has the feeling there should be a reproduction of Picasso in every home.

You mean he is a popular hero and everyone thinks he represents art today?

Yes. I think Picasso is the best artist of this century, but it is interesting to do an oversimplified Picasso—to misconstrue the meaning of his shapes and still produce art. Cézanne's work is really diametrically opposed to something like a diagram, but Picasso's isn't, nor is Mondrian's. Mondrian used primary colors and Picasso used basic kinds of colors—earth colors—although that's not even true most of the time. But there is a kind of emphasis on outline, and a diagrammatic or schematic rendering which related to my work. It's a kind of "plain-pipe-racks Picasso" I want to do—one that looks misunderstood and yet has its own validity.

How much difference is there in the drawing, placement, etc., between the real Picasso and yours?

Usually I just simplify the whole thing in color as well as in shape. I don't think simplification is good or bad—it is just what I want to do just now. Picasso made the *Femme d'Alger* from Delacroix's painting, and then I did my painting from his.

Why didn't you ever do a Léger?

Recently I have been tempted to do a Léger; it's something I may yet do. I like the idea. He really isn't someone I think I am like, yet everyone else thinks I am like him. I can see a superficial relationship; for obviously, there is the same kind of simplification and the same kind of industrial overtones and clichés. My work relates to Léger's, but I admire Picasso more than I do Léger.

What about Stuart Davis?

I like his work. He is as good a precursor of Pop art as anyone. He had the gas station idea, but it was linked to a Cubist aesthetic—which mine is to a degree, but not as much. Mine is linked to Cubism to the extent that cartooning is. There is a relationship between cartooning and people like Miró and Picasso which may not be understood by the cartoonist, but it definitely is related even in the early Disney. However, I think what led the American cartoonists into their particular style was much more the economics of the printing process than Cubism. It was much cheaper for the artist to color separately by hand. The reason for the heavy outlines, of course, was partially for visibility and partially because the colors didn't separate very well. You could use the outline to "fudge" over the incorrect color registration.

What about the very marked difference between your early unsophisticated girls and the later sophisticated ones?

Well, I think that may be because I couldn't draw cartoons very well after years of abstract painting.

You didn't get more interested in sophisticated girls and notice hair styles, makeup, and so on?

Yes. In the early ones I was looking for a tawdry type of commercialism as found in the yellow pages of the telephone directory. They

Roy Lichtenstein

were a great source of inspiration. Then another archetypical beauty became more interesting to me.

You mean the highly confectioned woman?

Yes, it's another kind of unreality; but the drawings of them by commercial artists seem to be much more skillful.

It relates to the way women present themselves or the way they would like to be?

Yes. Women draw themselves this way—that is what makeup really is. They put their lips on in a certain shape and do their hair to resemble a certain ideal. There is an interaction that is very intriguing. I've always wanted to make up someone as a cartoon. That's what led to my ceramic sculptures of girls. I was going to do this for some fashion magazine. I was going to make up a model with black lines around her lips, dots on her face, and a yellow dyed wig with black lines drawn on it, and so forth. This developed into the ceramic sculpture heads. I was interested in putting two-dimensional symbols on a three-dimensional object.

In many of your paintings you make various references to past styles or particular painters.

Yes. I often transfer a cartoon style into an art style. For example, the Art Nouveau flames at the nozzle of the machine gun. It is a stylistic way of presenting the lights and darks. In the *Drowning Girl* the water is not only Art Nouveau, but it can also be seen as Hokusai. I don't do it just because it is another reference. Cartooning itself resembles other periods in art—perhaps unknowingly.

You mean cartoon artists are not very aware of their stylistic source?

I really don't know. I suppose some are. They do things like the little Hokusai waves in the *Drowning Girl*. But the original wasn't very clear in this regard—why should it be? I saw it and then pushed it a little further until it was a reference that most people will get. I don't think it is terribly significant, but it is a way of crystallizing the style by exaggeration.

Thoughts on the "Modern" Period
Jeanne Siegel

Jeanne Siegel: *The fact that you use the content of art as subject becomes more and more apparent. For example, the new sculptures seem to refer both to the shapes of the thirties and the more current Minimal art. Was this your intention?*

This interview was broadcast on radio station WBAI in New York on December 13, 1967, and subsequently edited by the artist.

Roy Lichtenstein: Yes, both of these styles are embodied in the work. I think the similarity between the art of the thirties and much of the sculpture being done today is that they are both conceptual. For instance, the shape that finally evolves in a work is to a great degree understood to begin with. In a boxlike structure the rear of the box is evident from the front. You can conceive of and understand what the work will be all the way around from a glance. It is also conceptual in the sense that the artist knew what he was going to do to begin with, and this is true of much thirties architecture.

It's the thirties architecture that I'm really familiar with and not the art, most of which I think doesn't really exist as painting. It exists as architectural decor, as jewelry design, and interiors—things like that. The architects and designers of the thirties apparently—and I'm second guessing them—believed in the logic of geometry and in simplicity. Their art is composed of repeated forms, zigzag marks, repeated lines in a row, or decreasing or increasing spaces, and arcs described by a compass. It seems that the compass, T-square, and triangle dictated their art. It was an art of the plan, circles are bisected exactly in the middle, the page is exactly divided diagonally, and there's all this insane kind of logic—insane because it has no particular place in sensually determined art. There's no reason why it can't be geometric, but there's almost no reason why it should. And there's not much precedent for it, except in the architecture of the past. So it's mostly the conceptual aspects and the simplicity of the two arts that interest me.

Wasn't one sculpture derived from a Bambara sculpture?

I think the thirties style was influenced by primitive art. There's the influence of American Indian art in the zigzag, but it becomes more geometricized and turned into something else. In the same way the influence of African sculpture on Cubism carries over into the twenties and thirties art.

Do you assume that the viewer is aware of these references?

I think it may not be completely evident in looking at any one piece, but I hope it is evident because otherwise I don't know what they would be looking at exactly. Otherwise you read it as pure form, which is part of it, but I think that much of the reason for its existence depends on your understanding what it's about. I think it is true of all art, really. But I think six or seven years ago, we really thought we were doing pure form, and the final appearance that it had was an outgrowth of our own personality and not about some other thing; I think we forget that we were symbolizing, in a way, what we were doing. In other words, Abstract Expressionism is symbolic of itself—it's symbolic of interaction and of order. It's symbolic of trying to do an art which is of yourself entirely. But we hated to use the word symbolic.

When you say that your sources for the design came from thirties

Roy Lichtenstein

architectural decor, do you mean you actually go out and look at architecture?

Yes, but I think when I first started I didn't. I got the first inkling, I suppose, from a poster I did, *This Must Be the Place,* which was supposed to be Buck Rogers architecture, or that's what it meant to me. Then, when looking at it, it began to look very thirties. Later I did a poster for the Lincoln Center Film Festival [in 1966] and I wanted something about the movies, just as a design, and the thirties occurred to me; that's how I got into it. I started looking at actual objects of the thirties—architecture, jewelry, furniture—and found a lot of material. I found that much of the best of it was French, for some reason. Theirs was very elegant. It became a little more hokey in the United States.

Did they develop at the same time?

I think the United States is a bit later. I think it really came from the Bauhaus and Kandinsky and Léger, too, in a way. And then I suppose the idea became subverted. The obvious things, the simplicity and the geometry and all that, influenced by Cézanne's statement about the cube, cylinder, and the cone, all got made into art objects—and nonsense. Sometimes it was beautiful nonsense. And that's what seemed to happen, I guess, in the thirties to the art of the Bauhaus. The concepts they laid down became the purpose of their art. Or perhaps the concepts rationalize the art itself, which is generated from something else anyway, some kind of feeling or sense of what would be right. And then you say why and you write that down, as I'm doing now, and that maybe becomes a thing other people will take as real and work from.

Do both the new paintings and the sculpture relate to the art of the thirties in the same way?

Somehow the sculptures become more like real architectural details than the paintings. The paintings are more about the thirties in a sense —well, so are the sculptures, but they seem more to be like thirties *things.*

What things?

I'm thinking about portals, doorways, banisters, and things which they really obviously look like. And I like the idea, of course, of employing marble and brass, there's nothing unusual about that. First of all, marble is such a traditional medium for sculpture, and brass and bronze have been used forever, but, of course, the way I'm using it isn't particularly traditional.

Aren't the colors in the new paintings the same colors that you have always used?

It's the same color and same technique. I think that's *me* at this moment whether I do comics, brushstrokes, a Picasso, Mondrian, Cézanne, a landscape, or whatever, and now this. What you are probably asking is where does it fit in? What have cartoons got to do with the

thirties? I do think of the thirties as a sort of cartoon era. Another thing is, the Benday dots were blown up, and they meant at first, of course, reproduced material, but I think they also may mean the image is ersatz or fake. The dots indicate a fake brushstroke in my brushstroke paintings. In this case, it means fake twenties or thirties. You know, it's a stamp of not being the real thing. That may be part of why I work that way. I just feel that the same painting, technique, color, same way of going about it, work for the thirties images and I don't know why. The forms are different, but they relate very much to the Picassos I did, because the Picassos were cliché Picassos.

Some of the latest modern paintings make reference to the classical style. How do they differ from the others?

Well, I think that Art Deco went from completely abstract art to kind of a neoclassical, heroic art which I think, for instance, the statue in front of Radio City or Rockefeller Center might be something close to in style. The image became geometricized muscle—fellows with huge necks, small heads, and enormous shoulders. It was like a very simplified "animal cracker" classical art, which I guess was a way of employing geometry—which everybody seemed to like—toward a public message or statement that could be used in a mural fashion.

How would you characterize the spirit of the thirties?

I think they were very optimistic. Either they were optimistic or they figured we were all in this depression together. It developed before the depression, probably around 1923. It was very evident in the Paris Exposition of 1925, and it's been used since then, I suppose, until something like 1938—that's from the good times right through the depression and onward. My history may be wrong, but it's a little hard to understand how the same style or something like the same style persisted through the great boom and a bust and continued on. But there was a feeling that man could work with the machine to obtain a better living and a great future. I think thirties art is optimistic. The moving pictures of that time also have a kind of optimism about them. Maybe the optimism was in contrast to real life. But there was, I think, a real feeling, of man working with the machine that is really diametrically opposed to Art Nouveau, which tried to get handicrafts back into the machine production by the use of natural forms, tree shapes, and so forth, as if the machine had done away with beauty and let's try to get beauty back into our manufacture.

The thirties style is the opposite—it's the complete acceptance of the machine and the making of designs simple enough to be carried out by machines. I think that the Cubist aesthetic has always worked well with the economies believed necessary in architecture, engineering, and machinery. Expressionism, except for a little salute to Gaudí, almost never got into anything that architects could use. There was a real practicality

Roy Lichtenstein

about the Cubist aesthetic that lent itself to design, which more fluid kinds of form don't. I mean, there was really no reason why in the thirties you couldn't have thrown chicken wire around and sprayed concrete on it to make architecture—forms which, in a way, would be stronger and perhaps easier to produce than Cubist ones. I don't really know why Cubism had such a strong influence, but I guess I know in a way—it makes more sense and people love to make sense. And it's the business of making sense that I think I'm really having more fun with now. It may be the essence of what I'm about, if anything is. Thirties art made so much sense and that kind of sense is absurd in art.

Lichtenstein at Gemini *Frederic Tuten*

In 1895, Claude Monet exhibited a series of paintings of Rouen Cathedral. Twenty paintings in all (of forty in the series), they ranged from the view of the cathedral at sunrise to the cathedral at dusk. Monet had worked in series some four years earlier when he set out to record the changes of light (as well as other environmental conditions—wind, season) on a more or less static subject, haystacks.

FREDERIC TUTEN: How did you come to do the Monet Cathedrals and Haystacks—was Monet an outgrowth of the other artists you worked with . . . Picasso, Mondrian?
ROY LICHTENSTEIN: John Coplans was talking about a show on "series" [painting] that he was going to do—Monet was going to be in it. I was reminded that Monet had done work in series, and that was probably the origin.
TUTEN: Did you use any particular Monet cathedral in your series?
LICHTENSTEIN: Well, Monet did thirty or forty of them. Coplans gave me some photos for his serial show; some are in his book *Serial Imagery*. At any rate, I did use several sources and worked them about.

Lichtenstein began his Monet Rouen Cathedral paintings sometime in May or June of 1968. The first painting in the series was completed in July 1968; the projected series of fourteen paintings, while substantially finished, remained incomplete at the time of this writing—April 1969. (Monet, incidentally, produced his entire series in the space of some fifteen weeks.) The paintings are dissimilar from one another in the views of the cathedral, the arrangements of the colors and the dots, and the sizes of the dots. The Cathedral photographs are seen by Lichten-

From an illustrated brochure on Lichtenstein's Haystack and Cathedral prints, published by and © Gemini G.E.L., Los Angeles, 1969.

stein as companions or corollaries to his paintings, and some of the lithographs resemble the paintings in image and color, yet the lithographs uniformly bear the same view or image of the cathedral throughout the series of six prints. As with the paintings, no two lithographs are alike: This is true for both the Cathedral and the Haystack series.

The Haystacks follow the pattern of the Cathedrals: Both lithograph series begin in brilliancy (acid yellow dots) and end in darkness (blue and black dots)—the seventh print in the Haystack series is a black ink embossed engraved plate. Dot patterns and degrees of readability of the haystack images vary within the series. Lichtenstein ostensibly has maintained Monet's time sequence but has further compressed Monet's daybreak-to-dusk cycle. That is, if one reads the prints as a chronicle of the effects of light on an object.

Perhaps more to the point is the way the prints "progress," in both series, from recognizable image to total abstraction, although if the Monet references had not been stated, or if there had been no original Monet Cathedrals or Haystacks to frame the viewer's reference point, Lichtenstein's series (some prints reflect this more than others) would be the closest he has come to working abstractly and nonallusively. This is not to deny the continuity of Lichtenstein's working procedures, for, in referring to Monet's paintings in these most reduced or caricatured of terms, Lichtenstein is working as he has with artists before—Picasso or Mondrian, say—that is, by defining the essential features or properties of an artist's work and making them serve his own formal concerns.

In the instance of the Monet Cathedral and Haystack series, the parodistic elements found in his treatments of comic strips or Abstract Expressionist brushstrokes are reduced, negligible except, of course, in the very idea of "doing" the series itself.

It is perhaps invalid (and unfashionable) to speak of Lichtenstein's Cathedrals this way, especially since they may be seen individually or may be shuffled about without doing damage to the value of the individual print or to the series, but they do radiate a grandeur when seen in configuration. This effect has less to do with the psychological condition in which the viewer links Monet's Monets to Lichtenstein's Monets than to the extraordinary aesthetic achievements of both Lichtenstein's paintings and prints. What superficially appears to be a primitive array of basic colors and dot patterns—the prints use only yellow, blue, red, and black—is an accomplishment of subtlety and craftsmanship on the parts of both Lichtenstein and the printers of Gemini.

The "first" print in the Cathedral series is an acid yellow dotted outline of the cathedral image: The form is set against the pure-white paper ground, and the print's margin is inked buff-white to keep the sharp clarity of the white ground from being diffused at the edges. This is the

starkest of the Cathedrals, being the simple stencil outline of image, frail and evanescent. Of the series, this print alone bears only the outline of the cathedral; the other five, each different from one another in other respects, carry along with the cathedral image a standard background image—a kind of filling in of the bare outline of the cathedral. The "last" cathedral is almost indiscernible in its obscurity: Both the basic cathedral image and the background image are made of black dots, slightly off register, printed on a deep-blue ground. This "double black on a blue ground" cathedral is related to the print of the double black images on a deep-yellow ground, although the image here is recognizable. The other prints work with double blue images on a white ground, and with combinations of red and blue images on white grounds.

Various orderings of the interlocking dots or of off-registering the dots give some prints a greater moiré effect than others in the series; some dots combine to produce rosette or star patterns; some dots cream into one another, leaving a red slice, say, wedged between two blue arcs to form a perfect dot. Other prints, and this is equally true of the smaller Haystack prints, collapse in waves, band and throb, "flash"; in short, create retinal or optical effects similar to pure Op paintings: This is one more way in which Lichtenstein obliterates his cathedral image or destroys the object as subject, another way of creating multi-signification of structural and "literal" elements in his work. In any one print, there are at least four levels of accomplishment: the referential (the "reworking" of the Monet archetypes); the abstract (both in the abstracting of the Monet forms and in the creation of Lichtenstein's own abstract forms); the retinal (the optical effects); and, of course, all the above elements in simultaneous operation. Moreover, in configuration, the prints function within a "serial system" as defined by John Coplans: "Serial imagery is a type of repeated form or structure shared equally by each work in a group of related works made by one artist."*

In his paintings and silkscreens of Abstract Expressionist brush swipes, Lichtenstein demonstrated how what was once, for other artists, a vehicle for painting—the gestural stroke—became in his hands the subject for painting, and in a certain sense Lichtenstein's "brushstrokes" were the apotheosis of a style or manner whose originals were already frozen in convention. In his recent Cathedrals and Haystacks, Lichtenstein's dots no longer serve the function of looking like a commercial print, as in the comic-strip paintings, nor is it so much an integral part of the painting or print, as in his abstract, design paintings—the *art moderne* or Cubist-related work.

In the Monet paintings and prints, the dot, as well as all the reflections and nuances of the dot, is the subject, not merely a vehicle for image-making. It is probably less relevant to Lichtenstein that his

* John Coplans, *Serial Imagery* (Greenwich, Conn.: New York Graphic, 1968).

Cathedrals are cathedrals than it was to Monet, and, for that matter, I suspect that for Lichtenstein the Monet Haystacks might just as well have been muffins or any haystack form. Except for the ambiguous nature of the ploy, Lichtenstein is concerned neither with nature nor with Impressionism: He has found, once again, another existing pattern to transmute and make his own, a strategy successfully played only by such consummate aestheticians as Picasso or the Beatles.

Gemini. February, 1969

TUTEN: I'm amazed how you make such transitions, how you can move from Impressionism to Cubism—your Cathedrals and *art moderne* seem so unrelated. [I think what I had intended to ask was how Lichtenstein could assimilate and transmute so perfectly such disparate aesthetic sensibilities.]

LICHTENSTEIN: Well, of course, that has nothing to do with Impressionism, and my "modern art" has nothing to do with Cubism either. Once I determine what the feeling of a work will be, the problem seems to be reduced to adjusting positions. I mean, I reduce everything to that anyway, and once the idea for a work is in my mind, I ignore its meaning while I work.

TUTEN: Have you ever done anything completely in dots, as you have the Monet prints and paintings?

LICHTENSTEIN: Yes, I did a few landscapes that way. Henry Geldzahler owns one of them. One had a sea and a sky, one red, the other blue, and the overlap made a purple mountain in the middle of them; there were no lines and no flat areas of color. But, you know, it wasn't meant to be a Seurat or anything like that.

TUTEN: I wondered if your doing a Monet in a Pointillist technique was intended as some kind of art-historical joke.

LICHTENSTEIN: I don't think so, but of course if you find any profound meanings I'm sure I intended them. But it's not meant to be Pointillist; it's just the closest I can get to Impressionism, even though it looks more Pointillist than Impressionist. It's the same way I have always used the dots . . . it becomes like a quick cheap Impressionism, if you don't understand it too much . . . but then it has all the outward attributes of Impressionism . . . for instance, you get up close and can't tell what it is; you step back and can see it.

TUTEN: Do you see the prints differently than the paintings?

LICHTENSTEIN: Yes, I do see them differently; I don't quite know how. Maybe it's because here they are cathedrals in the style of cheap printings brought back again to printings—elegant printings. Also there is the relating of Monet's different daylight effects to the expediency of printing the same image in different colors. My Cathedral paintings use differ-

Roy Lichtenstein

ent views of the cathedral as well as different colors; and they are paintings about printing, not printing about printing.

TUTEN: The Monet paintings—Monet's, I mean—are very hard to read, at times you don't know what the image is, it's a blur.

LICHTENSTEIN: Yes, some more than others, the same as in my lithographs.

TUTEN: Where you are not certain if it is a microcosm or a macrocosm, a detail of a blown-up area: There is something that Monet does to them that destroys a literal reading, something about the perspective and the croppings, some of them anyway.

LICHTENSTEIN: I think all artists destroy literal meaning.

TUTEN: In *your* work the obscuring effect, the effect that destroys the "literal" reading of the cathedral image seems to be produced by two things—the hallucinatory quality of the brilliancy and of the moiré effects, and the very darkness of the image, as in the double black dots on a blue-ground print, where you simply cannot see it.

LICHTENSTEIN: Yes. Because the values are so close, which is the quality of some of Monet's Cathedrals anyway. Of course, I also like the colors I get with the dot variations when working only with black, blue . . .

TUTEN: Your series goes from bright yellow day to dark night. I know that Ken Tyler [the Master Printer, Gemini G.E.L.] sees them in terms of times of day, and Dorothy, your wife, says you do too, but I'm not so certain that you do. Dorothy calls them a shorthand version of Monet.

LICHTENSTEIN: My series is supposed to be times of day only because that is the way *his* were, and because it's kind of silly and fortuitous and obviously not about daylight at all.

Interview: Roy Lichtenstein *John Coplans*

John Coplans: *Most of the new prints seem to have direct references— at one level or another—to specific aspects of modern art.*

Roy Lichtenstein: Yes, the Cathedrals are meant to be manufactured Monets and so are the Haystacks. The modern prints—I mean the various ones of Peace Through Chemistry—are muralesque. They are a little like WPA murals.

They also seem to be very Léger-like.

Yes, and they are a play of Cubist composition. Of course, the imag-

From *Roy Lichtenstein, Graphics, Reliefs & Sculpture, 1969–1970,* catalogue of an exhibition at the University of California, Irvine, October, 1970. Catalogue © Gemini G.E.L., Los Angeles.

ery has also to do with the thirties. The theme is hackneyed, which is part of the idea.

Why?

I thought something could be made out of these old images. I don't know exactly why they appeal to me, but I like the idea of a senseless Cubism. At first Cubism had significance, it was saying something about vision, about unity, especially the relationship of figure and ground. But following Cubism—particularly in twenties and thirties *art moderne* —the style lost the point of Cubism completely, especially in the decorative arts.

Your sculpture also refers to decorative Cubism of the thirties.

Yes, I think I make images that are purely Cubistic, but the Cubism doesn't really tell you anything.

If you are using such Cubist-derived forms, is it only the image that is Cubist, or the composition as well?

The subject is Cubism and the image therefore becomes Cubism, but this has nothing to do with the formal qualities of composition—its real relationships. This is a matter of whether the relationships are seen and felt. No compositional devices really hold a work together.

What, then, makes your thirties images look as if they are made in the sixties? The element of parody? Surely formal properties outside the question of parody link these images to the sixties?

Of course, parody and irony are not formal aspects. These are probably the most obvious link to the sixties; but also the directness and the paint quality.

But what I'm really getting at, I suppose, is what really differentiates one of your sculptures from those of the thirties, apart from the question of idiosyncratic placement of each element.

I don't know, I guess it's hard to say. Maybe it's getting inside what the thirties style is really about that makes the difference. The artists or designers of the thirties didn't have the same remove as I have. I mean, they were more serious about it, and that results in a certain difference. It's not that I am not serious, but if they were serious in one way, I am in another. It's something like my Picasso or Mondrian paintings—mine are not *really* like either of these two artists. I also think there is a great similarity between thirties art and much present-day art. Both are conceptual and both do certain things which are so much alike in style. It's only that today most artists don't employ the more obvious aspects of the thirties look. But the fact that there is a sort of thought-out-beforehand, measurable, geometric, repeated, and logical appearance to most current art is very close to the thirties thinking. There certainly are many differences, but it is very close in some ways, so I'm not only playing on the thirties, I'm also playing on present-day geometric art. Current art is frankly decorative, at least a lot of it.

100 Roy Lichtenstein

In what sense do you use the word decorative—do you mean it's pleasing, sensuously pleasing?

Yes, it covers big walls with all kinds of glorious colors and shapes. I think it's a question of the level of relatedness and the level of meaning that distinguishes today's work from the thirties and the thirties work I'm working from and, say, the thirties work of Léger.

How do you see your sculpture in the context of this notion? I mean, your sculpture isn't in actual fact so much copied as invented.

Even though my work is similar to some thirties sculpture, mine is really more derived from architectural details, for instance, railings; and railings have a certain similarity to a lot of the sculpture being done today. I think the same is true of my paintings. They also refer to architectural detail and decoration, but there wasn't much serious abstract painting that was this stylized. Mine are much more removed, even though I think one *could* have painted like this in the twenties and thirties. I've never seen any painting like the Peace Through Chemistry image. There should have been images like this; it's a mixture of a kind of WPA mural painting and Cézanne or Grant Wood, mixed with American Precisionist use of city imagery.

It also has overtones of the thirties poster style.

Right, this is probably a more immediate source and brings in the simplicity of poster reproduction. I've combined a lot of images into what maybe thirties murals looked like. Then, of course, the dots I use make the image ersatz. And I think the dots also may mean data transmission. Previously they meant something more to do with printing; now I think they're decorative and they mean—I don't know if this is a correct rationalization or not—but I think they mean two things: one is simple data information, and the other is a way of making another value out of the same color—50 per cent red or 50 per cent blue. Actually, in these prints the dot color had to be changed several times. The red dots are not the same ink color as the flat areas of inked red. In printing commercially, the purpose of the dots is to get a free pink out of the deal. However, because red dots printed with the same ink as that of the flat areas don't look the same value, the printer changed the dot color to make them optically match the flat areas. Anyway, the dots can have a purely decorative meaning, or they can mean an industrial way of extending the color, or data information, or finally, that the image is a fake. A Mondrian with a set of dots is obviously a fake Mondrian. I think those are the meanings the dots have taken on, but I'm not really sure if I haven't made all this up.

It also seems to me that in your Cathedrals and Haystacks, unlike the Impressionists who suspended color in a veil of choppy brushstrokes, you do the same with a veil of hard optical dots.

Yes, it's an industrial way of making Impressionism—or something

like it—by a machinelike technique. But it probably takes me ten times as long to do one of the Cathedral or Haystack paintings as it took Monet to do his.

Unlike the paintings, in the Cathedral prints the image is stabilized. I mean, the view of Rouen cathedral is identical in each print.

Yes, I think that changing the color to represent different times of the day is a mass-production way of using the printing process. On the other hand, the paintings in any one set are different from one another, and I'm not too sure why I did them this way, but I planned them as four sets consisting of three paintings in each set, although I may extend one set to five paintings. Each set has different images. I mean, there are no two images or colors the same in any one set. Identical images are dispersed in the various sets, but the colors are different.

Then, are you going to insist that the paintings be kept in sets and not be broken up by a purchaser?

Yes.

On the basis that the serial idea is more coherent with three images seen at once?

I think it explains the serial idea much better, and a lot of the time the image of the cathedral is not very apparent. It is more apparent in one of the three than the others, and this gives coherence to the other two. But the other thing is that, although Monet painted his Cathedrals as a series, which is a very modern idea, the image was painted slightly differently in each painting. So, I thought using three slightly different images in three different colors as a play on different times of the day would be more interesting.

Doesn't the very limited palette of colors you see ever bother you?

No, it doesn't. Though once in a while I think, wouldn't it be great to extend my color range—but then it always seems it would be weaker and more artistic. I usually prefer an even more restricted range, and if I can do a thing in two colors, I do. I still use primary colors, but in these prints I try to get as many variations as I can.

However, in the prints your colors are very mixed, very secondary.

Well, they are the same colors and I try and get as wide a range as possible. It's not that I'm trying to get purple by using a mixture of red and blue—that's not what I mean—it's the range of combinations, such as using black and white and a small amount of a primary color in one painting or print, and in another, using a riotous combination of bright colors with graduated dots. I want to be blatant. I don't see that I gain anything by changing red to orange. The color range I use is perfect for the idea, which has always been about vulgarization. I've always used the same colors—red, yellow, blue, black, and sometimes green on white—but I think my use of color varies considerably.

Roy Lichtenstein

In some paintings or prints the image as such doesn't seem to be terribly important to you in comparison to the over-all color.

Once I know what it's going to be, it isn't important. I want to give it whatever power I can as an image. I mean, I don't want to lose the quality of the image, but once I've decided on it, I don't allow it to be an issue.

But the Cathedral prints are very abstract.

Yes, that's the idea. I follow to a logical conclusion Monet's general idea in a much more mechanical way. Of course, they are different from Monet, but they do deal with the Impressionist cliché of not being able to read the image close up—it becomes clearer as you move away from it.

I understand that for the Cathedral paintings you used an assistant quite extensively to cut the stencils.

Yes, and to paint the dots in, too.

All the tedious work is done by your assistant?

Yes.

As a consequence, your productivity has increased? Or your leisure?

Both.

You mean, without an assistant, you wouldn't have been able to tackle the Cathedral paintings—they'd have been too boring to do?

I don't think I thought of that. It wasn't too boring for Monet. I like to work. I even like repetitive jobs—but it would have taken me years, and I would rather carry out my other ideas.

In fact, using assistants gives you more freedom?

I don't like to repeat myself, but if I get the idea of changing black dots on a white ground to white dots on a yellow ground, I tell an assistant to mask out the required areas and make the changes. I can then see what this change looks like and that saves me two days of work. I don't *have* to use an assistant, but it frees my energy for use elsewhere. Moreover, if I had to make the marble, brass, wood, and glass sculptures myself, I would have to painstakingly learn all the required techniques and skills. I would turn out only one sculpture at the end of ten years, rather than several diverse sculptures in one year.

But you like to do part of your painting?

Yes, because the sculptures are done through drawing in the same way as the prints or the Cathedral paintings. The fact that someone cuts the stencil and paints on the dots exactly the way I would leaves no particular benefit for me to do it. I like to do a certain amount of tedious labor, though. I don't think it would be good to sit at a desk and just be a brain—I'd turn into a marshmallow in no time—so I always give myself some work to do on the paintings.

Do you use masking tape on your paintings?

I don't use tape because it masks out part of the painting. I like to let lines grow larger and smaller and to watch the whole painting while this is going on. I like the freedom of drawing a line in relationship to the whole painting; it's a hangover from my Abstract Expressionist days.

I notice that the prints are much more abstract than the paintings, and instead of using the dots to delineate the cathedral, you use them to disrupt the surface.

Yes, I do it in a couple of ways. In one, all the dots have the same centers, but some are darker than others, so the dots are divided into dark and light shaded areas. In the others, the dots in the darker areas are double shaded.

The latter cluster to form the image?

Yes, and the lighter areas are also dotted. The prints are done over a flat color such as red, yellow or blue, so it's possible to obtain a large range of color combinations even though I'm using only four colors.

But some of the Cathedral prints are monochromatic; for instance, the blue one.

Well, of course, I like to represent the complexities of Impressionism in one color. The blue represents the arrival of evening.

The colors are all used logically to denote the time of day, like yellow for noon? What's morning?

I'm not sure—I guess yellow. It's all a pretty abstract idea, but the purplish ones in red and blue are evening, too, of course.

What's the black one?

The black is on a flat blue color; that's midnight, it's most invisible.

You seem to have trouble indicating daylight.

Well, just a little bit of trouble—red and yellow stands for daylight.

I presume the various modern heads in the prints and the sculptures take off from the many Jawlensky Constructivist heads you once saw in Pasadena Art Museum's collection?

Yes, somewhat. I mean, they get pretty far from Jawlensky, but the idea started with his paintings.

Was it the thirties stylization inherent to these paintings of Jawlensky that interested you?

I guess what interested me was—"what in the world a modern head could be about"—I mean, to make a man look like a machine. It's the machine quality of the twenties and thirties that interests me. Picasso and Braque in Analytical and Synthetic Cubism weren't particularly interested in the machine aspect. It got consciously much more that way in Léger's painting and with the Futurists and Constructivists, the people portrayed becoming dehumanized by being related to machines. This relates strongly to comic-book images which are not machinelike but are largely the product of machine thinking. Then, the fact that in the comics the rendition of a head, for instance, is so altered by the eco-

Roy Lichtenstein

nomics of printing. The *art moderne* idea of making a head into something that looks as if it's been made by an engineering draftsman deals with industrialization and manufacture, which is what my painting has dealt with since 1961 or so.

Do you think the thirties style consciously arose out of the idea of combining man and machine?

Yes, I really do. It's a concession to inevitable industrialization—the opposite of pre-Raphaelite thought.

This may be a little offbeat, but has there been anything written on your iconography that really interests you?

Yes. I'm intrigued by unusual insights—things I haven't thought of. I think of them as inventive but not necessarily true. I mean, I'm sure my own insights are just as askew as anyone else's. I have certain feelings which I try to put into words, but I really don't believe in the words. I think one tends to think up things that sound logical or insightful about one's work anyway.

What do you think is the essential difference between your prints and paintings, apart from the obvious things such as medium, scale, etc.? Your Haystack paintings and prints are about the same size, I think?

The prints are a little smaller, but that's not significant. The paintings are all different images. In terms of exactness in placement and register, the prints are better, because they can be better controlled in this medium. Working on canvas isn't controllable in the same way. The paintings bear the tracks of corrections of various things. The prints are all worked out beforehand and appear purer. Your question was, is there any basic difference—I really don't think there is. They're all done methodically, step by step. If a print doesn't work, I throw it away. In the case of the paintings, I can erase and change parts until I am satisfied—I can add things that weren't in the original stencils. With the prints, everything is done before the final printing, but the process is very much the same. I do the dots first, then the colors and finally the black lines. That's not true of the Cathedrals, of course, which have no black lines. It's all only methodical up to a point and gets changed around whenever it is unsatisfactory. In fact, it's very hard to say.

Well, it is always taken for granted that it's possible to work at a greater scale in paintings and that there is more freedom to be impulsive, whereas printmaking is more systematic and has fewer possibilities for being impulsive. In retrospect, and from your own position and work, how do you now view the Pop style?

That's really a tough question because there are lots of ways to get at this. I don't know if my current work is more or less Pop than before. The subject of my recent paintings and prints is still a vulgarization of Monet's Cathedrals. I mean, they're a vulgarization in the regular sense of the word in that I'm industrializing his images. Also, I think my

imagery is taking on more subtle aspects than before, but I don't really think of my earlier work as lacking in subtlety. It may be that my early work is less "Pop" than people think, and that my recent work, though more subtle in appearance, is more "Pop." However, I have a feeling one shouldn't probe too closely into this thought.

But your current work is very remote from your earlier images. I mean, previously you selected images that were about a decade old. Now you range back almost a hundred years. Of course, your early Cézanne paintings went back to the same time, but you seem to be focusing on a period about forty years or more in the past. Have you any idea why?

The comics, and paintings of Picasso, Mondrian, Monet, and WPA murals, as well as the modern heads and designed objects, are all available to me as reproductions. The fact that the comic-book and advertising art was done more recently doesn't make it any more available to me than any other source of my images. I mean, it's still other people's graphic or three-dimensional works that I use, and that's what I was using in the early sixties. The fact that some of the images happened to be advertising art is almost incidental.

You still deny there is any social comment in your work?

I don't think I deliberately *put* it in, let's put it that way, but it's pretty hard not to read social comment in it. That is, I'm commenting on something, certainly. I don't think it's direct, and I don't think I'm saying that society is bad. That's not the meaning of the Cathedrals or Modern Heads or Peace Through Chemistry. But obviously they comment on some aspects of our society. They observe society and come out of our society.

But this has nothing to do with traditional realism.

Well, realism has usually meant vulgarization. I think the idea of discussing ideas about art apart from the specific artists is silly. Maybe that's a fault of a certain type of abstract criticism which really deals in the philosophy of an idea, and it doesn't seem to matter so much which artists are discussed. It's a question of the strength of an artist as against the strength of an idea.

Or style?

Yes, because a style or a critical idea considered independently from the particular artist can be fairly meaningless.

But you really don't see yourself as someone separate from the abstract artists in formal qualities, do you?

No, not fundamentally. But my work isn't *about* form. It's about seeing. I'm excited about seeing things, and I'm interested in the way I think other people saw things. I suppose "seeing" at its most profound level may be synonymous with form, or rather form is the result of unified seeing.

Roy Lichtenstein Interviewed *Diane Waldman*

Diane Waldman: *Isn't it true that people generally react to something new—to its most available characteristics—usually subject matter? And isn't it possible to say that any subject matter can be used?*

Roy Lichtenstein: Any subject matter is okay, but only if it brings significance with it, which is pretty elliptical reasoning when you come to think of it. The mysterious area isn't the treatment of subject. This is important but it's usually understandable after an artist has done it. It's the formal area which can't be explained: It has to be seen and it can't be seen by someone who can't see it. There's no logical or verbal way to get someone to see this kind of relatedness. I don't think of subject matter as an additional attribute to form, but my subjects are important to me personally. They add a joy and bravura and irreverence which I need. There has always been confusing talk about the relationship of subject matter to form. Part of the confusion is our inability to understand our own minds in this area. Most of our talk about composition, unity, subject matter, picture plane reflects this.

What about the picture plane?

It is often taken as a reality instead of as a phenomenon—a sense of picture plane or a sense of two dimensionality. There is nothing sacred about the canvas itself. Abandoning three-dimensional references or illusory space doesn't produce unified two dimensionality. Calling attention to the surface through paint texture, sand, staining, or even dots is only symbolic of the realization of plane. It doesn't serve an organizing function. A surface could just as well look like Vermeer or Ingres. While the artist's sense of two dimensionality of the painting surface is irrelevant. What about bas-relief or incised lines or Picasso's flashlight drawings or wire sculpture? Does it make any difference if a line is drawn on the surface or if it is incised or comes forward? It all only serves to create contrast. It is the contrasts, no matter how they are made, that must be unified as they are created. You see, I think that every mark you make, every line you put down, can't bear any relationships to representation or representational space at the moment it's being put down. It has to be divorced from that and become part of the painting space. This must be true whether the work being done is described as abstract or representational.

It seems to me that form has to exist whether or not subject matter is used. Artists like Noland or Stella who are using a type of subject that we might call nonrepresentational are not more concerned with form than you are.

Extract from Diane Waldman, *Roy Lichtenstein* (New York: Abrams, 1971). © Gabriele Mazzotta Editore, Milan.

I think the look of freedom or restriction is only stylistic and not qualitative.

If what you are saying is true, then it seems to me that the need to achieve a sense of unity forces the artist to seek the appropriate forms and these forms can be either representational or have nothing to do with natural forms. The end result is another reality in either case. In your work, the conception is something other than the reality of an object that exists in life, so that your painting of a refrigerator is not a refrigerator.

Yes, the marks are always abstractions that must have another kind of relationship to one another. An important part of recent painting may be that it seems to symbolize "thing"—"frankfurter," "circle," "stripe"—after generations of art which symbolized relationships. Johns and Rauschenberg understood this so well. The power lies in how the thing is conceived, not in what it is made to symbolize. The strength is sensed within the mark itself. I don't think it would make too much difference where the mark was, in a general way, on the canvas. That would be another consideration—more a taste consideration—whereas, say, we might put it off center in 1950, we put it in the middle in 1960. I think the relatedness can be sensed in the mark itself. Newman does this and Judd and Flavin. Because even one mark changes position and it creates a field, you don't need two marks to make a relationship. With one mark you have an infinity of places. It's very difficult to tell whether there's strength in it or not, whether it holds or not—there are so few clues. Maybe Mondrian started this feeling.

Mondrian is an interesting example of an often misunderstood artist. I have always seen him as a painter of great sensibility, but he is frequently regarded as a rigid or dogmatic painter.

I think that his work looks superficially rigid. But it couldn't have been done without an inner flexibility.

I think that there is a similarity to him in your approach to painting. Critics have often spoken about your art as anti-sensibility. In fact, you said that yourself.

You may link Mondrian with me anytime. I think I meant anti-sensibility in appearance.

Speaking of Mondrian, what made you decide to use certain painters like Picasso or Mondrian?

They just fit in. Mondrian used black and white and the primary colors. He was an obvious one to do and so was Picasso, in that Picasso is thought of as using simple colors and shapes surrounded by black lines. I was interested in doing other artists' works not so much as they appear but as they might be understood—the idea of them, or as they might be described verbally.

Why have you done so few artists?

I don't really want to go through a whole roster of artists. I only did it when a specific painting or group seemed right. I chose images that had become public and clear and conceptualized. Generally, this is true of the work I've done.

When you did your first Pop paintings, did you paint them in series or did you work on them separately?

To begin with, I did as many different things as I could: products and objects and girls and war, all at the same time. I worked on a variety because there were so many things to do at that time. I worked in every direction at once. Later I tended to focus more on single ideas.

It has been stated that your titles are a significant clue to your work. In one case, you used Picasso's title and in another you translated it into English. Would you say you were making any statement with your titles? I never gave any particular thought to the implications of titles; again, that seems like a very literary approach to your painting.

A lot of the titles aren't mine, but I think the Picassos were.

One Picasso subject is titled Femme d'Alger. *Another is* Woman with Flowered Hat.

That might have been only because the reproduction I took it from was either in English or French.

What about Preparedness? *How did you arrive at that title?*

That was an entirely self-conscious title. It has the same perversity as *Peace Through Chemistry*, what an unlikely notion! It's a muralesque painting about our military-industrial complex. That's the subject of it, more or less.

It sounds like a pre–World War II title—a thirties title—a Depression title. We must produce in order to protect ourselves, like Soviet titles now—to arouse the citizens to the defense of the country or to produce for the country. Preparedness *has that sort of a call-to-arms quality.*

I don't care that much about titles. They probably shouldn't be there. The painting is what it is. The nonsense that I can think of, that has to do with its relationship to today or the thirties, is just something else going on in my head, which doesn't add anything.

That reminds me of the Portrait of . . . Allan Kaprow, *which you did in 1961. How many did you do?*

I only did two. I meant to do a whole series.

Of the same painting?

Yes. I was going to do a group—maybe twelve—and show them together. I only did two, though, because it really did get boring and there were other things to do.

So, you did regard changing the title as humorous; repeating the same painting?

Yes, it's sort of obvious, present-day *Modern Times*—a production line.

I was also thinking of the drawing and the painting I Know . . . Brad. *Did you intend them to be totally different, with the same title?*

Well, I had the idea of "The Hero" Brad. "Brad" sounded like a hero to me, so all heroes were to be called Brad—a very minor idea, but it has to do with oversimplification and cliché.

Did you see the war cartoons at the time you were doing them as a comment on war?

Well, it wasn't the purpose, but I realized it would have that effect.

They are discussed now as significant statements in relation to the Vietnam war which developed, of course, afterwards.

It is no mystery that we are very big on protecting our interests around the world.

I didn't know if you meant it to be a comment on war or just on the aggressive nature of America.

A minor purpose of my war paintings is to put military aggressiveness in an absurd light. My personal opinion is that much of our foreign policy has been unbelievably terrifying, but this is not what my work is about and I don't want to capitalize on this popular position. My work is more about our American definition of images and visual communication.

A number of critics have written about the importance of the balloon to your cartoons. What do you feel was the effect of the words and the shape of the balloon?

I'm not sure. I think I wanted the statements to be typical and short —the essence of a situation; or very confusing and involuted like *The Scientist* or *Takka Takka* or *We Rose Up Slowly*. Of course, I wanted them to be arranged something like free verse. It relates to poetry the way the comics relate to painting. I really think of the lettering as a pattern of gray and the shape of a balloon as any other shape.

But in some instances, you use it very consciously as a separate area.

Yes, as a panel.

And it almost forces you to read it and then look at the painting or to look at the image and then read. But you can't do the two activities at the same time.

But it's like a Western version of Oriental writing or scrolls . . . the Bayeux tapestry or something like that. In the fifties, writing in art was done in a Cubist, artistic way. I liked the idea of doing straight draftsman's cartoon lettering; the "uninteresting" lettering went with the "uninteresting" shapes. Lettering interested me and I used it in several ways. I used lettering alone in *In* and *Art*.

I think that In *and* Art *were very effective,* Art *in particular (1962).*

Yes, it meant "This is *Art*." Or straight lettering is as good as any

other shape. I had ideas for long series of words, too. I wanted to do *Flat,* among others; but *Art* more or less did it for me.

Do you see any difference between the enamel pieces like the Explosions and the new pieces of sculpture that you are doing—the twenties and thirties pieces?

I think they're really different—maybe different in intent. The enamel explosions (I've said this before) were meant to make the ephemeral forms of explosions more concrete. This is true of the porcelain landscapes, too. To make them in steel and glass seemed to make them more concrete for me and bring them further from reality. Although the brass things have the same sort of two dimensionality as the explosions, they are more like actual architectural details than the porcelains are like real explosions. They are almost really banisters.

I think we've all been influenced by a rational approach. There seems to be a more apparent justification for doing what one is doing if it relates to something that seems rational.

That's what interests me about *art moderne.* It has such great concern for logic: 45-degree angles, radii of circles, and dividing the area into two or three equal parts of progressively larger parts. There's a kind of absurdity attached to their concern with logic. In my work I like to relate the thirties to today's rational art. But today's work has a kind of irony. It knows it's odd; it knows it's unusual to be rational. A Donald Judd that seems rational has a kind of self-awareness. The logic isn't a naïve constructive element. It has nothing to do with that, if I'm reading it right.

Why did you decide to use Rowlux?

Rowlux is just an interesting material which has a reflective quality that can simulate sky or water, either one, because it is so amorphous. A sort of ready-made nature. It appears to have depth which makes it like real water or sky. Because it focuses light, you get brilliant reflections which make it more like an actual landscape than a painted surface . . . like real water reflecting real sunlight. A very expedient way of producing a sky or water.

Did this develop out of the paintings?

Yes.

In some of the landscapes on canvas, I thought you had achieved an unusual effect, as though one were actually out-of-doors and looking up at the sky.

Dots can mean printed surface and therefore plane, but in contradiction, particularly in large areas, they become atmospheric and intangible—like the sky.

They have an almost translucent effect of depth. And then you kept the sides of the canvas open—so that one had either a sense of floating or of the sky floating past.

Those are sort of fortuitous effects of dots.

Why did you enlarge the dots?

I think the larger dots are more effective in my recent work. In the early work, I didn't know how to control them very well. I didn't realize that I could use dots that large—maybe I couldn't have. If I had put very large dots on more complex shapes, like faces, they may have become unreadable. In a geometric painting or even a simple landscape, large dots don't destroy the exterior form.

The dots seem to establish themselves as an independent form in a way. They are both a part of a pattern and a separate entity so that one can now focus on a dot where it was not possible in the earlier work.

I like to keep it a little below that level. I think that if they became polka dots or individual shapes that you can focus on, they would have to be brought into a composition rather than remain a texture.

What was your reason for changing a prepared ground to one that you primed yourself?

I always painted on a printed ground, but later I painted it again with my own white. I thought the canvas might change color in time, and, also, it's easier to make corrections when I paint on my own white. But more important, I like it whiter now. Everything became sharper, I guess, as I went along and I just like that.

Roy Lichtenstein

||| on lichtenstein

Roy Lichtenstein and the Realist Revolt
Robert Rosenblum

In the twentieth century, the tempo of artistic change is frighteningly rapid. In America, what was only recently seen as a triumphant new constellation of major painters (whose styles ranged from the "action painting" of Pollock to the "inaction painting" of Rothko) has suddenly receded into a position of "old master" authority that poses a heavy burden upon the younger generation. Some of these "old masters" themselves have found difficulties in maintaining the superb quality they achieved a decade ago; and for their successors, the problem has been even more acute. To yield to the power of what had quickly become a tradition meant an *a priori* condemnation to a secondary, derivative role. One might be certain of producing beautiful, virtuoso paintings by working within these given premises, but one also risked never creating any truly new ones. To be sure, some recent painters have succeeded against these enormous odds in producing work of extremely high quality and originality (Stella, Louis, and Noland, among them); but in general, most abstract painting of the later 1950's and early 1960's has begun to look increasingly stale and effete. Even in the hands of the most gifted satellites, it has often turned into a kind of academic product in which rapid, calligraphic brushwork—once the vehicle of daring innovation and intensely personal expression—was codified into a mannered, bravura handicraft *à la* Sargent; and large-scaled formal simplifications—once majestic and emotionally overwhelming—have frequently become merely decorative and hollow. Moreover, a commitment from a purely formal realm, untainted by references to things seen outside the confines of the canvas, began to be felt by many as a narrow restriction that prevented commentary on much that was relevant in contemporary American experience.

Some artists responded to this predicament by reintroducing fragments of reality, either in fictive or in actual presence, within a style that remained essentially dependent upon the "old masters" and especially upon de Kooning. A newer and more adventurous path has rejected still more definitively this dominating father-image by espousing, both in style and in frame of reference, exactly what most of the masterful older generation has excluded. The early flags, targets, and numbers of Jasper Johns were decisive signposts in this new direction. Not only did they reintroduce the most unexpectedly prosaic commonplaces in the poetic language of abstraction; but, equally important, they at first used the actual visual qualities of these images as positive pictorial elements. The flat objects Johns originally painted were painted as flat objects, identical with the picture plane, and not as seen through Ab-

From *Metro,* no. 8 (April, 1963).

stract Expressionist lenses that shuffled and fractured colors, contours, and planes. What was rejuvenating about these works was not only the bald confrontation with a familiar object in the arena of a picture frame, but also the bald clarity of the pictorial style which accepted the disarmingly simple visual data of these signs and symbols—total flatness, clean edges, pure colors, rudimentary design. To spectators accustomed to the dominant modes of abstract painting, these pictures were a jolting tonic, like a C-major chord after a concert of Schoenberg disciples. In the same way, Johns's recent sculptures—beer cans, flashlights, light bulbs—challenged the complex spatial dimensions of an oil painting, and therefore, placed in the context of a work of art, this Hawaiian love goddess [*Aloha*, 1962] obliges us to scrutinize her as we never did before. She may first be looked at as a distressing sociological phenomenon, a member of a strange new race bred by the twentieth century. Embodying a popular American erotic fantasy, this vulgarized descendant of Ingres's and Gauguin's odalisques is startlingly ugly, though her monstrous vapidity, alternately grotesque and comical, is consistently hypnotic. Her fascination, however, resides not only in the cultural shock of really examining for the first time a spectacle so common that we have always closed our eyes to it, but also in the visual surprise of perceiving closely the mechanized pictorial conventions that produce this creature.

Much as many nineteenth- and twentieth-century artists were excited by the unfamiliar flatness and simple linear means of styles that ranged from Greek vase-painting and Japanese prints to children's drawings and primitive textiles, Lichtenstein now explores the mass-produced images of the crassest commercial illustration. By magnifying these images, he reveals a vocabulary of uncommon rudeness and strength. Coarse and inky contours, livid primary colors, screens of tiny dots, arid surfaces suddenly emerge as vigorous visual challenges to the precious refinements of color, texture, line, and plane found in the Abstract Expressionist vocabulary.

Like all artists, however, Lichtenstein has chosen his visual sources discriminatingly and has learned to manipulate them in the creation of a style that has become uniquely his. From the multiple possibilities offered by commercial illustration, he has selected those devices which produce a maximum of pictorial flatness—thick black outlines that always cling to a single plane; an opaque, unyielding paint surface that bears no traces of handicraft; insistently two-dimensional decorative patterns—woodcut arabesques and mechanically regimented rows of dots—that symbolize texture and modeling. Thus, the Hawaiian girl is first seen as an illusion of the most voluptuously contoured anatomy, but these sensual swellings are quickly and brutally ironed out by the two-dimensional conventions of Lichtenstein's style. Like the nudes of

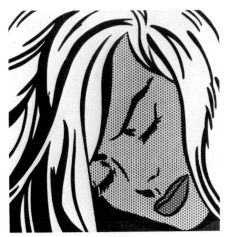

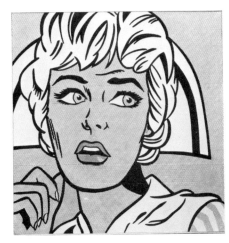

39. *Sleeping Girl*, 1964. Oil and magna on canvas, 36″ x 36″. Collection Mr. and Mrs. Philip Gersh, Los Angeles, California.

40. *Nurse*, 1964. Magna on canvas, 48″ x 48″. Collection Karl Ströher, Hessischen Landesmuseum, Darmstadt.

41. *We Rose Up Slowly*, 1964. Two panels. Oil and magna on canvas, 68″ x 92″. Collection Karl Ströher, Hessischen Landesmuseum, Darmstadt.

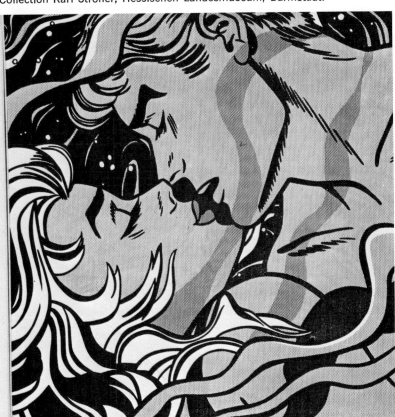

42. *Blonde Waiting*, 1964. Oil on canvas, 48″ x 48″. Collection Mr. and Mrs. Richard L. Weisman.

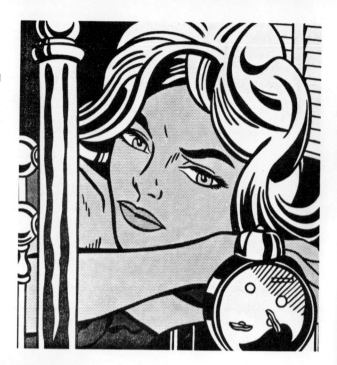

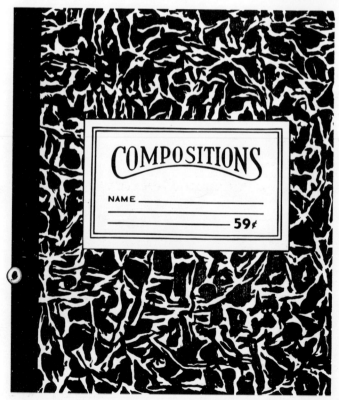

43. *Compositions II*, 1964. Oil on canvas, 56″ x 48″. Collection Mr. and Mrs. Michael Sonnabend.

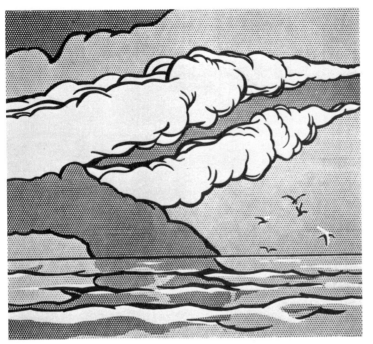

44. *Gullscape*, 1964. Oil and magna on canvas, 68" x 80". Collection Dr. and Mrs. Eugene A. Eisner, Scarsdale, New York.

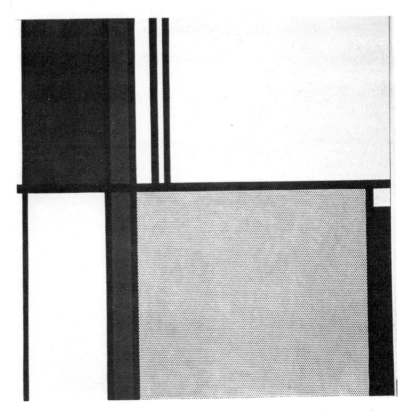

45. *Non Objective II*, 1964. Magna on canvas, 48" x 48". Collection Mr. and Mrs. Michael Sonnabend.

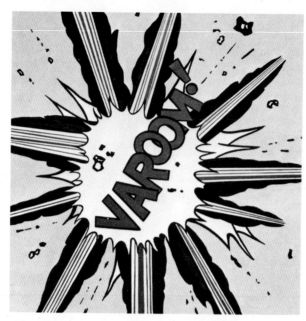

46. *Varoom*, 1965. Liquitex on canvas, 59" x 59". Collection Kimiko and John Powers, Aspen, Colorado.

47. *Desk Explosion*, 1965. (Edition of eight.) Enamel on steel, 20½" x 16".

48. *Explosion I*, 1965. Enamel on steel, 98" x 67". The Ludwig Collection, Wallraf-Richartz Museum, Cologne.

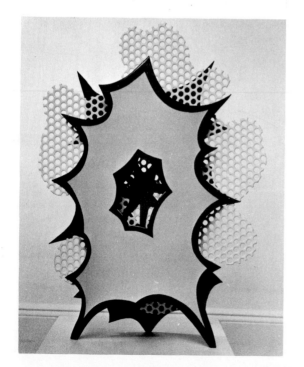

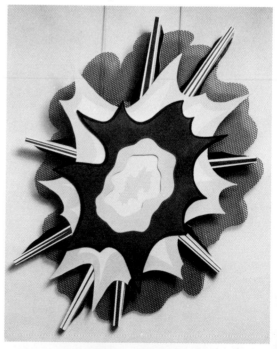

49. *Landscape with Column*, 1965. Oil and magna on canvas, 48″ x 68″.
Collection Dr. Hubert Peeters.

50. *Blonde*, 1965. Glazed ceramic, 15″ high. The Ludwig Collection, Wallraf-Richartz Museum, Cologne.

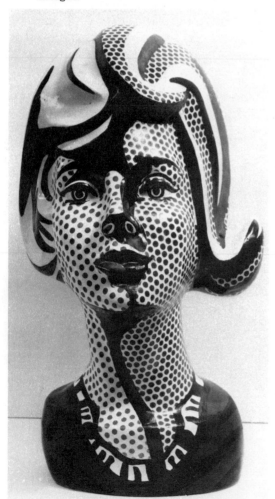

51. *Ceramic Sculpture No. 7*, 1965. Glazed ceramic, 9½″ high. From the collection of Mr. and Mrs. Burton Tremaine, Meriden, Connecticut.

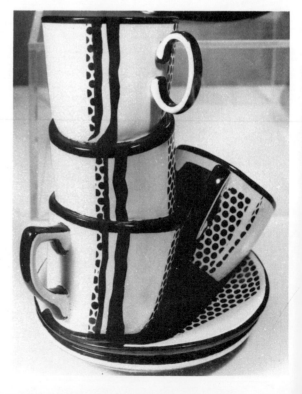

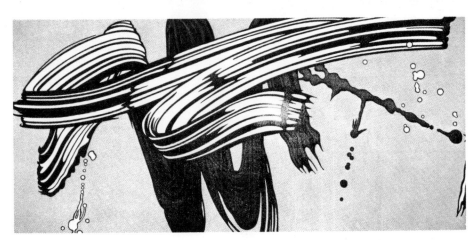

52. *Yellow and Green Brushstrokes*, 1966. Oil and magna on canvas, 84″ x 180″. Collection Karl Ströher, Hessischen Landesmuseum, Darmstadt.

53. *Big Painting No. 6*, 1965. Oil and magna on canvas, 92½″ x 129″. Kunstsammlung Nordrhein-Westfalen, Düsseldorf.

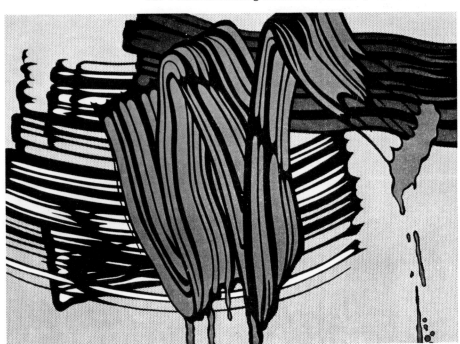

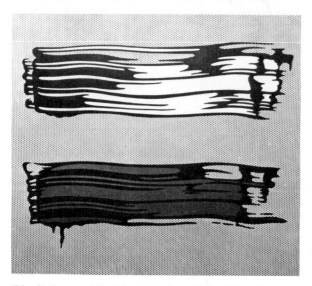

54. *Yellow and Red Brushstrokes,* 1966. Oil and magna on canvas, 68″ x 80″. Private collection, Paris.

55. *Stretcher Frame,* 1968. Oil and magna on canvas, 30″ x 30″. Collection Mr. Irving Blum.

56. *Ocean-Motion,* 1966. Mixed media, 22½″ x 16¼″. Collection the artist.

57. *Modern Painting,* 1967. Oil and magna on canvas, 24″ x 36″. Collection Dorothy Lichtenstein.

58. *Haystack No. 2,* 1969. Oil and magna on canvas, 16″ x 24″. Collection Mr. and Mrs. Carlo F. Bilotti, New York.

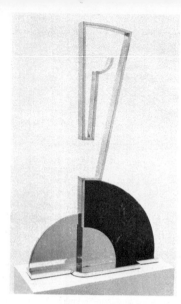

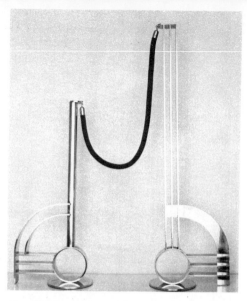

59. *Modern Sculpture with Horse Motif*, 1967. (Edition of six.) Aluminum and marble, 28¾" high.

60. *Modern Sculpture with Velvet Rope*, 1968. (Edition of three.) Brass and velvet rope, 83¼" high.

61. *Modern Painting with Classic Head*, 1967. Oil and magna on canvas, 68" x 82". Collection Mr. Irving Blum.

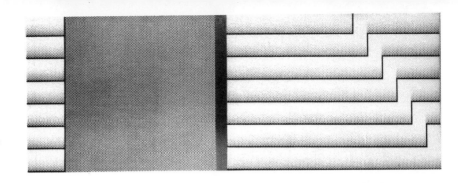

62.
Yellow Abstraction, 1968. Four panels. Oil and magna on canvas, with brass and wood, 48″ x 132″. Collection Mr. J. M. Rossi, Paris.

63.
Study for *Preparedness*, 1968. Oil and magna on canvas, 56″ x 100″. The Ludwig Collection, Wallraf-Richartz Museum, Cologne.

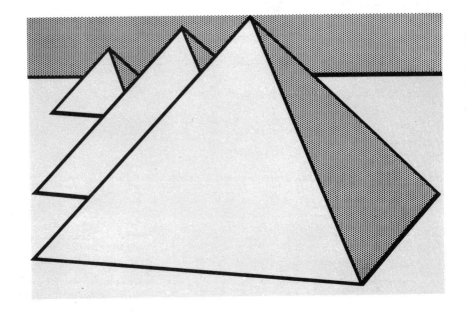

64.
The Great Pyramid, 1969. Oil and magna on canvas, 129″ x 204¼″. Collection Des Moines Art Center, Nathan Emory Coffin Memorial Collection.

65. *Little Aviation,* 1968. Oil and magna on canvas, 68″ x 36″. Collection Mr. and Mrs. Michael Sonnabend.

66. *Rouen Cathedral (Seen at Three Different Times of Day) II,* 1969. Oil and magna on canvas, 63″ x 42″ each canvas. The Ludwig Collection, Wallraf-Richartz Museum, Cologne.

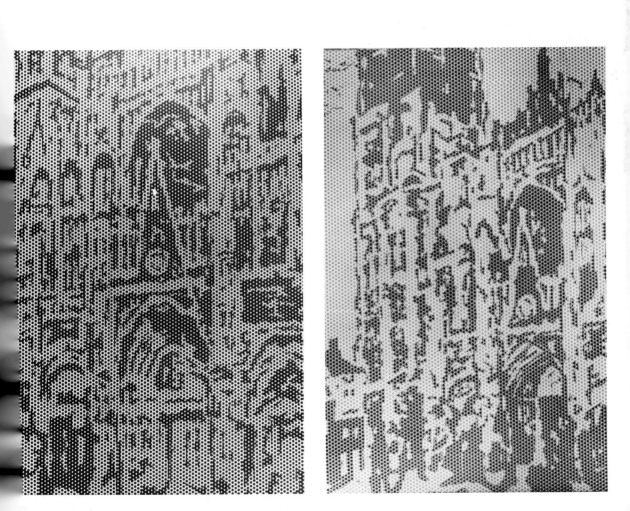

67. *Modular Painting with Four Panels, No. 2,*
1969. Oil and magna on canvas, 96" x 96".
Private collection.

68. *Modular Painting with Four Panels, No. 6,*
1970. Oil and magna on canvas, 108" x 108".
The Ludwig Collection, Wallraf-Richartz Mu-
seum, Cologne.

69. *Modular Painting with Four Panels, No. 9,* 1970. Oil and magna on canvas,
90" x 120". Collection the artist.

70. *Mirror*, 1970. Oil and magna on canvas,
 24″ diameter. Collection Mr. Gian Maria
 Persano.

71. *Peace Through Chemistry*, 1970. Oil and magna on canvas, 100″ x 180″.
 Collection the artist.

72. *Mirror (36" diameter) No. 6*, 1971. Oil and magna on canvas. Collection the artist.

74. *Mirror (four panels, 96" x 72") No. 1*, 1971. Oil and magna on canvas. Collection the artist.

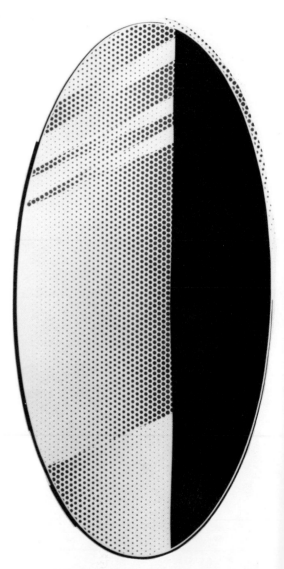

73. *Mirror (72" x 36" oval) No. 2*, 1971. Oil and magna on canvas. From the collection of Mr. and Mrs. Robert Kardon.

Ingres, whose anatomies become so monstrous when extracted from their compressed spaces, Lichtenstein's exotic lady offers a compelling tension between the abstract autonomy of sinuous contour and compositional flatness, and the resulting distortions of a jointless arm, a muscleless throat, a boneless face. Throughout the painting this interplay of style and subject commands attention, whether one looks at the rude contrast between a flat black and flat red shape that creates a lipsticked mouth; the rich, curvilinear inventions that indicate shading and texture in the cascades of black, perfumed hair; or the totally flat patterns of tiny red dots that alternately become rounded, pink flesh. *Head, Yellow and Black* belongs to the same genetic and pictorial race. The American counterpart of her Hawaiian cousin, she is a pretty girl of the domestic variety; but again, studied closely, the total vacancy of expression and the amphibian physiognomy provide a shocking sociological observation, which, in turn, is supported by an equally startling pictorial invention. The cosmetic complexities of mascaraed eyes, tweezed eyebrows, and permanent waves are transformed into linear abstractions of almost Art Nouveau fantasy. This rich visual incident is then contrasted to the taut and bleak expanses of empty skin surface, monotonously textured background, and mat black dress, so that the whole creates a calculated pictorial intricacy surprising in what seems, to begin with, so crude an image.

In *The Kiss* [1962], the "girl next door" meets her mate, a virile Air Force pilot who seems to have dropped from the clouds in order to provide the total ecstasy that, in a less secularized society, was once experienced by a swooning Santa Teresa. This fervent embrace—a crushing fusion of blonde hair, a military uniform, polished fingernails, deeply closed eyes, and a momentarily grounded airplane—is again masterfully composed in terms of a remarkable variety of linear and textural invention, witness only the sweeping descent of erotic abandon that begins with the pilot's visor and continues downward through the forehead of Miss America, the part in her hair, and finally the knuckles of the clenched male fist.

Lichtenstein's sociological exploration of American mores is further elaborated in the *Eddie Diptych,* which describes the dramatic rupture between teen-age daughter and disapproving parents so common in popular fiction. Ironically reviving the narrative means of a medieval religious painting (a diptych with long verbal description, here both soliloquy and dialogue), the *Eddie Diptych* presents a comic-strip crisis in which the ingredients of Western tragedy are bizarrely reflected. Youthful rebellion, parental opposition, omnipotent love are re-created by the *dramatis personae* of this vulgar literary medium with results that are at once funny and disturbing as an accurate mirror of modern popular culture. Pictorially, the diptych is no less intriguing. The colors

—the harshest yellow, green, blue, red—produce flat and acid surfaces of unfamiliar visual potency; and the complex lettering is used ingeniously as both a means of asserting the composition's taut flatness and as a delicate decorative pattern of black and white that relieves the assaulting intensity of the opaque colors. The enclosing white frame of the right wing and the structure of the lettering in the left wing—a column arranged around a vertical axis of symmetry—are particularly handsome pictorial devices culled from comic-strip sources but assimilated to Lichtenstein's personal style.

If Lichtenstein has imagined new heights and depths of American comic-strip drama, he has also considered the more prosaic domain of American advertising. The national fetish for domestic cleanliness revealed in ads for everything from soap flakes to bathroom deodorizers is reflected in a number of pictures that extoll the virtues of Good Housekeeping. In *Woman Cleaning,* the gigantic head of a synthetic housewife smiles down at us to register the pleasure and ease of a periodic refrigerator cleaning. In other pictures, these sanitary rituals are further dehumanized. Following the images of mechanization that Léger had explored in the 1920's, Lichtenstein at times shows a disembodied hand performing a simple functional operation. In *Spray,* only the pressure of a housewife's manicured finger is necessary to freshen domestic air; in *Sponge,* the effortless sweep of a lady's left hand works cleansing miracles. Here again, the mass-produced coarseness of Lichtenstein's visual sources—the diagrams on the labels of sanitary products—is unexpectedly transformed by a witty pictorial imagination. In *Sponge,* for instance, the blank, untextured areas vividly convey textures as unlike as skin, sponge, and enamel, just as the familiar screen of dots derived from cheap printing processes is instantly identified with a coat of dust and grime.

Similar hygienic concerns dominate *Step-On Can with Leg,* where the compartmented, sequential arrangement of "how-to-use" diagrams inspires a two-part pictorial demonstration of how a flowered garbage pail is opened by stepping on the pedal. The dainty pressure of a high-heeled shoe, as seen on the left, is apparently sufficient to raise the lid, as seen on the right. Pictorial as well as mechanical rewards are offered in box two, where the checkered pattern of a dress, now visible in the upper left-hand corner, and the changed position of the garbage pail complicate the simple symmetry of the image in box one. A diptych is again used in *Like New,* in which the "before and after" demonstrations of American advertising are transformed into a painting whose abstract qualities are more explicit than usual in Lichtenstein's work. Here an ad for invisible weaving is surprisingly enlarged in a two-part symmetrical design. What first seems, however, a boringly tidy regularity of mechanically repeated dots and sawtooth edges is unexpect-

edly upset by the darkened, irregular aureole in the left panel, which is suddenly recognized as a cigarette burn in a swatch of cloth. There could hardly be a better example of Lichtenstein's ability to re-create the tawdry visual environment of commercial imagery as an extraordinary abstract invention.

Lichtenstein's inventory of American popular culture includes any number of cherished objects that range from ice-cream sodas and new tires to beefsteaks and dishwashers. Like the machine-made creatures who use them, these objects are mass-produced forms of unforgettable ugliness. *Black Flowers* provides the Woolworth's contribution to the art of flower arrangement—a hideous china vase stuffed with a cornucopian abundance of poppies that must be made of plastic; and, similarly, the art of jewelry descends to the kitsch splendors of an advertised engagement ring whose crowning glories must surely be a glass pearl and two zircons. These 1984 horrors of mass production extend as well to food. *Turkey,* the American dream of a holiday dinner, becomes an inedible, inorganic merchandising product; and Lichtenstein's other selections from supermarket and drugstore displays are no less synthetic and indigestible conclusions to the pleasures and graces of the Western still-life tradition.

Even more startling are Lichtenstein's recent comments on another familiar product of American merchandising—great works of art. Appropriate to a period in which the Sistine ceiling can be bought together with toothpaste and breakfast food, Lichtenstein focuses the mechanized lens of mass production on these sacrosanct, handmade relics of the Western tradition. *Man with Folded Arms* looks at a great Cézanne portrait through the eye, first, of a reductive compositional analysis in a published study of Cézanne, and then through the eye of Lichtenstein's own style in which wall plane and dado become a screen of printer's dots, infinitely reproducible, and the figure becomes a simplified linear diagram transformed into the pictorial equivalent of plastic flowers. This reinterpretation of artistic tradition in the commercial light of the 1960's is even more astonishing in Lichtenstein's version of Picasso's *Femme au Chapeau.* Here the horror of a Picasso head of the 1940's — part human, part bull, part dog—becomes still more bizarre when read through Lichtenstein's vocabulary. The flat, opaque colors and vigorous black outlines are consonant enough with Picasso's own style to permit the grotesque force of the original painting to be felt; but this comical ugliness is further compounded by imposing the mass-produced schematizations of a comic-strip image upon it. In the realist tradition of the nineteenth and twentieth centuries, Lichtenstein has found his content in a fresh examination of the shocking new commonplaces of modern experience that had previously been censored from the domain of art; and in that tradition, he has suddenly rendered visible what familiarity

had prevented us from really seeing, whether comic-strip dramas or Picasso reproductions. More than that, he has succeeded in assimilating the ugliness of his subjects into new works of art, whose force and originality may even help to reconcile us to the horrors of the Brave New World in which we live.

Roy Lichtenstein *Otto Hahn*

Roy Lichtenstein's work seems so obvious that we generally miss the essential. At first glance we catch the humor, the cultural allusions; but these qualities which won the artist immediate success distract our attention from the formal problems which, alone, underlie Lichtenstein's real newness.

In order to transform "the image" that serves him as model into a picture, Lichtenstein performs a series of technical operations that are actually a reflection on the world and on the way of apprehending this world. In other words: a reflection on life and on language.

The Choice of Images: "The Cliché"

Continuing the tradition of common subject matter—like Courbet painting workers—Lichtenstein turns to the world of commercial illustration. He chooses a simple image in which, in a standard space, standard elements illustrate standard sentiments.

The cliché is an emotion or effect in its stereotyped totality. It has an impersonal, direct, and conventional form. When the girl in *Hopeless* says: "That's the way—it should have begun. But it's hopeless," this is a cliché, for the sentiments remain in the domain of the banal and undetermined. If the girl were ugly, or if her sadness were softened by a smile (or by the humor of caricatural drawing) referring us to a particular situation, the banality of the cliché would become anecdotal. Thus, when an aged but still handsome actor says with a nostalgic glimmer in his eye, "Hamlet, a remarkable play, a very satisfying role," this is not a perfect cliché but an anecdotal "cliché" which refers to a specific case: It is the aged actor who is nostalgic and silly.

Impersonality is therefore one of the conditions which raises the banal to the level of generality, in other words, the human condition. That is why, for Lichtenstein, to choose a "cliché" and to purify it are one and the same act, which aims to pass from the individual situation to the human condition in order to localize sociological myths and sentimental stereotypes in their generality.

Impersonality enables him to approach artistic grandeur; for one may

From *Art International* 10, no. 6 (Summer, 1966). Translated by Arnold Rosin; amended by James Fitzsimmons.

speak of "nobility" and "grandeur" when a sentiment exists by itself, uncontaminated by anecdote and surrounding circumstances. Whatever the sentiment, high or low, it must be detached from its context in order to approach the monumental: It is mean to be cruel with the neighbor's cats and nice to one's own; on the other hand, to extend one's cruelty—or goodness—to the whole world constitutes a monumental attitude, for nothing can make it relative.

Detached from context, outside of time, the impersonal cliché is close to monumental grandeur. Lichtenstein's first task, therefore, is to efface any personality, any psychological specification which would refer us back to a situation or anecdote. The girl must cease to be precise and individualized in order to become merely the stereotype of a girl.

But if there were only this sole operation, Lichtenstein would be nothing more than a comic-strip artist specializing in clichés, in stereotypes and impersonality. To escape from simple illustration, Lichtenstein proceeds to remodel the forms.

The Remodeling

After having established the impersonal image in a first drawing done by hand, Lichtenstein enlarges this drawing and remodels the lines. Disregarding the subject matter and representation, he looks for the arabesques, the rhythms, harmonies, and balance of the composition. By this operation, painters generally impose their own style. Lichtenstein is probably the only one to impress a work with his personality without imposing a personal repertory of forms. For he remodels the forms by referring to a cultural arsenal: He transforms a network of shadows into a Youngerman, a step-arrangement of houses into a Mondrian, a sinuous curve into Art Nouveau or Arp. . . . He adopts an indifferent attitude toward the order he imposes.

This point is very important. If Lichtenstein had imposed a unique style, he would, I repeat, have become a comic-strip illustrator who turns to painting and is recognizable by his personal style. This is what Lichtenstein's imitators have done, and for this reason they are nothing but Sunday comic-strip painters. With his impersonal attitude toward styles, Lichtenstein rejects his private emotions and raises the problem to the objective level of communication, of methods of mechanical codification and their cultural background. Here, Mondrian, Youngerman, Seurat, Art Nouveau are no more than codes: formal processes used in commercial art.

For Lichtenstein, while drawing on a cultural arsenal, adopts none of the meanings of painters like Mondrian, Youngerman, and the rest. Thanks to the precision and uniformity of his drawing, Lichtenstein cleans up the "Mondrian style," the "Art Nouveau style," and empties them of their intentions and personality. The uniformity of line mecha-

nizes the drawing, flattens the surface, eliminates organic life, and draws our interest to the methods of codification which now accede to an autonomous existence.

Lichtenstein is the only painter to utilize this destructive power of precision. With Léger and Mondrian the contours are imprecise; a bulging, a thickness of painting, a variation of intensity, all betray the artist's hand. This imprecision is almost an artistic necessity; it creates life, denies the painting as an image, refers us to a world in becoming, and gives the work an extensive value. The work is thus offered as an imperfect form in an incomplete series. If Mondrian, thanks to an IBM machine, had exhausted all the possibilities of vertico-horizontal structures as well as of different color harmonies, and if he had executed his works in plastic precisely cut out, he would have created nothing but an encyclopedia of model structures. This would not be art but a work of scholarship, a compilation of technical diagrams. Because of the undetermined and unfinished, no certainty is definitive, and the different artifices—lines, colors, forms—are the beginning of an analogical chain which remains at the same time ambiguous and in perpetual expansion. The identity thus broken creates the dynamism of the work. A painting by Mondrian is at once a thought and an artisanal approximation: The lines are not only black bands or black spaces, they are also beams, streets, a window frame conceptualized in the form of a proposition of order, a dream of purity, and so on; the color is at one and the same time pictorial artifice, a search for purity, compositional equilibrium; but it could be a wall or calm space and so on. With Léger the heavy black outline is at once form, *matière,* character, depth, perspective, brushstroke, pictorial method.

With Lichtenstein, neither the *matière* nor the line betrays or contradicts the other. The lines are lines; the arabesques are definitive forms, the color has no ambiguous role between *matière* and organic life. Lichtenstein limits interest to the real presence of the line, the arabesque, the color, in their function as artifice. Any allusion to organic life is thus eliminated, and it is truly the image itself which is put in question. Since the problem is centered on the image, the dynamism of the work develops not toward nature (as with Mondrian, where the black lines could be walls or windows) but toward language and its relationship with mechanical processes, ideas, and so forth.

In order to escape from the usual illusionism of artifices, whose function is to blend with shadows and outlines, Lichtenstein treats planes in the same manner as lines. Thus in *Girl with Ball,* after having remodeled the lines of the arm to correspond in function with the harmony of the curves, he reforms the space between the hair and the ball in order to give them an autonomous value. The hair is then balanced again, as in a work by Youngerman or Arp, to the detriment of the logical distribution which light and shadow ought to have. The lines

Roy Lichtenstein

and forms exist for themselves but float without reference to a body, without flesh or substance. Any quiver of life is definitely eliminated.

By reinforcing the presence of planes and forms, Lichtenstein introduces a new distortion which eliminates any naturalism, any psychological truth: The lines have an internal coherence, a formal logic, but their logic does not entirely correspond to the object which it should support. The methods of codification thus become ambiguous: false in relationship to naturalism, but true in their stylistic unity. And this ambiguity saves them from being merely a simple caricatural deformation.

By comparing Picasso's *Woman Seated in an Armchair* [*Femme dans un Fauteuil*] with Lichtenstein's reproduction, we can outline the stages of remodeling.

1. Lichtenstein simplifies the features in the sense of equalizing them.
2. In order to retain certain contrasts, he accentuates the shadows (those of the armchair) and emphasizes certain curves (arms, belly).
3. Certain details are eliminated.
4. Elements are emphasized—always in the sense of equalization: In the Picasso the woman's ears are treated differently, the one is obvious, the other half obliterated, in half tone. With Lichtenstein both ears have the same presence and value.

With Picasso there is an indeterminacy between form, color, and drawing, which blend and interpenetrate in a synthetic unity. With Lichtenstein these three elements are separated. The *color* is reduced to a pure tone—that is, uniform, without nuance, as in Matisse's *papiers decoupés*.

The *drawing* is a pure outline which cuts the forms into conventional ones.

The *construction* is of classic balance, orderly layout.

The work is the sum of these three simple elements. How can their superimposition move us? With Arp and Mondrian and in Matisse's *papiers decoupés,* the forms and the simple color are made significant by an original composition. With Lichtenstein the composition is classic, and the forms refer to cultural schemata. But his novelty resides in the fact that he orients the work toward language and that he is led to take up the problem of the function and content of language, that is to say, the twin analysis of form and content—in other words, code and myth.

Structure of the Language: Its Code

The fictive world of imagery is questioned on the level of the different figures of optical rhetoric. The analysis of the functioning of optical rhetoric leads Lichtenstein to envisage an entire analogical chain which

would be like a collection of substitutes or alternative possibilities: mechanical dots, moiré plastic, perforated sheet metal are the analogous codes whose combination leads back to the same signification, to the same analysis of codes.

By creating relationships with different industrial substitutes, Lichtenstein, in 1964–65, arrived at an art that was almost entirely optical. Following his logic to the end, he was led to reduce the mechanism of the image to a system of illusions. The fictive world of the image and its artifices are thus questioned in their most fundamental state: in their optical play.

Just as he was logically drawn to optical problems, so he automatically encountered Art Nouveau, whose problems were very close to his own, since Art Nouveau was an art for the machine. William Morris, the first decorator of modern times, said: "The true means of creating with hope of success a drawing model for wallpaper is to frankly accept its mechanical character, and to avoid the trap which consists in making people believe the wallpaper is handpainted." Art Nouveau therefore adapted its forms to the requirements of the machine: Very graphic, without color nuances, it brought the problems of style to the level of line, which at the same time became decorative and constructive. Moreover, it clearly separated line and form on the one hand, and color on the other.

Lichtenstein, who wants to accentuate the mechanical character of his models, finds himself close to those who "frankly accept the mechanical character."

Structure of the Language: Its Myths

Taking this subject matter from the stereotypes of mass-media communication, Lichtenstein questions the object of communication.

As advertising and comic strips speculate on the latent dreams of a society, or on its nonrealized, still-longed-for needs (to have a Frigidaire, for example), they contain particularly suggestive and powerful myths. Consequently, Lichtenstein's work, while analyzing the mechanical system of illusion, elaborates a repertory of illusions, dreams, and desires. This is the mythological part of his work.

In the pictures of the comic strips we find dreams of courage, heroism, love; dreams of dramatic tension (solitude, sadness); and dreams of domination—the myth of the superman.

In advertising we find dreams of an organized, practical, simple life; dreams of an easy, joyous life. Dreams of travel and culture (the Parthenon series and those of Greek columns). Dreams of infinite landscapes and sunsets, of objects mythified (automobile tires, golf balls).

Roy Lichtenstein

Picasso and Mondrian are also taken up as cultural myths circulating in society under a form degraded by mechanical reproduction.

Recently Lichtenstein has turned to Greek mythology—the myth of mythology—and the myth of painting, expressed as the brush dripping with paint of the Abstract Expressionists.

Significance of the Work

Starting from an image produced by man (and not from nature, from a landscape, or an apple), Lichtenstein analyzes the meaning, content, and significance of this production. He adheres closely to that group of American painters who, around the years 1960–62, questioned the fictive world of the commercial image:

- Rosenquist took his subject matter from idealizing advertising, realized by pictorial means (painted posters).
- Warhol turned for inspiration to newspaper photos.
- Oldenburg, to different forms of display art, including shop windows.
- Lichtenstein took his subject matter from the comics and linear publicity work.

All four started from an artificial image (transformed by the machine) and followed the problem posed by Jasper Johns: Is it a flag; is it a painting? But in addition to the formal problem of identity, they were interested in the meaning and content of the image manipulated by man. They added a sociological dimension by showing interest in the objects or mental schemata to which this manipulation is applied. This led them to commercial art and mechanical imagery with all these states of *condition, action, reflection, formal structure:*

- the possibility of being reproduced (condition);
- the emotional impact intended to attract attention or to sell (action);
- the revealing of myths and mental diagrams (reflection);
- the transformation of a desire into an image, of the image into a painting (structure).

The development of the modern cultural movement enables us to understand this return to content and this interest in the commonplace "cliché." The period 1945–60 was one of demystification. The myths of love, heroism, work were systematically destroyed. A pessimistic literature sought to reveal a nothingness which is the "truth" of everything: Love is nothing more than egotism; friendship does not exist; man is merely viscera; comfort is but an illusion. This literature of the absurd and of despair corresponded to that Abstract Expressionism which ex-

pressed the same disgust by gesture, cry, violence, themselves considered futile.

After fifteen years of demystification, destruction, "crise de conscience," love, the wish to have a Frigidaire, to accomplish outstanding deeds, remained present as mental constants of society. Absurd or not, futile attitudes or not, the myths and their cortege of illusions revealed their sociological persistence. The attention of the artists of the sixties was drawn to these objective facts which were analyzed in a double light: actual presence of the myth on the one hand, absurdity of the myth in its illusory mechanical aspect on the other. Confrontation and culture were thus joined, coldly and without illusions.

In order to analyze the objective facts and to localize sociological phenomena, these painters took as their subject of reflection language and the means of popular communication. Like other Pop painters, Lichtenstein took this production seriously. It is wrong to think that he is being funny, or engaging in facile mockery. He respects his models for their content, their truth, in the same way that we may respect and take seriously a secretary who falls in love with an actor she will never meet, a man who hangs on his wall a bad reproduction of a Picasso, or who dreams of winning the sweepstakes. Each situation contains its own tragedy, its own tension and truth. Even if the dream is laughable and naïve, the facts which engender it continue to be true: solitude, poverty, the fear of death.

This respect leads Lichtenstein to the most prosaic subjects, where the dream-object is the least hidden and the least relativized by the humor of caricature, or by different possible screens: skillful plunging or cinematic views (Rip Kirby type, with clever shadows and multiple grays), or the elegance and cultural refinement of Mannerist line drawings. His models are naïve and emphatic and express their feeling in a direct way.

If Lichtenstein had done nothing more than recopy and mechanically enlarge his models, he would have been unable to free and clarify certain optical, mechanical, and sociological inferences. Photographic enlargement would have created a multitude of meanings as well as details referring back to a situation, a humor, or the psychological character of some comic-strip hero. Since Lichtenstein is interested in the human condition, he has to correct his initial subject matter by eliminating the anecdotal and draw attention to the systematic method by simplifying and emphasizing it, and next by turning to the printing process by which nature tends to conceal its own systems.

But if Lichtenstein's art has nothing in common with mechanical enlargement, his method of painting is based on a mechanical system. If he had recopied the comics or advertisements like some Flemish primitive, Titian, or Cézanne, he would have scattered our attention, for the work would then have been a questioning of the processes of vision

Roy Lichtenstein

and perception. Once again the question would have been: How is the world seen by man?

In contrast to Cézanne's and Titian's classic painting, Lichtenstein does not approach the subjective problem of perception and sensation. He shows the mechanism of a fact: The fact is subjectively chosen and clarified, but it is then carried over to the canvas in an objective, cold manner. Moreover, this was Rosenquist's method: He did not copy a tomato or spaghetti, or even a poster representing a tomato or spaghetti; Rosenquist paints the poster directly on the canvas, so that the spectator is literally facing the poster and its illusory method.

Having remodeled and clarified his image, Lichtenstein therewith establishes a new relationship between the image and the spectator before whom he places this image—this product of civilization. For the image is at one and the same time a woman (or sunset) and a mechanical artifice, an artifice and a form of language and communication, the sociological reality of a dream and the mechanical poverty of that dream. Lichtenstein thus speaks of sentiment and language and of their mutual relationships. His cool detachment creates a shock, produces an interplay, an overturning between the truth of the mechanical artifice and the falsity of the emotion—between the truth of the emotion and the falseness of its translation into image. Artifice and dream, image and language, this is what Lichtenstein speaks of, giving them a monumental grandeur which refers back to the human condition. He presents a purified and structured fact: This is how men dream and how they speak of their dreams. Love, glory, victory, force, comfort, art, travel, objects—such are the dreams that are unfolded in the papers and these dreams speak, revealing at the heart of life an emptiness which nothing but these illusory images can fill, images which, however, become true from the sole fact that men throw themselves into them. Subjective commentary would merely dilute the objective content of the facts. Lichtenstein therefore forces himself to look lucidly and to order his perspective so as to reveal the significance of one of the forms of our daily world. And here precisely lies the tragic element of his art, in the icy rigor with which he rejects any anecdotal relating of his own emotions.

Roy Lichtenstein's Period Style: From the Thirties to the Sixties and Back *Lawrence Alloway*

Through the period in which Roy Lichtenstein simulated comic books in his painting, 1961–65, other possibilities showed up sporadically and were not let go. There were, for instance, the whole objects, viewed

From *Arts Magazine* 42, no. 1 (September–October, 1967).

dead on, one at a time, scattered through 1961–63, and there were the references to other artists: Erle Loran's Cézanne compositional schema, 1962, Picasso in 1963–64, Mondrian in 1964. By the last year of the comics period Lichtenstein has considerably systematized his method of working, and instead of ranging freely, as in the earlier sixties, testing out the perimeters of his area, he began to paint in runs. The girls' heads of 1964–65, for instance, are all in close-up and all are elegant. The explosions, the sunsets, the seascapes, the brushstrokes (all invented), are done as sets between 1964 and 1966. One can describe the work either as being concentrated thematically or as being conceived in groups or sets, in which case the effect is of diffusion among individual works. The latter description is probably truer, because thinking and working in terms of a period is to be in an extended situation, as opposed to trying to squeeze everything into one knock-them-dead picture. The prints, banners, and multiples of Lichtenstein also point to an idea of diffusion, this time by stepped-up distribution.

Lichtenstein has revealed an increasing interest in three-dimensional form recently, at first mainly as a paradoxical accompaniment to pictorial elements. His ceramic sculptures of stacked cups in the same medium as the original objects (a sculptural first?) were colored in a thick handicraft way, and his heads of girls carried two-dimensional symbols for shadow and volume overlaid on real masses, so that the representational signs became decorative devices. Similarly, the explosions are ironic monuments, combining solid slices with pictorial images of flame and smoke. Referring to the "solidification" of sunsets and explosions, Lichtenstein observed, "Cartoonists have developed explosions into specific forms. That's why I like to do them in three dimensions and in enamel on steel. It makes something ephemeral completely concrete."* It is a VARRROOM forever. However, his new Modern Sculptures, though they have their double takes, do not depend on incongruities of graphic and plastic convention. The new sculptures autonomous but still charged with complex references, this time to the formal vocabulary, to the *style,* of another period, the thirties. His combinations of brass or copper with tinted glass, or of green and black veined marble with shiny metal, carry a period reference, as do the forms themselves, such as gleaming parallel bars, rounded corners, stepped forms, arcs partially buried in other forms. These are the same forms that he uses in his paintings, but hard and clear in a way that the earlier sculptures, stretched between allusive image and physical fact, were not.

It makes no difference whether Lichtenstein invented or copied particular comic-book images (he worked both ways), because a reference

* As quoted in John Coplans, "Talking with Roy Lichtenstein," *Artforum* 5, no. 9 (May, 1967). [*Ed.*]

to the general style of the comics is legible. (This is not something that will, as it were, dry out of the painting, leaving a pure formal structure for the ages to contemplate: popular references are easily accessible in medieval art, in Brueghel, in Hogarth, in Seurat, in the Expressionists, and are part of the meaning of the art.) The thirties function in Lichtenstein's new work, not as references to major monuments like Radio City Music Hall or the Chrysler Building, but as a style, the overall characteristics of which Lichtenstein uses on the terms of his own art. (The Picasso and Mondrian paintings are in the background here.) His pleasure in reference and annexation, in allusion and parody, goes back at least to his free paraphrases of nineteenth-century Western paintings which he did in the early fifties.

Today, the forms of the thirties have a particular meaning, both in terms of familiarity and of irony. The thirties have been, as Lichtenstein calls them, "a discredited area, like the comics"; on the other hand, they have become visible, even conspicuous again. Lichtenstein observed wryly of the period: "I think they felt they were much more modern than we feel we are now." Sustaining ideas of the thirties were the machine aesthetic and technocracy, which assumed a happy future as the gift of the Machine. A kind of Platonism of the production line promoted machine-made forms to the status of Pure Form. Although there were puritanical and exuberant versions of the machine aesthetic (Alfred Barr, for instance, stuffily deplored the "modernistic"), both extremes shared basic assumptions. The geometrics of the thirties, lean or splendid, are charged with idealism, but even the timeless dates. Thus the forms of the thirties are symbols of an antique period with a naïve ideal of a modernity discontinuous with our own.

The two attitudes to industrial design, one apparently rational, one apparently commercial and indulgent, are merging now, as can be seen by referring to a typical document of the period (for instance, the Museum of Modern Art's "Machine Art," 1934). Sections of wire rope are displayed like flower patterns and outboard propellers shine like Brancusi. Black glass cylindrical vases, chromium pretzel bowls, blackface electric clocks without numerals, cantilevered desk lamps are now not the logical form of good design but the record of somebody else's aesthetics, as much nostalgic as functional. These objects are merely the classy end of a spectrum which includes Horn and Hardart automats. The forms, therefore, that used to symbolize the machine and its benefits have changed their meaning to symbolize the taste of the period that produced them. The symbolic content has shifted from the original referent to the channel itself, where it has been located by Lichtenstein's serious ironies.

There are links between the sixties and the thirties as well as an irrevocable difference, and Lichtenstein's new "period" depends on the

double focus. For one thing, we live among its monuments and its detritus, from the dazzling Chrysler Building to a thousand run-down "swank façades" (Lichtenstein's phrase) stuck onto delis and bars all over the U.S. It is as a public style, perhaps (ball rooms in luxury liners, Hollywood homes, sets for musicals), and as threshold architecture (bar fronts, shop windows, hotel and movie theater foyers) that the thirties form sense received its most luxuriant embodiment. Especially the foyers of movie theaters are orgies of invention and inflection. The machine aesthetic was anti-handcraft and anti-nature, values which are, broadly, associated with Pop art. Hence, the industrial content of Pop art has a precursor, all ironies aside, in the thirties. The revival of interest in old movies (as movie history became public property owing to late-night TV and, maybe, film societies, too) amplifies the Pop culture of new movies. It is probably relevant to note that Lichtenstein's first full-scale play with thirties forms is his poster for the Fourth New York Film Festival (designed, summer 1966). Prior to this, however, he had made an unintentional thirties work, *This Must Be the Place,* 1965, a lithograph of the New York World's Fair treated in "a Buck Rogers way" in which he inadvertently "invented" various thirties clichés.

Thirties architectural ornament and industrial design, which are the sources of Lichtenstein's new densely packed abstractions, are diagrammatic, in their distinctness and repetition of bands, darts, arcs, fanned triangles, bisected discs, stepped forms, rounded corners, scooped planes, and zigzags. Details of these paintings have ironic parallels to minimal art, but, in addition to this correspondence, there is a battery of elaborate inflections. Forms are expanded, echoed, shifted, and bent before your eyes. It is the interlocking and crowded plane of these inflected forms that gives Lichtenstein's Modern Paintings their peculiar claustrophobic bounce, their stocky élan.

Lichtenstein has commented appreciatively on the "cartoonish" quality of much thirties decoration, and if one thinks of cartooning as something like "vivid reduction" the link to the rest of his art becomes clear. Miró and Picasso are relatable, he observed, to "cartooning," which he defined as "highly-charged subject-matter carried out in standard, obvious, and removed techniques."* He has recorded his liking for the "diagrammatic" property of Picasso and Mondrian. The cartoon (and caricature) is a route to the simplified, the strongly formed, and there is a comparable principle in Lichtenstein's reduction of color to four (blue, yellow, red, and a sparingly used green). "Anything that could be vaguely red becomes red. Actual color adjustment achieved through manipulation of size, shape, and juxtaposition."† This binary system for judgment of color intensity, with its semblance of programming, is sup-

Ibid.
†*Ibid.*

Roy Lichtenstein

ported by his even and unaccented drawing, which purports to be impersonal. He has even deceived people into thinking it is.

Lichtenstein's point of departure is usually a specific detail in a French, German, or American book or magazine of the period (either editorial or ads in the latter). Here are the prototypes of the linked and embedded forms, the stylization and the counterchange of his original paintings. These derivations are as active a process of organization by which to make art as any other. Among the material he has collected, which functions somewhere between reference library and sketchbook, is one that hits the mood of the thirties with particular aplomb, a promotional book, *52 Ways to Modernize Main Street with Glass*. Here are variant designs for curved plate-glass store windows, endless combinatory possibilities for Vitrolite, an opaque structural glass, which gives many thirties buildings their shine (the range includes "gleaming ivory" and "tropical green"). It was much used to clad lustrously the squat, blind, sign-bearing towers that push above drugstores, gas stations, and cinemas in sluggish celebration.

The specific origin of many Lichtenstein works does not give them the status of covert commentary on hermetic originals or closed-circuit jokes. He is engaged in total critical response to the thirties as subject, as artifact, that is not, in any sense, camp. It is more like doing the archaeology of one's own life and place. Lichtenstein's choice of source, and the "size, shape, and juxtaposition" of the forms in his works are accessible formally and iconographically. The formal features he uses are representative of the form-sense that permeates the whole period. Solid glass, multilayered ash trays, for instance, are often like models of a Ziegfeld or Arthur Freed set for, respectively, stately or animated chorus girls. In a film still of *Broadway Melody,* in Lichtenstein's possession, the mise-en-scène is an inventory of swank type-faces, and the smooth shading reveals the love of continuous graded planes that occurs in much thirties design and architecture. The positive-negative pattern of the girls' costumes echoes much jewelry and textile design of the period, and extends into their hair (dark on one side, light on the other). It is a handy example of the way people resemble their designs, a subject that Lichtenstein is about to develop in paintings of the human image in neoclassic streamline.

Roy Lichtenstein *Richard Morphet*

Common to the few major artists of any period is the gift of making accessible to the spectator, through the work of art, species of experience previously either unknown, or considered impossible to embody in

From *Roy Lichtenstein,* catalogue of an exhibition at The Tate Gallery, London, January–February, 1968.

the form of art, or which, while springing from the existing experience of art, operate now in so altered a context as to effect a radical rejuvenation of the language of the art itself. Roy Lichtenstein has made it possible to see afresh in these ways. Whenever his figurative paintings of the early 1960's were first encountered, the harshness of his imagery and the (seeming) lack of intervention by the artist between source image and finished painting appeared to many, at first glance, quite implausible as art. Yet this very unacceptability, by suggesting to the spectator that what a first glance had identified as the entire content of the painting could not possibly be all, was a means of directing to it a scrutiny more searching than any that more familiar idioms could provoke. The experience of contemplating imagery associated with one social and physical context (mass communication)—from which were derived the essentials of its style—in a context (the individual painting) with its own quite separate purposes and systems of seeing, revealed paradoxes and contradictions impossible to resolve. These were an important part of the paintings' power and were so insistent partly because of their unexpectedly dispassionate mode of presentation. Yet such was the immediacy of the imagery and so swift the ability to comprehend it (a particular circular configuration obviously representing a golf ball or a man in period clothes George Washington), that attention was inevitably directed also to considering what remained, after this recognition, in terms of painting. The surprising discovery was that each painting was a complex of shape, texture, color, and line of exceptional formal liveliness and drama.

While the total experience of a Lichtenstein must always involve an awareness of constant ambiguities as to the function and identity of the parts and the whole, one effect of these paintings was to pose and answer the quite basic question "What is the actual *appearance* of things?" The representation of a golf ball, for example, not only *resembled* a golf ball but *was* a remarkable arrangement of small arcs half-embraced by an ornamented black crescent. Designs of the force and strangeness in abstract terms that Lichtenstein gave to commonplace images were not to be found either in the avowedly abstract work being done in the United States at the time or in his source images. Nor had Johns and Rauschenberg, for example, in their immensely important preceding paintings, presented their imagery in ways that facilitated to such an *extent* the exploration of a painting as a formal experience detached from representational factors. Yet paradoxically it was with imagery more immediately assertive (because less apparently artlike) than theirs that Lichtenstein had made possible such temporary dislocations within the total experience of the painting. In a way analogous to certain dance forms of Merce Cunningham, he had produced works in which two quite distinct series of communication unfolded simultaneously—repre-

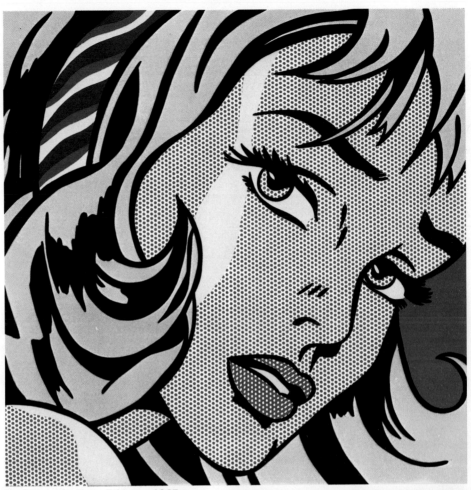

V. *Girl with Hair Ribbon*, 1965.
Oil and magna on canvas, 48"
x 48". Collection the artist.

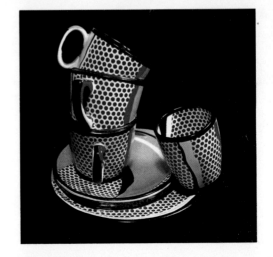

VI. *Ceramic Sculpture*, 1965. Glazed
ceramic, 8" high. Private collection.

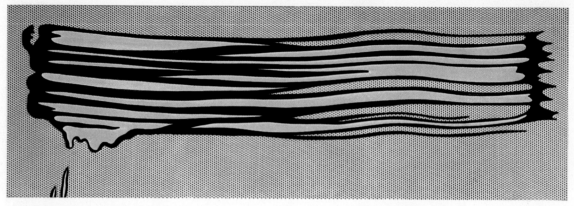

VII. *Yellow Brushstroke II*, 1965. Oil and magna on canvas, 36″ x 108″. Collection the artist.

VIII. *Modern Painting with Ionic Column*, 1967. Oil and magna on canvas, 62″ x 82″. Collection Mr. and Mrs. Gardner Cowles.

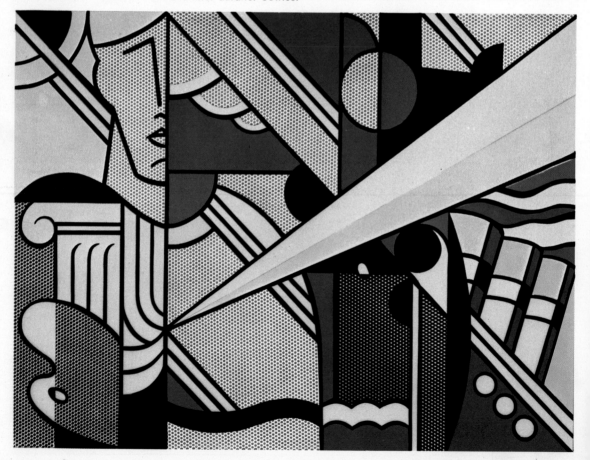

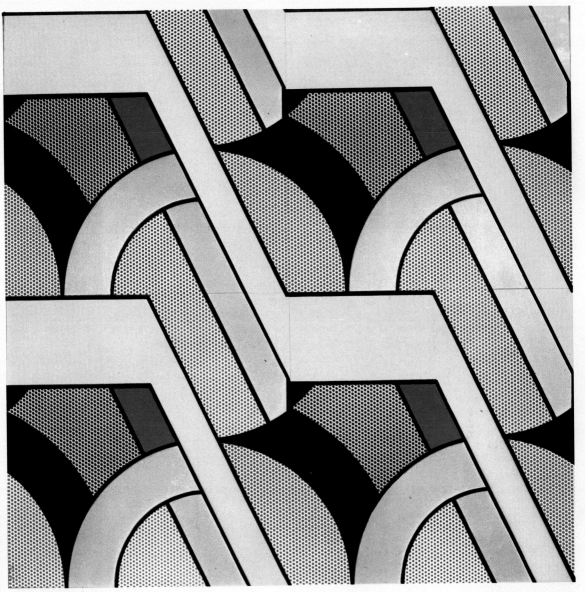

IX. *Modular Painting with Four Panels, No. 3*, 1969. Oil and magna on canvas, 108" x 108". Collection the artist.

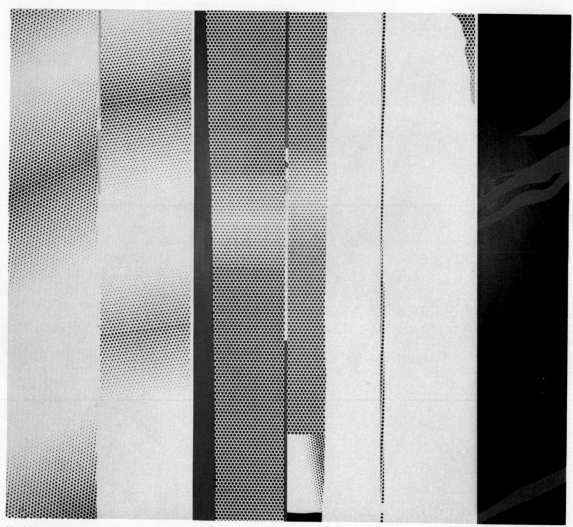

X. *Mirror (six panels, 120″ x 132″)*, 1971. Oil and magna on canvas. Collection the artist.

sentation information and narrative on the one hand, and on the other dramatic shifts of scale, color, shape, and texture, making another narrative. These had no point of contact except the strange and crucial fact of their being identical in substance; although such a dichotomy operates to some extent in all painting, in Lichtenstein's it became, through his handling and especially because of the scale and sheerness of his work, a major theme in itself.

The dispassionate exposure for examination of the simple elements composing a work of art has an emotional quality of its own, shared by works as otherwise dissimilar as those of Louis, Warhol, and Morris. In the situation of the very early 1960's, Lichtenstein's imagery gave so raw an impression as to delay or preclude a formal reading. But by 1968 one's first engagement with any of his paintings is as direct as an abstract exploration as it is in the confrontation with arresting images. If the truth of Lichtenstein's observation in 1963 that the "formal statement in my work will become clearer in time"* is already apparent, this is partly because of the consistency with which each painting before and since has revealed, beyond its diverting immediate impact, pictorial systems whose determinedly simple elements interact with a complexity highly relevant to the present state of painting as a whole. The look and the feel of a Lichtenstein canvas lead to this conclusion as much as his own emphatic assertions of a dominating formal concern. ("Once I have established what the subject matter is going to be I'm not interested in it any more"; "Once I am involved with the painting I think of it as an abstraction. Half the time they are upside down, anyway, when I work."†) Yet the peculiar importance of his contribution to the marked concern shown by artists in the 1960's with the fundamental ingredients of art, lies in the recomplication of the experience of painting which he brings about by marrying the formal potential of his material to the bold redeployment of preexisting styles and images. Each of his paintings thereby becomes an involved maze of experience in which to reach a position of apparent certainty always leads rapidly elsewhere.

Because the formal element in Lichtenstein's work is so inescapable, it is impossible for his imagery finally to play the uncomplicated and direct role that a superficial examination might suggest. The formal and the representational experiences of his work, impossible to disentangle, interfere with and qualify one another. The claimant character of his imagery may obstruct or delay the fuller investigation of his painting, or it may act, less fiercely but no less insistently, as a factor so limpidly stated and declared, complete in itself, that consideration of the process

* As quoted in G. R. Swenson, "What Is Pop Art?", *Art News* 62, no. 7 (November, 1963).

† As quoted in Bruce Glaser, "Oldenburg, Lichtenstein, Warhol: A Discussion," *Artforum* 4, no. 6 (February, 1966).

that produced it or of the painting's wider effects is repeatedly referred back to its level of understanding, its irreducible presence. More complex still, Lichtenstein deliberately creates the confusion of blurred distinctions (engendered by the instant readability of his imagery) between his images' roles in previous contexts and their functions now. These confusions, although the cause of misunderstanding of his aims when they are seen in isolation, have the positive effect of intensifying the quality of elusiveness common to all his work.

In Lichtenstein's work to 1965, it is the apparent slightness of the changes made between source imagery and finished painting that provides so startling or ambiguous an introduction to each work. In fact, the alterations made in the visual constituents of an image are frequently extensive, and even were this not so, the acts of isolating and enlarging, and the change of context, would alone produce something entirely new. These various carefully conceived and major acts of invention are the basic facts on which the complex effects of his work depend. Complexity is, however, increased by Lichtenstein's deliberate concealment of the degree to which he has been at work; thus the initial experience of his paintings of the early 1960's seems often to produce in the spectator as a sense of outrage that something which appears to him as a nonart entity previously complete in itself should masquerade as art.

By some, this outrage is felt with such intensity that the mental apparatus which normally relates a painting (regardless of type or quality) to the context of art is, however temporarily, put out of action. Lichtenstein is intrigued by the frequent tendency of people on seeing his work to regard the representation of an object as being itself that object. Thus, however absurdly, a canvas seven feet wide can be regarded as an actual comic strip, an adaptation of a Mondrian painting as identical with the work adapted, a brushstroke as large as a man as simply a single gesture of hand and brush. By a roundabout and accidental route, it is almost as though paintings when regarded in these ways were again able to take on the magical property of identity with the object represented, ascribed to religious images in Byzantium. This sounds, and is, ridiculous. Yet as Lichtenstein has himself shown, confusions are made, for example, not only between a painting, based on the stylized lines and shapes of a commercial representation of a frankfurter, and its original commercial representation, but even between the painting and the frankfurter itself. Such a confusion is especially curious since the forms Lichtenstein used in the early 1960's were so heavily stylized.* His own

* "I had been interested in the comic strip as a visual medium for a long time before I actually used it in a painting. This technique is a perfect example of an industrial process that developed as a direct result of the need for inexpensive and quick color-printing. These printed symbols attain perfection in the hands of commercial artists through the continuing idealization of the image made compatible with commercial considerations. Each generation of

Roy Lichtenstein

departure from the exact compositions of his sources in newspapers, comics, and magazines intensified this quality of stylization, producing in each work a dialogue on that level which inevitably tended to confuse rather than strengthen any first impression of a representational kind. Nevertheless, Lichtenstein's simplifications also convey so strongly the character of the original subject that formal experiences cannot actually efface it.

The insistent character of the particular situations represented (albeit at one remove) in his early paintings is only partly the result of their amplified scale or their blatant intrusion into a largely abstract milieu. For already at the stage of selecting his printed sources, Lichtenstein was guided by the wish for a final image of maximum compression in which literary and formal energy would coincide. ("For the war pictures and teen romance pictures . . . [I look for] material which seems to hold possibilities for painting, both in its visual impact and the impact of its written message. I don't think I'd be capable of making them up. I try to take messages which are kind of universal or, in a way, either completely meaningless or so involved that they become ludicrous."*) Lichtenstein's source images are themselves brusque simplifications, and he simplifies them still more. The circumstances or mood of their depicted content, already easily grasped, are made explicit by Lichtenstein's simplification. So pure and condensed a form of the figurative idea is produced that it has a directness and persistence not possible in the source image. Its embodiment in a painting makes the image yield varieties of experience separate from its figurative content. But these perceptions are forced to relate to the (otherwise totally unrelated) sustained intensity of mood that an image refined for conceptual economy imposes. The mood, in which irony invariably plays a part, can be of excitement, terror, violence, embarrassment, idealism, seduction, rapture, despair, or utopian domestic hygiene. The conjunction between this content and the painting's content in the wider sense is never more disorientating than when it brings into focus Lichtenstein's coolly ordered technical procedures and formal decisions through which his potent images took shape. The urgent sense of such a sentence as "I pressed the fire control . . . and ahead of me rockets blazed through the sky" comes across strangely when the letters equally convey refinement of handling and conscious elegance of shape.

Lichtenstein's essential concern is not so much with the clipping,

illustrators makes modifications and reinforcements of these symbols, which then become part of the vocabulary of all. The result is an impersonal form. In my own work, I would like to bend this toward a new classicism." [Statement by Lichtenstein in John Rublowsky, *Pop Art* (New York: Basic Books, 1965).]

* As quoted in Alan Solomon, "Conversation with Lichtenstein," *Fantazaria* 1, no. 2 (July–August, 1966).

painting, or paint marks he adapts, as with the *style* of an earlier representation or object, or the style through which it may be unexpectedly transposed. The end product, his own painting, thus necessarily puts greater emphasis on physical ingredients than on the giving of exact identifying information. Yet such is the persistence of the painting's representational effect that a disturbing confrontation is set up between the spectator's sense of the object identified and his perception of what is actually before him—a series of arabesques, perhaps, or an agglomeration of contrasting shapes in which it is difficult to find a point of stability. In the realization that nothing is what it seems, basic expectations are upset, an experience that provokes a greater receptiveness to unexpected sensations. One of Lichtenstein's most curious developments of this confusion is his sculpture of crockery, where the patterns, based on commercial artists' shorthand for the fall of light on cups, saucers, and plates, are disposed on actual tea and dinner ware. The result, almost illegible as either crockery or symbols for crockery, is yet quite patently both (and neither).

The representational force of Lichtenstein's work has stimulated an unfortunate tendency among European critics to separate discussion of it from its basic context—American painting since the 1940's—and interpret it as principally a branch of sociology or satire, as a series of comments on an affluent society. This misreading has continually dogged much Pop-associated work. Of course Lichtenstein's work, with its irony, its sense of tone and mood, and its involvement with forms of communication, does illuminate contemporary society, often making articulate, with a compact precision, states of feeling of which one had previously been implicitly aware. These insights should not be considered as divorced from the principal effect of a work, and Lichtenstein makes positive use of the fact that they make themselves felt inescapably. But the whole ambience and presentation of his painting ultimately declares that, however exotic or compelling the associations of an image, and to whatever extent a painter allows these to come through in his painting, the *use* of an image does not by itself indicate the nature of the artist's feelings about the subjects represented, or even imply that he has any feelings on the subject at all. Lichtenstein's own statements, in fact, repeatedly situate his endeavor in the context of painting rather than of social criticism. ("I'm using these aspects of our society . . . as subject matter, but I'm really interested in doing a painting."*) Obviously the presentation of a subject of intense emotional, dramatic, or associational significance, by a method with a quite different orientation, imposes acute problems of focus when assessing the real nature of the individual work. Lichtenstein's deliberate envelopment with ambiguity of a hard core of unalterable fact, and his relish for the obstacles that a painting

* *Ibid.*

Roy Lichtenstein

can itself contain to the discovery of its own essence, help account for the central role in his work of the principle of decoy.

Confusion of the painting with an earlier representation of its apparent subject, or even with the ostensibly represented object itself, confusion of style with substance, and the assumption that the intention of a painting is to embody the feelings its subject matter recalls, are not the only such diversions. Lichtenstein's paintings abound in curious surface correspondences, albeit ludicrously detached from their contexts, to the work of others. He has commented on the affinity with Hokusai of the lines in his *Drowning Girl,* 1963, as have others on the shapes that recall Pollock and Youngerman in his *Compositions II,* 1964. Some of his recent thirties-style sculpture almost parodies David Smith in the large-scale constructive wielding of shapes in space. *Non Objective II,* 1964, employs the scheme of a Mondrian painting for ends that ignore the aims of Neoplasticism,* while *Golf Ball,* 1962, locates brutalized versions of accents used by Mondrian in his progress toward abstraction to depict an intensely specific object. The disembodiment and irrelevance of these connections, combined with the fact that they are there to be observed, confuses reality yet again. Ultimately their very boldness and absurdity redirects attention to the pictorial elements in themselves. Lichtenstein might, however, be said to make use in his own terms of the insights of previous schools on a more fundamental level. To look no earlier, the eccentric disposal of formal incident across the picture surface shown by many Dada works and Dada's acceptance of visual and intellectual banality as a basis for art remain common factors, even though Lichtenstein does entirely different things with his material and in a contrary spirit. Surrealist art indicated the suggestive power of fluid shapes seen out of context, and even Abstract Expressionist approaches are recalled at several removes, not only in largeness of scale but in the (here transmuted) declamatory intrusion of each visual element in the picture area.

Perhaps the most powerful of Lichtenstein's decoys is the apparent slightness of the changes he makes between source image and finished painting. This deception, already discussed, creates the important con-

* "When I do a 'Mondrian' or a 'Picasso' it has, I think, a sort of sharpening effect because I'm trying to make a commercialized Abstract Expressionist painting, let's say. At the same time I'm very much concerned with getting my own work to be a work of art, so that it has a sort of rebuilding aspect to it also. So, it's completely rearranged: It has become commercialized because the style that I switch it into is one of commercialization. At the same time I recognize that this is only a mode or style, and it's not the truth of my own work because my work is involved with organization. I don't want it to appear to be involved in this. But the result that I work toward is one of creating a new work of art which has other qualities than the Picasso, or the Mondrian, or the Abstract Expressionist painting." [Lichtenstein in Rublowsky, *Pop Art, op. cit.*]

On Lichtenstein

frontation in his work between expectation and yield. The seeming obviousness of a Lichtenstein painting, to which its smooth finish adds the illusion that it was complete before it was started, masks another most important content of each work—the fact that the painting is the embodiment of Lichtenstein's process, and still more of a complicated act. Lichtenstein has described in detail how he executes his paintings. The paint, for all its lack of inflection, has a "placed" and laid-on quality that accentuates its distinctness from the canvas. It is true that it simulates to some degree, especially in the earlier work of the 1960's, the texture of the printed imagery to which it relates, but its eventual effect is to draw attention by its physical disposition to the process by which it reached the canvas. Thus once again the idea and experience the painting affords the spectator differ radically from his first experience of it.

In the complex and highly physical process thus brought to mind, Lichtenstein becomes as "lost" in the large area of the painting surface as were the Abstract Expressionists, while keeping a precise control in the forming of its autonomous shapes. The process emphasizes how Lichtenstein, in taking possession of his source imagery (in which in any case he makes significant alterations in detail), not only *renews* it, but is involved with his material in so immediate a way as to make each painting an entirely new and fresh creation. It is widely accepted by now that the styles and commercial-art idioms that provide Lichtenstein's subject matter are his "landscape" as naturally and validly as Provence was that of Cézanne, and as much his natural material as was elementary form for Malevich; it ought to be similarly recognized that the change he makes between "landscape" or material and finished work is equally fundamental. The fact that it is makes all the more significant the outwardly minimal extent of his alteration of source images in the early work, and, in the outwardly more "invented" work since 1965, the superficial subordination of the painter's role to the demands of preexisting styles. While the appearance of noninterference ranges from considerable to complete, the actual degree of independent creation is total. This gap between appearance and actuality, which is understated or disavowed, contributes vitally to the mood and force of Lichtenstein's work. Paradoxically, the spectator becomes involved with the intellectual and physical process of the painter by means of the apparently stark, unyielding, and unrevealing impact of his work.

Clearly, Lichtenstein's determination in 1961 to fly in the face of what seemed in the art situation of the time possible or "allowed," directly contributed to his paintings' presence, assertiveness, and poise. The sensational nature of the particular imagery he employed, while it creatively set in motion the decoys and shifts in level of experience already discussed, could not finally obscure the almost defiant simplicity, regardless of the subject represented, of selecting, simplifying, and

Roy Lichtenstein

actually applying to a canvas what appeared as merely a bald representation of some commonplace thing. The series of target and flag paintings commenced by Johns six years before, and Rauschenberg's exposure, for example, of his own bedcover on the flat surface of a painting, had been crucial departures. But with Lichtenstein not only was the conscious orientation more toward other artists' ways of insisting on the object, but its exposure in his paintings was more uncompromising—the bald existence of the unitary images he usually chose was accentuated by the abandonment of gestural or conventional painterly handling.

These qualities could not but be seen in the context of the still prevailing Abstract Expressionist styles of the New York School. The fresh impetus these styles had had till the early 1950's became steadily dissipated as they were more widely adopted. The direct encounter with paint as a substance, the vivid revelation of self often assumed in its use, the heavily dramatic (or delicately modulated) character of the paint marks, and the keen seeking for a strong if indeterminate illusion of space were approaches grown so familiar as to constitute (except in the hands of a few, often the earlier pioneers of these approaches) positive impediments to challenging aesthetic experience. To renew directness in this respect, it was necessary to establish new ground. Lichtenstein's neutral paint texture and his paintings' sense of preconception challenged prevailing ideas of the importance of materials and of self-discovery in the act of painting. The feeling of uncritical acceptance, the inescapable specificness, and the actual flatness of his images undermined the spatial premises of much current painting and *appeared* to abandon, by Abstract Expressionist standards, any quality of adventurousness.

Although it seemed to many in 1961 that this left nothing of worth, Lichtenstein was in fact opening whole new areas of aesthetic investigation; his paintings' very extremeness of statement in an unexpected direction was the means of *making visible* these new areas. It was particularly crucial, after the dream-associated imagery of Surrealism, and the qualities of abandon and casting off from fixed points shown by Abstract Expressionism, that Lichtenstein should make it be seen, however mundanely to a first impression, that whatever else it is, to paint is to put down forms on a surface, and to look at a painting is first of all to see those forms. An inescapable power could not help but attach to paintings that made evident such a bedrock recall to essentials, and this firm fact was the foundation for the superstructure already described of ambiguity and deliberate decoy. In particular with his flat paint surfaces and familiar imagery, Lichtenstein implicitly proposed—by contrast with Abstract Expressionism's open declaration of theme through substance—that a painting or sculpture might deliberately work

in spite of its limitations as to painterliness and in spite of its flagrant associations. Built-in contradiction has in fact emerged as one major theme of new work, figurative or abstract, painting or sculpture, throughout the 1960's.

Compared to general practice in the New York School in 1961, Lichtenstein's handling of paint was almost rigid in its impersonality and flatness. By the standards of his own subsequent work and of the general situation today, it appears rather freely drawn. In *Stove*, 1962, for example, Lichtenstein's pencil drafts are, obviously consciously, not entirely concealed. Even so crisply formal a work as *Large Spool*, 1963 (where the asymmetrical linear wedges disposed with a symmetrical feeling have ironic links with [Frank] Stella) has a hand-done appearance perfectly compatible with its taut presence and complex effects. The application of dots in 1961–62 was in general varied, a single expanse often containing specks as well as fat and smudgy dots, producing an unevenness evident to close examination. Seen now, in contrast to the immaculate sharpness of Lichtenstein's recent surfaces, the paint in these early paintings is striking evidence of the strangeness and thus the force of Lichtenstein's exposed isolation of such images at that date. His technique has always served immediacy of communication in his work; in tightening it since the early 1960's in response to the linked pressures of his work as a continuous development and of the general art context in which it occurs, he has fully maintained this quality; his early work, after several years, retains its directness undiminished through this same unity of technique with over-all function.

The ease with which naunces of texture, touch, and form in a Lichtenstein painting are now examined is a measure of the degree to which he has helped change our ways of seeing. It also reflects his direct affiliation with seemingly very different types of innovation in American and other art. Many of these links (which range from the environmental-theatrical events of Rauschenberg, Cage, [Steve] Paxton, etc., to the painting of Stella and from the sculpture of Morris to "funk" art) center on the searching examination of things as they are, yet equally on the fact that it is often in what is most seemingly self-evident that the greatest indeterminacy lies.

Lichtenstein's work compels consideration of things as they are partly through its insistence on the physical facts (consubstantial with his images) of the painting or sculpture. The range of industrial and commercial devices open to him makes possible, partly through fierce clarity of definition, an extraordinary variety of visual fact. The contrasts thus experienced in the progress of the eye across his work are eloquent in their own right, like some fantastic landscape, as much mental as tangible. In one painting, for example, attenuated fronds in a tall yellow channel with curious globular offshoots, on the left, contrast

Roy Lichtenstein

strongly in pace with the strangely shaped system of convulsed curves springing from one side and ending in the heavy pendant of the largest disc of all. These yellow areas, internally irregular though they are, frame an even expanse of small red specks, alternately eyeball-close and infinitely distant, in which float small jerky shapes. One of these, curved with two pointed ends, resembles a flying saucer both in shape and in the way it hovers, distanced in that its horizontal stripes are much more closely spaced than the wide gray ones they echo in the top right-hand corner. Here and there, fragments of solid dark colors suggest still deeper distances illogically glimpsed between the projecting brilliances of adjoining shapes. This strangely evoked topography is *Blonde Waiting,* 1964.

In organizing such subtle and complicated systems, Lichtenstein shows a highly original sense of adjacency and of the almost sensory interaction between shapes in pure terms of weight, interval, isolation, or interference. His concern here with basic physical sensations such as touching, flying, floating, accumulating, pivoting, is yet another fundamental that places his work squarely within the basic exploration of perception and analogy that unites contrasting idioms in art today. The assumed simplicity of his restriction to standard shades in each of a handful of "obvious" colors merely masks the precision and refinement he brings to these effects by most carefully calculating the detailed and over-all balance of each design: Congestion or spareness of detail could so easily create a matter-of-fact inertness.

Max Kozloff has rightly observed that in greatly enlarging popular images so that they can be read in these ways, Lichtenstein diminishes the integrity of the signs and objects that his images nevertheless so clearly outline. It is curious how often in his work disembodiment of this sort leads to experience which, though quite otherwise expressed, has odd correspondences with the experience disembodied. In the Tate's *Whaam!,* 1963, the drama of color, shape, and texture contrasts could hardly be greater. Both the letters "WHAAM!" which stream outward in sequence suggesting deep space, and the violent flattened color areas that form the explosion, bring attention back through their painted *autonomy* to the flat surface and the completely controlled means that put them there. The lettering that communicates one pilot's urgent thoughts is disembodied from meaning, to float gently in space (space not so much of sky as of yellow, blue, and black depths), but it equally denotes meticulous precision of touch. Yet the represented episode thus dematerialized is itself of extreme violence. Though drained of its original emotion by Lichtenstein's technique, its aesthetic effect has both urgency and vehemence on quite another level and mood.

The tendency of Lichtenstein's work always to return one to the physical elements of which it is composed is especially marked in his

seascapes, both kinetic, collaged, and in enamel (solid or perforated). Here the periods during which physical substance or abstract illusion delay representational reading are particularly extended. Yet the bluntness of the physical means seems paradoxically to yield more easily a sense of infinity (and this, strangely enough, simultaneously with the simple physical sense of material). Especially is this the case in the almost farcically simple and tongue-in-cheek kinetic seascapes. The elementary movement here of lamp or "sea" has a banality that parallels the cliché of the subject, yet the effect strangely goes beyond this to give unexpected and fresh senses of the movement of sea or the passage of time.

Almost every element in a Lichtenstein painting or sculpture of the 1960's is being put to uses not originally foreseen for it. Not merely transposed into an art context, it is made to work there in defiant opposition to the apparent nature of its existence. Much of this hinges on flattening which in turns sets up contradictory illusions of depth. The balletic formations in space within a flattened golf ball are a clear example, and the complexities of Lichtenstein's adaptation of pulp comic imagery have been mentioned. Still simpler imagery in no way reduces the wealth of paradox. In his horizontal brushstroke paintings, with conscious irony, Lichtenstein, by the act of flattening, makes the very object which most clearly adheres to the canvas float freely. In the "Modern" series of paintings and sculptures from 1966, he takes the popular decorative style of the thirties, a phenomenon which was most often an ornamental addition or clothing to essential form, and in destroying this role makes it the very structure of his work. He gives it this fundamental function while combining its elements in promiscuous permutations that superficially suggest a yet more purely decorative capacity.

There is a discrepancy between the immediate expectation of visual slackness aroused by each "Modern" work and the vigorous assertiveness actually discovered in its individual elements. One is drawn into a system that discloses, in place of whimsicality or superfluousness, the deployment into a coherent whole of parts whose very abundance and contrariness would seem to preclude unity. It is a unity, neither familiar nor obvious, that holds its difficult elements in a balance exact enough to give both sharpness and fluidity to the constantly transformed reading of the shapes before one. False starts are presented repeatedly to the eye and mind, temptations to read any given element in terms of an architectural and planar function which its lateral relationships swiftly deny. The seemingly mannered and gratuitous motifs that crowd together in fact carve up the logical surface of the canvas to yield disconcerting complexities of space and directional emphasis. In the sculptures the bizarre conjunctions of materials and the, at first glance, very

Roy Lichtenstein

casual, fragmentary associations of the form, lead unexpectedly to a strong awareness of any work as a number of individual parts each with a self-declaratory "personality"—jerky or fluid, linear or solid, swift or sluggish, reflecting or opaque—that tends to isolate it and to make still more strange Lichtenstein's avoidance of visual turmoil or excess for something taut and finely strung. Just as in the paintings from pulp comics, Lichtenstein is constructing in idiosyncratic for forceful abstract terms. He enriches their effect by the potentialities of both decoy and mood latent in associations outside art. He uses simultaneously two vocabularies—of objective constructive art and of eccentric abstraction. The strangeness of his creations in terms of either masks the real extensions he makes to art in terms of each.

Despite the brutality of their intrusion into the art scene, Lichtenstein's paintings of 1961 had a strong quality of poise, deriving not only from the calm selection and limpid presentation of "impossible" images but also from the refinement of his placement of images within the canvas area (a quality that obviously gains added interest from the lack of refinement of many sources). Running throughout his several transformations of style since 1961 is an extreme sensitiveness to the relation between pictorial components and the canvas edge. After the "simplicity" of early subjects where the ball of twine, for example, could hover so mysteriously or draped curtains could appear to lift themselves off the ground balanced by their nylon tips on the canvas edge as between two bars, there has been a tendency to engage the spectator more directly in the picture area by cutting off dominant formal elements at its limits. Lichtenstein seems to have been testing how far it was possible to go with various kinds of compositional emphasis, without disrupting a painting's finely judged effects.

Amid unitary, isolated images and the almost baroque spread of incident of paintings like *Live Ammo,* 1962, he investigated also the diptych form, of which his contrasting uses epitomize his continuous refusal, even in paintings of closely related character, to repeat a formula; the inner inventiveness of his output from work to work even exceeds the outer. The small diptych *Step-on Can,* 1961, explores the narrow borderline between dispassionate repetition and a lateral reading as sequence. *Eddie Diptych,* 1962, and *We Rose Up Slowly,* 1964, formalize and accentuate the contrast between a large image panel and a slender panel containing only a column of text; the text panel appears not as a subordinate appendage but as an important pictorial component. *As I Opened Fire,* 1964, actually a triptych, is perhaps Lichtenstein's most ambitious exercise in strangely uniting, visually (as well as figuratively) warring elements. In *Whaam!,* the largest diptych, apparent bald incompatibility between component canvases is more clearly presented than anywhere else, especially in the contrast between the

centralized explosion panel and the more irregular, more obviously truncated imagery in the panel containing an otherwise intact plane. Lichtenstein has observed in a letter (10 July 1967): "I remember being concerned with the idea of doing two almost separate paintings having little hint of compositional connection, and each having slightly separate stylistic character. Of course there is the humorous connection of one panel shooting the other."

As everything conspires to maximize the insistence and distinctiveness of every part of each work, Lichtenstein's output is impressively consistent with those qualities in late twentieth-century life that arouse his admiration or fascination—energy, precision, and clarity.* A common misconception about his work sees it as a simple acceptance of the world as it is. But in fact by making use of aspects of the world (so vivid and pressing in themselves as to be impossible to ignore) for aesthetic purposes, he brings into existence something new and surprising. Thus in the end, a Lichtenstein work, far from offering only swift and superficial experience, involves the spectator in a system of endless complexity. Whatever may appear to be happening in it, the attention is directed to contradictory activities within the same system. Whatever the point of entry, denial, illusion, and paradox are encountered. Each such element leads the spectator to another; indeed the process of paradox and dislocation is the means by which the full riches of each work are revealed. Form, image, and process contribute to the total experience their contradictory and, at moments, autonomous sensations, but separation of their essentially interdependent effects is not finally possible. To experience this makes plain that the apparent simplicity of Lichtenstein's work is, to say the least, creatively deceptive.

Anti-Humanism in Art
Paul Schwartz and Alain Robbe-Grillet

Paul Schwartz: *Your interest in the plastic arts would seem to parallel your perspectives in literature, or anti-literature. Would you agree?*
 Alain Robbe-Grillet: Yes. But all the same one must not confuse the

* "I'm interested in portraying a sort of anti-sensibility that pervades the society and a kind of gross oversimplification. I use that more as style than as actuality. I really don't think that art can be gross and oversimplified and remain art. I mean, it must have subtleties and it must yield to aesthetic unity, otherwise it's not art. I think that it's really a kind of conceptual rather than a visual style which maybe permeates most art being done today, whether it's geometric or whatever." [*Ibid.*]

From *Studio International* 175, no. 899 (April, 1968).

plastic arts with literature, surely. That is, it's not from the literary point of view that I take an interest in the plastic arts. I have done painting myself for a fairly long time: what one might call paintings in the vague sense of the word. That is, on the one hand, formal compositions with materials linked either to Pop art or to *sculpture concrète* with raw materials, *l'Art Brut*. I still say to myself that perhaps, later, I will suddenly take up what they call *les tableaux*. Do they still call them that?

It still sometimes happens. But are you continuing?

No. At present, you might say my interest is that of the spectator. But the participation of the spectator in modern art, in the plastic arts, is a creative one. One doesn't look at a Pop art painting in the way one looks at a painting by Rembrandt. It's as though the Rembrandt painting were finished, were closed upon itself, and as though there were no place for the spectator. While, on the contrary, for modern art as for the modern film the participation can be called formative. As though the indicated or the directly inscribed elements in the work had need of the spectator in order to live. The famous phrase of Marcel Duchamp, that it is the viewers who make the painting, this completely changes the rapport between the author and spectator, and this is just what contemporary viewers so often misunderstand. They misunderstand because they simply confront a work, and this is true in all areas of creation. The work needs them in order to be. This is one of the great problems for the plastic arts as for the modern cinema.

But in the plastic arts, what specifically interests you most?

In contemporary art I have been very close to the experiences of Roy Lichtenstein and of all that followed—which is to say, the integration in a plastic work of, on the one hand, the object belonging to an acquisitive society and, on the other, the images belonging to that society, for example, the comic strips—but, in fact, everything that can be included in some vague way under the name Pop art, without limiting it to a school in any precise way. And I have been, let's say, closer to that revolution than to the one preceding it, that of lyric abstraction. Yet, I've often been struck by the fact that even the creators of this modern art seemed to misunderstand the interest implied in their discoveries. I will try to explain why. In an interview that Lichtenstein gave to a French weekly—it was *La Quinzaine Littéraire,* I think—they questioned him about his conception of his work. And they asked: How were you led to inscribe comic-book images in your paintings? He replied: Well, struck by the lie that existed in the search for a depth of sentiment in lyric abstraction, I thought it necessary to restore a certain flatness. In other words, the flatness that Cézanne discovered, surely. It is vain to abandon it now. On the contrary, one ought to search out an even greater flatness.

Now, everything he said at that point was fascinating. Wonderful because he spoke about form, because he was speaking of plastic form. He said: I have the feeling that these flat images conform far more to what really goes on inside us, to what really goes on in our heads, than those false depths they are still trying to introduce into painting, in the name of abstraction: not flat abstraction as in Vasarely, but in lyric asbtraction.

Well, that's terribly interesting. But then they ask him: What does all that mean? Is there a meaning? In particular, is there a social significance? And immediately, he replies: Yes! And he begins speaking about the war in Vietnam, and he says: Look, I am aware that the Americans are not participating deeply in the idea of this war. There are deaths, there are Vietnamese dead, there are American dead, but for the people it all goes on as though they were comic-book deaths. They don't really suffer in any depth. What I show in my paintings is that state of flatness to which they are reduced, and in sum I show the level of abjection at which they exist.

What does that mean? It means that this flatness represents the critique of flatness, and that, consequently, when Lichtenstein and the other American artists have reformed American society, the people will understand that this flatness is—how shall I say?—an abasement of the human element. And they will be able once again to participate with all their heart in the world and will be able to paint like Rembrandt again. It would have no further interest. The experience would be finished.

In other words, if the experience really has to be limited to a superficial critique of society, which is in reality a humanist critique, a nineteenth-century critique, that has no interest. What is so striking is that almost all contemporary artists whose formal thought is very much in advance of their conceptual thought say precisely the same thing. When they ask Godard why there is blood in his films, he replies: It's not blood, it's red paint. Very interesting reflection. The red paint is flat and the blood exists in depth. He shows what can be rediscovered there in the way of a certain flatness of image. Then they ask him: Fine, and what does that mean? And exactly like Lichtenstein, he replies: Well, I want to show people in what state they are now, etc., the acquisitive society, the capitalist, and all that. Same story. Which is totally limited to a vaguely humanist critique, completely *dépassé*. Well, it's essential to situate these modern experiences in flatness, to find instead a true level having to do with a search for something future and not something retrograde in the way of an outmoded depth.

Yet, there may well be a plastic crisis occurring. An impasse brought about through an extreme limitation of means, especially conceptually.

But an impasse is a very good thing. Art has always been in an impasse. Only the boulevard is worrisome.

166 Roy Lichtenstein

Though an impasse can be dangerous as well.

Ah, yes! And danger is excellent for art.

I was thinking especially of the elimination of metaphor. For example, Minimal art, an art without references.

Yes, but at the outset I think it's quite simple. Metaphors are always humanistic. So that to reject metaphor is in the last analysis to fight against this completely *dépassé* humanism, this transcendent humanism, if you will. But I think one will discover subsequently a new sense of metaphor. And at that moment something will have been discovered.

Which implies an enormous shift in vision.

It does, in fact.

Almost biological.

Almost biological. Yes. Except for the fact that even those artists shackled by this transcendent humanism are going to continue to push further in the formal domain. Which is encouraging all the same.

There are those who see a future in Kinetic art.

Well . . . Kinetic art has principally impressed me in its decorative aspect. It may be important, but I am less sensible to it. This is not a critique. It's just further from my own sensibility. In any case, that is pretty much what I think about art today.

Roy Lichtenstein: Technique as Style *Gene Baro*

Lichtenstein's muse is the printing press and his inspiration the modern processes and conventions allied to it. Looking for an image, he found an arsenal of images in contemporary printed matter, particularly in cartoons and in advertising; these carried with them, from Lichtenstein's viewpoint, certain desirable qualities of rawness, simplicity, and aggressiveness. The qualities belonged not to the images themselves, but to the economics and techniques of their future. Lichtenstein, who is essentially a graphic artist, came to understand how the conventions that attach to commercial art as a result of its final dependence upon printing might be utilized to invigorate painting. The work of his maturity addresses itself to the problem of translating the formal idiosyncrasies of the one medium into the aesthetic formalities of the other. In Lichtenstein's painting, technique is transformed into style.

Am I slighting these images? I think not. Lichtenstein's way with subject matter, not subject matter itself, gives his work distinction. Choice of image is made meaningful by treatment, Lichtenstein's subjects being both uncomplicated and commonplace. In fact, Lichtenstein's imagery has a very wide range; technique, consistency, and

From *Art International* 12, no. 9 (November, 1968).

relatedness of treatment resolves the disparities. *Turkey* (1961) and *Modern Painting with Wedge* (1967) expresses a unified sensibility; using only small modifications of means, Lichtenstein achieves approximate effects. Time has refined but not radically altered Lichtenstein's approach.

In the late 1950's, Lichtenstein, like many other artists of his generation, was looking for an alternative to Abstract Expressionism, especially to its element of subjectivity. He experimented with the use of banal imagery in combination with then-current expressionist techniques. What he wanted was a cooler, harder, more remote effect than tachist involvement would or could accomplish. The issue was of sensibility, the wish to produce an art equally free of brutality and idealism, to respond to the *quality* of the visible world, especially to the impersonal energy of the urban environment, to reflect its brashness and brightness that nevertheless concealed a thousand subtleties.

In a television interview with Alan Solomon, Lichtenstein described his preoccupation in the late 1950's and the emergence of the style now associated with him:

I had the idea of painting banal subject matter of some kind or other, very standard cliché work; not the comic strips, but other things. It had just been in my mind for a while. I had done a few drawings involving ten-dollar bills, some things involving Donald Duck and Mickey Mouse a few years earlier in a sort of Abstract Expressionist context. That would be about 1957. I did a few drawings and things, didn't go too far with it, and continued doing a kind of Abstract Expressionism. I began again in 1960–61 to paint cartoons, still involved in a kind of Abstract Expressionist form of painting, using humorous or animated animal cartoons like Mickey Mouse and Bugs Bunny and things. I don't think the paintings were successful at all and I've destroyed most of them. But in '61 I got the idea of doing one fairly straight, where the painterliness which had been in my Abstract Expressionist paintings was no longer part of it, and the kind of texture that I would use would be the commercial texture of halftone dots and flat printed areas. When I did it I had no idea that anyone would be interested. In fact, I really felt as though no one in the world would look at these because they were certainly humorous and I was serious about them as paintings. A lot of people were very encouraging about it. Allan Kaprow was very interested in them and George Segal liked them; Bob Watts came over and saw them.

I was positive that no gallery would want to see them, possibly with the exception of Leo Castelli—and when I did take them there he was very receptive to them. I kind of doubt that anyone else would have been. He had apparently also seen, or within a very short time was to see—I'm not sure whose he saw first, as it was all within a matter of weeks—Andy Warhol's and Jim Rosenquist's work.

Roy Lichtenstein

The accidental character of the development is worth noting. Here, presumably, was one experiment among many; but it was the "right" one; it accorded with a taste already in formation; it propounded, for an important segment of opinion—one with avant-garde pretensions—an acceptable aesthetic; and it related, though superficially, to technical experiments, adaptations, and imitations of mass graphic media then also taking place.

What is clear is that Lichtenstein recognized what he'd got hold of. He didn't fool himself into thinking that he was commenting upon American society or making symbols of it. He saw that the conventions of commercial art, based upon print, took on an entirely new resonance, even an ambiguity, when applied as a technique for painting. The raw simplicity of commercial design—a function of the economics of the print medium—was both amplified and chastened by the augmented scale necessary to painting and by the kind of precision required at size for "impersonal" handling.

The insight may have owed something to prior work done by Jasper Johns and Claes Oldenburg, both of whom, in separate ways, had urged the ambiguity of the image-object relationship. Be that as it may. Lichtenstein's attack proved unique. He was able to develop a method of painting that approximated not only the effect of commercial printing, but some of its processes as well (for instance, through mechanical projection of the image onto the canvas; through stenciling, a mode of impression; through the use of Benday dots, a device of photographic printing; and through the limitation of color to primaries and complementaries with black, laid on in a predetermined sequence).

Lichtenstein's desire to establish a fine-art aesthetic based upon a mechanical process for the mass production of information and commonplace imagery involved him in paradox. He must seem to imitate, but in fact not do so. Initially at least, it was necessary to use a commercial subject matter, to get as close as possible in external feature to an original, so that the inner transformation, the formal reconstruction and refinement of the whole, underlying the surface effects of brashness and banality, would gradually assert itself. In short, Lichtenstein aimed at an impact art whose blatancy and subtlety of effect would at length be understood to belong to a unified formal visual statement.

In their original printed state, Lichtenstein's models had a specific function. They supplied minimal visual information in the context of advertising or cartooning. They symbolized an object or they objectified a narrative. They might be vulgar, in oversimplifying and coarsening the thing or the action pictured, but they were not banal. It was only when they were projected as fine art that these images developed the potency to shock.

People who would not be troubled by the sight of a ball of twine or a standing rib roast in the pages of the newspaper, people who read the funnies with satisfaction on Sunday, were suddenly disturbed at the look of these things translated into Lichtenstein's paintings. There, they seemed larger than life-sized (they had in fact been smaller than life on the printed page). Their "presence," expressed as large simplicities, enforced a sense of emptiness. Meaning appeared to lie in the things pictured. But was this possible? Art is serious.

Too much associated with their models or with the original objects depicted, the paintings remained invisible—until, of course, their means impinged, however unconsciously, upon the feelings of the observers. It then became comfortable to experience Lichtenstein's art in terms of its structural essentials: elegant drawing, sensitive scale, two-dimensional space, decorative color, balanced composition achieved through the interaction of line, flat colors, and implied textures. With Lichtenstein, the stylized vocabulary of commercial art, dictated by the economics of printing, formed the basis for a new pictorial language that made description and decoration indistinguishable. Freed of their function, the printing devices could be deployed to unify or to ornament a composition, to be its ingredients or to adjust its mood.

Drawing forms the basis of Lichtenstein's painting. Probably, this reflects a natural preference; but drawing is also a requirement of the developed method of work. This is perhaps especially true of the paintings based upon one or more models. Lichtenstein's initial problem in this work was to react freshly to the image he wished to adapt, keeping as close as possible to the appearance of the original while investing it with a new feeling. This new emotion or aesthetic appeal—no drawing is free of this claim on feeling—could then be disguised or submerged by the subsequent stages of composition, for Lichtenstein's aim was to realize "impersonality" as an effect of the painting. If he had desired an impersonal result, instead of the mere appearance of one, he would have repeated the subject mechanically. The impersonal look is necessary to Lichtenstein's painting; allowing the observer to penetrate it, to sense the delicacy and strength of the controlling aesthetic imagination, is even more important. Without this sort of resonance (and without some other communicable function), the images would really be banal.

Lichtenstein is worth quoting at length on his methods of work and attitudes toward it, for certain strengths and difficulties are then readily revealed. In an interview conducted by John Coplans,* Lichtenstein was asked how he did his painting. He replied:

* "Talking with Roy Lichtenstein," *Artforum* 5, No. 9 (May, 1967).

I just do them. I do them as directly as possible. If I am working from a cartoon, photograph, or whatever, I draw a small picture—the size that will fit into my opaque projector—and project it onto the canvas. I don't draw a picture in order to reproduce it—I do it in order to recompose it. Nor am I trying to change it as much as possible. I try to make the minimum amount of change. Although sometimes I work from two or three different original cartoons and combine them, I go all the way from having my drawing almost like the original to making it up altogether. It depends on what it is. Anyway, I project the drawing onto the canvas and pencil it in and then I play around with the drawing until it satisfies me. For technical reasons I stencil in the dots first. I try to predict how it will come out. Then I start with the lightest colors and work my way down to the black line. It never works out quite the way I plan it because I always end up erasing half of the painting, redoing it, and redotting it. I work in Magna color because it's soluble in turpentine. This enables me to get the paint off completely whenever I want so there is no record of the changes I have made. Then, using paint which is the same color as the canvas, I repaint areas to remove any stain marks from the erasures. I want my painting to look as if it had been programmed. I want to hide the record of my hand.

Here is a procedure designed to insure integrity of surface. From painting to painting, a Lichtenstein will have a particular panache, the consequence of method. The devices that mimic the print medium, arbitrary in the paintings, will also be more obtrusive there. The work may look programmed, but its dependence upon drawing is obvious. The color will seem to be coloring, and we are reminded of the distance between printing and painting and of the clear relationship of drawing to the one medium and of its arguable relationship to the other.

The surface of a Lichtenstein painting is part of its vital strategy. So to speak, it is the deadpan element in which the pictorial drama takes place. The surface, neutral itself, *contains* the apparently crass image along with the subtle devices of composition, scale, line, flat shape, color, and implied texture that transform it, establishing the whole as art.

In short, the standardization of surface serves a standard strategy. Until 1966, we were asked to look at Lichtenstein paintings in pretty much the same way, though the landscape and brushstroke series (1964–66), it must be admitted, offer important deviations, principally a shift in feeling away from grossness characterized by the earlier cartoon paintings. There is no overlap. The Lichtenstein *Girls* (1964–65) force the image, playing it against stylistic refinements—the older strategy. The landscapes and brushstrokes, anticipating the exploration of the images and devices of 1930's decorative style, are themselves already more decorative, more stylized.

The more decorative Lichtenstein's paintings are, the more integrated they tend to be, the more unified in effect. In the recent paintings, the potency of the image is almost wholly a consequence of the formal structure (for instance, in *Modern Painting with Two Circles,* 1967); the quality of the surface is consistent with the pictorial experience; nothing works to complicate the viewer's response. Here, Lichtenstein's typical devices are used directly but discreetly; such associations as there are develop from the image, conceived as a stylistic sum, and not from this or that technique. Looking at this painting, we do not think of printing or cartooning, of Benday dots or any other subdivision of facture. As always with Lichtenstein, the drawing element is notable, but even drawing is chastened here, a servant of the full conception.

In contrast, the paintings of a few years earlier bristle with ingenuities. *Tex!* (1962) evokes cartooning and suggests printing, but really means to establish the opposite, that this is a painting, after all, and a piece of fine art at that. Here, the dependence upon drawing is emphasized; several drawing styles are used, pointing here and there in the realm of art. In this connection, the complexity of the explosion is worth considering (Lichtenstein likes to give shape to the visually formless phenomenon, to stylize the unfixable visual event). The composition is an elaborate system of oppositions, dynamic reversals, and balances.

It might be thought that the relatively simple appearance of *Modern Painting with Two Circles* results from its being nonrepresentational. In fact, this quality flows from conception and not from subject. With Lichtenstein, refinement of means is not a function of elegance reference but of decorative insight (see, for example, *Black and White Sunrise,* 1964, *Dawning,* 1964, and the untitled sunburst of the same year).

From the beginning of his stylistic self-discovery in 1961—and probably for long before, though there is not a body of prior paintings available to prove it—Lichtenstein's decorative sense has been of the first importance to him. It provides the discipline he imposes upon the visual world. It is an instrument of self-criticism, in part intuitive, in part rational. It is a guide to order, and Lichtenstein, of all the arrived artists of his generation, has been most faithful to pictorial order and meticulous in bringing order to bear upon his imagination. Thought of in this way, he is a natural conservative.

Lichtenstein has been fascinated by visual form as a kind of language—not as symbol but as information or emblem. His awareness that contours, shapes, and textures have a communicative emotive content, and even carry a charge of cultural meaning, has allowed him to enrich his designs and to give the decorative element in his work unusual substance. This interest, rather than an explicit social or political

Roy Lichtenstein

one, has often dictated the choice of Lichtenstein's imagery. But also, he has been conscious of how artistic means have been used in contemporary society and what ends they have been made to serve. He has sometimes chosen to push a particular contention forward, to exaggerate and dramatize it. For instance, he has emphasized, in one phase of his painting, a highly charged subject matter—love, war, or another form of violence imagined or implied—and expressed this material in a standardized, impersonal technique. In short, he has intensified the difference between manifest charged content and convenient mechanical means that is characteristic of cartooning. In another phase, his paintings based upon paintings, he has simplified and reduced, changing essentials and exploiting the paradox of appearances. Here, again, it was perhaps the nature of printing that provided some of the inspiration so-called.

Whatever the source of the visual problems dealt with in Lichtenstein's paintings, whatever the arguments they propose, their ultimate rationale is aesthetic. No theory or program or technique or comment is allowed to interfere with a final visual synthesis or to dominate it. The artist's interest is in an equilibrium of all the forces and means he controls. Lichtenstein has said he would like his work to have the appearance of being programmed; actually, he is concerned to program the viewer's responses.

Lichtenstein's aesthetic standards may be thought of as eclectic. Certainly they belong to the past as much as to the present. For instance, he composes in a largely traditional way, but despite his use of routine methods of fracture in the service of a strictly compositional result, he can be said to *discover* his painting in the process of making it. Only the tracks of the lucky accident or the sudden insight will be eliminated. At the same time, the covering of all personal tracks and painterly marks is his rule, a position he shared with painters of very different general aims. He participates, too, in the regard for flatness—the insistence upon the two-dimensional picture plane—that has been part of the avant-garde aesthetic for some time, but his ideas of pictorial space owe more to Cubism (or to the Japanese woodcut) than they do to the current practices of American color abstraction. Often for him, the pictorial rectangle is simply an area in which the requisite illusions are created. Light and dark, mass and line, positive and negative space, color and texture—these elements in relationship are the Lichtenstein painting. Scale—the really personal ingredient—often elevates an otherwise mundane arrangement.

The decorative strain in Lichtenstein's painting provides much of its virtue. To put it another way, decorativeness renders both Lichtenstein's method and matter original. Frequently, it is an understanding of the expressiveness of shape and pattern (see *Aloha,* 1962); sometimes

On Lichtenstein

it relates to the sheer verve of the drawing (see *Ball of Twine,* 1963); in other instances, it combines the two and adds that special sensitivity to texture that is part of Lichtenstein's power over the print medium (see *Duridium,* 1964). There is also a certain decorativeness to be found in the purity or severity of Lichtenstein's reductions (for instance, in his comment upon Picasso, *Femme d'Alger,* 1963) or where his pictorial format receives precisely, but with our having the sense of augmented scale, the illusion of the object (see *Compositions I,* 1964).

He has been successful, too, in establishing objects as real while treating them illusionistically. Notably, this has been in his ceramic pieces (*Ceramic Sculpture I*—cups and saucers, 1965, and *Blonde I,* 1965). There, three-dimensional forms have been treated descriptively as if they were in two dimensions. The formal illusion imitates and also modifies the lateral shapes (of which it has become part); the sense of the whole is of decoration enhancing and animating the matter of fact, of two experiences proposed as one.

Lichtenstein enters his best work as a disturbing presence, a dislocation of some kind, a delayed effect. He is the element—the visual element—that prevents the work from being impersonal, though it must seem so. His manifestation may be in wit, in emergent pattern, in exquisite refinement, in formal paradox. He is capable of enforcing his personality upon work that does not come directly from his hand but that is the application of his conception. I say capable because it does not always happen. The ceramic pieces are by way of being an exception. Some of Lichtenstein's graphics, for instance, are conceived in terms of print and of material and have the desirable subtlety and authority. With others, Lichtenstein appears to be imitating the idiom and multiplying images associated with him. This work is not far off commercial art. A recent *Time* magazine cover of Robert Kennedy was just that, neither better nor worse than others one might point to almost without looking.

In general—with the exception I have just named—Lichtenstein's three-dimensional pieces and free-standing sculptures seem to me to be lacking the personal element I have referred to. They are merely ideas made visible. The Explosions (see *Explosion I,* 1965) are clever; the sculptures involved with 1930's style don't add anything to our understanding of the original idiom; in fact, they make explicit what was nuance and implication in the original decorative features (see *Modern Sculpture,* 1967).

Sculpture, anyway, goes contrary to Lichtenstein's visual intelligence, which is profoundly sensitive to shape and pattern rather than to form, to space as an expression of area rather than to space as an inversion or interruption of mass. His remarkable achievement has been to bring the page to painting, and to make a subtly expressive and brilliantly decorative painting style out of techniques associated with print.

Roy Lichtenstein: Insight Through Irony
Nicolas Calas

Lichtenstein is a merciless critic of illusion, both cultural and aesthetic.

In 1951 (thus two years before Larry Rivers), he undertook to re-interpret *Washington Crossing the Delaware*. As he was to say many years later, he has always had an interest "in a purely American myth-ological subject matter."* Lichtenstein was temperamentally unsuited to rework pictorial themes, either in terms of expressionist distortion, as Larry Rivers excels in doing, or in terms of complicated syntactical re-constructions, as did the Cubists. Lichtenstein re-forms to clarify. The twentieth-century great masters of clarification are Matisse and Léger. Matisse, borrowing from a conventional Persian miniature, made com-positions which focused on the interplay of figure and ground. Léger was at his best when he clarified in order to glorify the worker as the hero of industry. Lichtenstein clarifies in order to criticize: "I want my images to be as critical, as threatening, and as insistent as possible," he said to Coplans. His interviewer then asked, "About what?" and Lich-tenstein replied: "As visual objects, as paintings, not as critical com-mentaries about the world." He adopts "a detached impersonal handling of love, hate and war" and believes "the closer my work is to the original, the more threatening and critical the content."† It follows, it would seem to me, that only a work which touches upon a myth whose validity is accepted by the viewer, could be threatening. A viewer im-mune to the values inherent in the myth would remain insensitive to the threat.

Through an intensified and perfected promotion of a set of cultural patterns in behavior and taste, comics and ads came to be viewed as the raw material of a new iconology. How upsetting the image of a frankfurter that is both so similar and yet so unlike the one heroized by the ad! How threatening the image of a Greek temple which looks so harsh in comparison with the original hanging in a Greek restaurant or on a poster of a travel agency. Lichtenstein is quoted by Coplans as saying: "an Oldenburg Fried Egg is much more glamorized merchandise and relates to my ideas more than Johns's Beer Cans."‡ While Olden-burg re-forms to distort expressionistically, Lichtenstein prefers elegant

* As quoted in John Coplans, "An Interview with Roy Lichtenstein," *Artforum* 2, no. 4 (October, 1963).
† *Ibid.*
‡ *Ibid.*

poses. Dali's photographer took an unfair advantage of this by making Lichtenstein, unknowingly, adopt a Beardsley pose. Dali excels in elaborating half-truths. Lichtenstein is not, as he claims, the Beardsley of our day; Lichtenstein remains much closer to the cartoons than Beardsley did to the Japanese print. Beardsley wanted to seduce and pervert, not to threaten and criticize; he belonged to fashion, Lichtenstein transcends fashion. He blocks the way to total identification with the original by simulating the photoengraver's dots which, on the printed page, can only be seen through a magnifying glass, and identifies the finished product with the process of reproduction. In other words, the Benday dots are to the painting of Lichtenstein what the brushstroke is to Abstract Expressionism: an image of process.

A key image for the understanding of Lichtenstein is his series of paintings of brushstrokes made to look as much like a Hokusai version of a brushstroke as Kline's were made to look like bona-fide action painting. In his interview with Coplans, Lichtenstein points out that "the very nature of the brushstroke is anathema to outlining and filling in as is used in cartoons." To the erratic and idiosyncratic tracings of the expressionist, Lichtenstein opposes the standardized image or "stamp." He is closer to the stamp collector who is on the watch for imperfections in a stamp, but unlike the latter who prizes the defective specimen, Lichtenstein re-forms it, as his purposes are not identical with those of the original designer: The illustration in the comics is meant to be seen in a narrative sequence, while his purpose is to unify.* To unify, he has to clarify, which he does by flattening figure and ground in what might be called an artistic re-evaluation of the industrialized reproduction. It was Mondrian who unwittingly provided the basic rules for mass reproduction. Lichtenstein may well have deduced that with Magna colors a red or a blue can be made as impenetrable as black and therefore could be treated as line.

Unlike Mondrian, who structures his paintings on fundamentally cubist principles, Lichtenstein abstracts by emptying the figure and the ground of all "useless" elements. For instance, in his version of *Girl with Ball* (1961), the girl's nose has been reduced to two dots for the nostrils, her teeth to a white arc, the horizontal line between chin and mouth was omitted, the arms left jointless. Lichtenstein abstracts by subtraction. He is a master of the inverted close-up, for the closer our scrutiny the more abstract the figure appears. The image is often thematically incomplete, since it has been lifted from its context. Unlike the narrative illustrator who follows a time sequence, Lichtenstein conceives in purely spatial terms.

Lichtenstein's paintings may be considered as aggressive and threatening by the Andrew Wyeth kind of realist and by the minimalists. To

* G. R. Swenson, "What Is Pop Art?", *Art News* 62, no. 7 (November, 1963).

Roy Lichtenstein

the event depicted by the realist, he opposes the interrupted event and to the primary structure, arbitrarily chosen representational elements.

Through with the comics, Lichtenstein took on reproductions of modern masterpieces, for those too, as he correctly observed, form part of the popular myth. I think he has failed with the Cubists, especially with Picasso's *Woman with the Flowered Hat*. A convincing clarification of this portrait would require the dissolution of Picasso's complex fusion of the two poses. Lichtenstein's version is an unconvincing structure with an awkward figure-and-ground relationship.

Lichtenstein proved eminently successful with his series of landscapes. In his *Temple of Apollo,* he froze the atmosphere by reducing the sky to a field of blue with white Benday dots and contrasted it to the sea—a field of white and blue Benday dots. Against this background, the ruins of the temple seen from the vantage point of the single standing corner formed by the columns look harsh; and his mercilessly black shadows that fall upon the temple are as aggressive as the sun projecting vivid yellow upon the foreground. What a relief to have an artist kill that local color of romanticism that glows on all the advertisements of Greek and Roman temples.

From skies with temples or with sunsets, Lichtenstein turned to reproductions of Monet's cathedrals and haystacks. These are among his finest works. The mechanics are not easy to unravel, based as they are on a clever interplay between screens and dots. Thus, the bright color, whether screen or dots, corresponds to the bright sections of the cathedral while the black dots and the dark areas—screenless—indicate the somber part of the edifice. Through an interplay of yellow dots on black ground and black dots in yellow screen, a Neo-Impressionist blur is achieved which approaches the haziness and diffusion of light Monet obtained with his brushstrokes. In other versions, more complicated, a white screen with both blue and red dots is used to achieve a purplish haziness, presenting the edifice in varying light. With the relative instability of "microelements," Lichtenstein approximates the atmospheric effects of Pointillism. Undoubtedly Lichtenstein has carefully studied the technique of the Op artists: While the latter use pattern as subject matter for kinesthetic effects, Lichtenstein, like Seurat, resorts to Pointillism to create an image that is new.

Having made his critique of Abstract Expressionism through his reappraisal of the comics, Lichtenstein leveled his sights on Minimal art through a re-examination of the modernistic designs of the thirties. Alloway, the first to draw attention to the significance of Lichtenstein's work of this period, quotes the artist as saying that the forms of the thirties are "a discredited area like the comics."* As is well known, the

* Lawrence Alloway, "Roy Lichtenstein's Period Style," *Arts Magazine* 42, no. 1 (September–October, 1967).

modernistic was frowned upon by purists such as Le Corbusier, Gropius, Ozenfant, and also Alfred Barr. However, for artists of Lichtenstein's generation, Art Deco has a fascination akin to that Art Nouveau had for Dali and the Surrealists. Unlike Art Nouveau, whose soft forms and herbal motifs evoke the vegetative aspect of life we associate with sleep, dreaming, opium, Art Deco with its aggressive angles, metallic and plastic surfaces provides a dynamic image: that of mass-made massif furniture, often inexpensive-looking but expensive furniture and decoration intended to glamorize lobbies of movie theaters. As Alloway remarks, "we live among its monuments and detritus, from the dazzling Chrysler building to a thousand run-down 'swank façades' (Lichtenstein's phrase) stuck into delis and bars all over the U.S."

A number of these mementos have been remodeled by Lichtenstein into flat sculpture, horizontal or vertical, mostly in brass, occasionally with mirror. These are reminiscent of the flat sculpture of artist-workers welding, painting, polishing steel with industry and for the glory of art.

Some of Lichtenstein's Art Deco paintings might be traced back to Kupka's works, such as *Black Wheel* (1929) or *Hot Jazz* (1933). Lichtenstein's *Modular Painting with Four Panels #2* is a *tour de force*. The four panels are not just a repetition of four modulars, for together they form two large central discs which divide the picture vertically in two. When we focus on the discs and mentally subdivide the painting we are faced with a contradiction, for the discs are but the effect of an optical phenomenon. The composition has to be re-evaluated as an indivisible whole, for the borders of the over-all square are not interchangeable. The picture is a feast to the eyes. The combination of vibrant colors with soft colors—dotted or screened—is most satisfactory. No artist today knows better than Lichtenstein how to use complicated design to enhance color. But for myths, the pyramids would not have been erected. Lichtenstein sees them in the context of the tourist myth. His painting *The Great Pyramids* is an exercise in funny geometric forms. They make the pyramids look like an overturned ziggurat. Tourists would have to come to New York to see that!

The Glass of Fashion and the Mold of Form
Elizabeth C. Baker

Roy Lichtenstein's new paintings based on mirrors show that he has taken on another broad challenge—that of abstract, invented forms. The Mirror paintings are close to being total abstractions. Nothing recog-

From *Art News* 70, no. 2 (April, 1971).

nizable is "reflected" in them, but their surfaces are broken into curving shards of "light" or angular refractive complexities. They are, in effect, elaborately composed pictures of reflections of air.

The Mirror series began more than a year ago, in the fall of 1969. It overlapped with the bursting baroque style of the big figure works, with their Art Deco imagery in mural scale and their contained energy which was tremendous, even ominous. The Mirrors, by contrast, are limpid, expansive, cool, open, the opposite of impacted—they evoke space, light, and transparency. They are a deliberate attempt by Lichtenstein to develop his familiar, commercially derived vocabulary in a direction which is both more abstract and more pictorial than any work he has made before. The mirror theme is a brilliant choice; it enables him to unleash a new range of inventive bravura, a heightened exploitation of spatial effects, and a new freedom in suggesting illusion.

These are such subtle paintings that they invite consideration as formal entities quite apart from Lichtenstein's usual dosage of ironic, dislocating, sly, or "culturally debased" subject matter. Although he is handling much visual complexity, he also seems to have undertaken an almost neoclassic purification of his style.

However, it would be simplistic to conclude that he is really foresaking his famous penchant for loaded subject matter. The Mirrors are, of course, ambiguous in many ways: The emotional impact, the enigma of a blank mirror, is always present. But these works are so concretely realized in terms of the translation into immediate, physical, elaborately coded visuality that the connotations of the "nothingness" depicted cannot possibly be considered as either metaphysical, symbolic, or Surreal.

The general feeling in the recent past has been that tough, even nasty, subject matter is an essential counter-irritant to Lichtenstein's sophisticated art-history references and the elegant niceties of his style. The Mirrors would seem to be almost entirely without this perversity. Their compositional virtuosity might indicate a settling into neo-Neoplastic or purist concerns. Yet Lichtenstein resolutely remains impure. It is too easy to deduce that he has belatedly set himself up in competition with 1960's abstraction—in a sense, he has been doing that all along. While the new paintings signal ambition and daring in throwing such weight to the formal side, they are certainly not devoid of other kinds of meaning. The current nostalgia-binge in the mass media may have spurred him to move away from cultural specifics for now. At the same time, his alertness to the current art situation suggests a likelihood that he sees abstract art at this particular moment as having overtones of being "culturally debased." Formalism per se may be turning into a danger area. (The recent uncertainty in the work of a number of '60's innovators, as well as the strenuous efforts to be "post-aesthetic" of

many younger artists, corroborate this.) The whole formalist enterprise for Lichtenstein may be slightly, and desirably, taboo. All of which is not an implausible extension of his earlier "use" of Abstract Expressionism. In any case, in the Mirrors, it is likely that he is interested in both the abstract potentialities of his own style and "abstraction" as a subject.

During the '60's, he was isolating, cataloguing, categorizing, commenting—selectively disinterring and preserving recently discarded and eminently perishable phenomena. Along with this went a tendency to make work more and more openly involved with aesthetic tradition. Now there is a change of emphasis that is significant—if not in kind, in degree. The Mirror subject matter dictates fewer of the paintings' elements than ever before.

A mirror presents a virtually endless range of possibilities for visual transcription, all the while retaining its identity. Therefore, the artist is faced with a maximum number of plastic decisions within the scope of the elements of his style.

The Mirrors retain "period" specifics of sorts—the '30's mood of the preceding Art Deco series persists. Circular, oval, or tall multiple panels making up larger aggregates—the shapes evoke 1930's movie-star dressing tables or faceted walls for some classy boudoir. There are 2-foot circles, 3-foot circles, plump 5-by-4-foot ovals, attenuated 6-by-3-foot ovals, as well as other sizes. The multipanel rectangles are mostly very large; one of them is ten feet high. It will be remembered that an actual tinted mirror was introduced into one of the earliest of his Art Deco works, the 1967 *Modern Sculpture,* and that the mirror-finished metal characterized his subsequent sculptures in this vein.

The specific source for the "imagery" of the mirrors is the schematic denotation of reflections and highlights derived from cheap furniture catalogues or small glass-company ads. However, the distance of Lichtenstein's illusory Mirrors from their sources is so great that the interest is frankly elsewhere. Any tacky connotations (formerly to be cherished) are now dissipated in the paintings' final fastidious grandeur.

Lichtenstein's work has had other abstract phases—the cut-out Explosions, a few of the Landscapes, some of the recent modular "Modern" panels which are all geometry. The Brushstrokes and the more representational Landscapes, while not abstract, were invented forms. But in addition to their free, made-up character, the Mirrors, for the first time, make possible an almost systematic investigation of how much can be done with this ostensibly stripped-down vocabulary.

The independent life contained within Lichtenstein's characteristic "commercial" devices of flat primary colors, unmodulated pure white ground, and mechanical, stenciled Benday dot screens is one of the most remarkable aspects of his art. The seemingly absurd limitations

of these "restrictive," "inexpressive" means have helped to make them entirely his own—no doubt partly through the apparent craziness of using devices lifted from crude sources and extending them far beyond Pop irony (at first little by little, later by leaps and bounds) into a whole series of effective engagements with modern and older art. However, what once seemed a capricious choice can now be seen as crucially important and astonishingly perspicacious. The way the vocabulary breaks down into separate components lets it recombine in different ways which are perhaps closer to the versatility of parts of speech than to the more familiar potentialities of a personal "manner" stemming from touch. Paradoxically, what results is an exceptional flexibility, as the wide range of subjects and visual problems dealt with attests.

In the Mirrors, the graphic devices from which Lichtenstein builds his beyond-graphic paintings relate in many ways to earlier phases of his work, but they also take on new implications.

Some of the Mirrors are florid and tightly composed, others minimal, immaculate, with expanses of white punctuated only by a lone curve or a refractive edge or two. There may be delicate abutments along dotted or solid edges. Slivers of color or spears of screen fragments cut into solid areas or voids. Important among the more vehement invented elements are areas of solid color, usually dark blue or black, particularly since these stand in for the stiffness and resilience formerly instilled through wiry internal contour lines which are now absent. Sometimes the solid color areas are geometrically regular, sometimes eccentric, organic, fanciful, almost Art Nouveau.

Since the Mirror-edges are congruent with the shape of the paintings, the invented light schemes operate freely inside. A preceding series, the Monet Cathedrals, also abandoned internal contour lines, but in that group there was a troublesome clash between Lichtenstein's dot motif and Monet's brushstroke surface module, as well as a lack of structural clarity. (Lichtenstein's work depends heavily upon clarity, not being compatible with nuance). As in the Cathedrals, only the edges of the dot screens or color areas delineate the imagery in the Mirrors. But now the shapes are large and their junctures faultlessly lucid.

The dazzling sensation of sheets of light which the Mirrors produce is directly related to the fact that the dot screens are newly and regularly graduated from large to small, and thus have the possibility of suggesting either tilting planes or graded shade, highlights, reflections, or voids. Only occasionally does the dot pattern (true to its original commercial source) appear flat—as it typically had before. The Monet Cathedrals were also involved in luminosity, by implication, through formulas of equivalency for Impressionist light. However, the representation of light in the Mirrors has other more relevant precedents—the stylized searchlight beams of the Art Deco works or, more paradoxical, the elaboration

of graphic (two-dimensional) highlight conventions in the three-dimensional ceramic Cups and Heads.

The dots offer an extremely wide range of interpretation, from decorative accents to flat or tilted halftone. Their intermittent exploitation as halftone is now a vital element, although any breaching of the pictures' flatness is avoided through manipulation of color in conjunction with the surface tension of the dots, aided, as well, by the synonymousness of a mirror surface with flat glass.

A casual reference to styles of art remains an important element, especially in the large polyptychs, where Cubism is clearly in the (reflected) air. It is as if Lichtenstein had worked back through the synthetic, layout-type Cubism of the Art Deco paintings to an enormously blown-up transmutation of the planar fragmentation and angular fluctuation of Analytical Cubism—monochrome and all, rebuilt illusionistically by the tilting planes of dots, whose structuring takes place in a broad, prismatic way.

Lichtenstein's encyclopedic allusions to art history (especially modern) were at first obscured by his subject matter, his technique, and his tough contemporary look. Then he dropped so many clues that the emphasis swung the other way, and even heavy bits of camp (which he likes and of which there have been plenty) were taken as formal exercises. Clearly he is equipped with the erudition and the confidence to carry off art-historical raids. But the significance of the references and usages should not be exaggerated. The ease and effectiveness with which he alludes to Cubism now—after mostly taking pains to avoid it in the past—should come as no surprise. But his commitment to Cubism is no greater than, say, to Ingres, Mondrian, or Greek temples.

Neoplasticism is frequently invoked as well. Often in the blankest Mirrors there is a witty, even nutty, and quite unmistakable quotation of small square Mondrianesque red fleck, galvanizing a whole area in what is, in effect, an authoritatively and manneristically imitated mannerism. Lichtenstein's colors, always quick to evoke Neoplastic primaries whenever formal design is dominant, heighten the Mondrian effect in the Mirrors. His colors haven't changed much since the earliest paintings, but they look different now. They operate in a more variable way. The general acceptance of Lichtenstein's color as derived from four-color-process printing inks is an inaccurate approximation of his having chosen simple, bright, commercial-*type* primary hues. (While the yellow is close to "process yellow," his red is actually a medium red, almost an Indian red, unrelated to the luminous magenta of "process red" ink, and his blue is an intense opaque ultramarine, nothing like the garish turquoise of "process blue.") Commercial affinities not withstanding, in a context as thoroughly abstract and as obviously anti-invented as this, the reference of the colors seems entirely within the

Roy Lichtenstein

conventions of twentieth-century art (Mondrian, Léger, Stuart Davis, etc.). In addition, the colors in the Mirrors, freed from heavy contours, are now exploited to new effect vis-à-vis the delicately calibrated black-and-white value scale of the dots. The colors are put through a series of changes in luminosity too, for example, when there is an overscreening of dots on yellow, or the burning glow of dark blue against black.

Scale is important in the Mirrors. The amplitude of the large ones has a quality of expanding concrete physical space. The assurance to work big has developed slowly in Lichtenstein. He has not (like many of his colleagues) exploited large scale to gain authority, although it occurs rather often now. In the present works, the dot screens are the same size whether the painting is tiny or huge. Thus the dot size has an explicit relationship to the scale of each work. The internal scale of even the small paintings is such that a two-foot tondo can look balefully imposing. The dot provides a concrete physical unit which overrides illusion and sustains an indomitable materiality. In this respect a comparison with both Byzantine mosaics and Pointillism is relevant because of the similarity of the neutral, basic unit.

In regard to the elegance and precision of these paintings—extreme, even in the context of an elegantly precise oeuvre—it is worth mentioning that the final equilibrium is attained through a fairly laborious method; after a small sketch develops the basic idea, the paintings are worked out to scale with movable areas of paper. These are repeatedly adjusted; then the paintings may be painted, painted out and repainted, before the eventual decisions are reached.

The fact that these paintings continue to require detailed examination as specific entities is proof of the vitality of the changes intrinsic to Lichtenstein's work. Its compellingly interesting quality is linked to an evolution toward greater conceptual and formal complexity within consistently stringent limits. His persistent tendency to renew or to shift the balance between various elements from one phase to the next seems to have little to do with the sway of art-world enthusiasms at any given time. If anything, his detachment from such factors is notable. Rather, it reflects an awareness of the perishability of subject matter and, at the same time, a need to encompass its transitoriness within his fundamentally timeless intentions. This amounts to taking risks which more often than not pay off magnificently, as in his brilliant Mirror series in which his equilibrated tensions between the eye and the mind are at a higher pitch than ever before.

Bibliography *Jane Salzfass*

Works listed chronologically by author

Interviews with Roy Lichtenstein

ANTOINE, JEAN. "Metamorphoses: l'École de New York." *Quadrum*, no. 18 (March, 1966).

COPLANS, JOHN. "An Interview with Roy Lichtenstein." *Artforum* 2, no. 4 (October, 1963).

———. "Talking with Roy Lichtenstein." *Artforum* 5, no. 9 (May, 1967).

———. "Lichtenstein's Graphic Works." *Studio International* 180, no. 928 (December, 1970).

GLASER, BRUCE, ed. "Oldenburg, Lichtenstein, Warhol: A Discussion." *Artforum* 4, no. 6 (February, 1966).

PASCAL, DAVID. Interview with Roy Lichtenstein. *Giff Wiff* (Paris), May, 1966. In French.

ROBERTS, COLETTE. "Interview de Roy Lichtenstein." *Aujourd'hui U.S.A.*, nos. 55–56 (December, 1966–January, 1967). In French.

ROSE, BARBARA, and IRVING SANDLER. "Sensibility of the Sixties." *Art in America* 55, no. 1 (January–February, 1967).

"Roy Lichtenstein . . . Modern Sculpture with Velvet Rope." Statement in *Art Now: New York* 1, no. 1 (January, 1969).

SIEGEL, JEANNE. "Thoughts on the 'Modern' Period." Transcript of radio broadcast on WBAI, New York (December, 1967).

SOLOMON, ALAN. "Conversation with Lichtenstein." *Fantazaria* 1, no. 2 (July–August, 1966).

SORIN, RAPHAEL. "Le Classicisme du Hot Dog." *La Quinzaine Litteraire*, January, 1968. In French.

SWENSON, G. R. "What Is Pop Art?" *Art News* 62, no. 7 (November, 1963).

WALDMAN, DIANE. "Roy Lichtenstein Interviewed." In *Roy Lichtenstein*. New York: Harry Abrams, 1971.

Books Relevant to Lichtenstein's Work

ALLOWAY, LAWRENCE. *The Venice Biennale 1895–1968: From Salon to Goldfish Bowl*. Greenwich, Conn.: New York Graphic Society, 1968.

AMAYA, MARIO. *Pop Art . . . and After*. New York: Viking Press, 1965.

ARNASON, H. H. *History of Modern Art: Painting, Sculpture, Architecture*. New York: Harry Abrams, 1968.

BATTCOCK, GREGORY, ed. *The New Art: A Critical Anthology*. New York: E. P. Dutton, 1966.

BECKER, JURGEN, and WOLF VOSTELL. *Happenings, Fluxus, Pop Art*. Hamburg: 1965.

BOATTO, ALBERTO, and GIORDANO FALZONI, eds. *Lichtenstein*. Rome: Fantazaria, 1966.

CALAS, NICOLAS. *Art in the Age of Risk and Other Essays*. New York: E. P. Dutton, 1968.

CALVESI, MAURIZIO. *Le Due Avanguardie del Futurismo alla Pop Art.* Milan: Lerici, 1966.

COMPTON, MICHAEL. *Pop Art.* Feltham, Middlesex: Hamlyn House, 1970.

CRISPOLTI, ENRICO. *La Pop Art.* Milan: Fabbri, 1966.

DIENST, ROLF-GÜNTER. *Pop Art.* Wiesbaden: Bechtold, 1965.

FINCH, CHRISTOPHER. *Pop Art: Object and Image.* New York: E. P. Dutton, 1968.

HERZKA, DOROTHY. *Pop Art One.* New York: Publishing Institute of American Art, 1965.

HUNTER, SAM. *New Art Around the World.* New York: Harry Abrams, 1966.

KOZLOFF, MAX. *Renderings: Critical Essays on a Century of Modern Art.* New York: Simon & Schuster, 1969.

KULTERMANN, UDO. *The New Painting.* New York: Praeger, 1969.

LIPPARD, LUCY. *Pop Art.* New York: Praeger, 1966.

PELLIGRINI, ALDO. *New Tendencies in Art.* New York: Crown, 1966.

ROSE, BARBARA. *American Art Since 1900.* New York: Praeger, 1967.

————. *American Painting: The Twentieth Century.* Cleveland: World, 1969.

ROSENBERG, HAROLD. *The Anxious Object: Art Today and Its Audience.* New York: Horizon, 1964.

RUBLOWSKY, JOHN. *Pop Art.* New York: Basic Books, 1965.

RUSSELL, JOHN, and SUZI GABLIK. *Pop Art Redefined.* London: Thames & Hudson, 1969.

SOLOMON, ALAN. *New York: The New Art Scene.* New York: Holt, Rinehart & Winston, 1967.

WALDMAN, DIANE. *Roy Lichtenstein: Drawings and Prints.* New York: Bianchini, 1969.

————. *Roy Lichtenstein.* London: Thames & Hudson, 1971.

Writings Primarily on Lichtenstein's Work

ALFIERI, BRUNO. "Towards the End of 'Abstract' Painting." *Metro,* nos. 4–5 (1962).

————. "The Arts Condition—The Arts Future." *Metro,* no. 9 (1965).

————. "A Critic's Journal, II," *Metro,* no. 10 (1966).

ALLOWAY, LAWRENCE. "Notes on Five New York Painters." *Albright-Knox Gallery Notes* 26, no. 2 (Autumn, 1963).

————. "Roy Lichtenstein's Period Style." *Arts Magazine* 42, no. 1 (September–October, 1967).

"Art: Discredited Merchandise." *Newsweek,* November 9, 1964.

"Art: The Slice of Cake School." *Time,* May 11, 1962.

BAKER, ELIZABETH C. "The Glass of Fashion and the Mold of Form." *Art News* 70, no. 2 (April, 1971).

————. "Roy Lichtenstein." *Art News* 70, no. 9 (January, 1972).

BANNARD, DARBY. "Present-Day Art and Ready-Made Styles." *Artforum* 5, no. 4 (December, 1966).

BARO, GENE. "Roy Lichtenstein: Technique as Style." *Art International* 12, no. 9 (November, 1968).

BERKSON, WILLIAM. Review: "Warhol, Oldenburg and Lichtenstein at Bianchini Gallery." *Arts Magazine* 39, no. 7 (May, 1965).

———. Review. *Arts Magazine* 40, no. 3 (January, 1966).

BOIME, ALBERT. "Roy Lichtenstein and the Comic Strip." *Art Journal* 28, no. 2 (Winter, 1968–69).

CALAS, NICOLAS. "Roy Lichtenstein: Insight Through Irony. The Guggenheim Retrospective." *Arts Magazine* 44, no. 1 (September–October, 1969).

CAMPBELL, L[AWRENCE]. Review. *Art News* 50, no. 3 (May, 1951).

———. "Roy Lichtenstein." *Art News* 67, no. 7 (November, 1963).

CANADAY, JOHN. "Pop Art Sells On and On—Why?" *New York Times Magazine,* May 31, 1964.

———. "Art: The Lichtenstein Retrospective." *New York Times,* September 20, 1969.

CHEVALIER, DENYS. "Lichtenstein: du plan au volume." *Lettres Françaises,* March 18, 1970. In French.

COPLANS, JOHN. "The New Paintings of Common Objects." *Artforum* 1, no. 6 (November, 1962).

———. "Pop Art U.S.A." *Artforum* 2, no. 4 (October, 1963).

DALI, SALVADOR. "How an Elvis Presley Becomes a Roy Lichtenstein." *Arts Magazine* 41, no. 6 (April, 1967).

DANIELI, FIDEL A. "Roy Lichtenstein." *Artforum* 3, no. 4 (January, 1965).

DE MOTT, HELEN. Review. *Arts Magazine* 33, no. 9 (June, 1959).

E[DGAR], N[ATALIE]. "Castelli." *Art News* 61, no. 1 (March, 1962).

"Everything Clear Now?" *Newsweek,* February 2, 1962.

FACTOR, DONALD. "Six Painters and the Object." *Artforum* 2, no. 3 (September, 1963).

F[ITZSIMMONS], J[AMES]. Review. *Art Digest* 26, no. 7 (January, 1952).

"Four Drawings: Roy Lichtenstein." *Artforum* 3, no 4 (January, 1965).

FRIED, MICHAEL. "New York Letter." *Art International* 7, no. 9 (December, 1963).

FRY, EDWARD FORT. "Roy Lichtenstein's Recent Landscapes." *Art and Literature,* Spring, 1966.

———. "Inside the Trojan Horse." *Art News* 68, no. 6 (October, 1969).

GELDZAHLER, HENRY. "Frankenthaler, Kelly, Lichtenstein, Olitski." *Artforum* 4, no. 10 (June, 1966).

G[EIST], S[IDNEY]. Review. *Art Digest* 27, no. 9 (February, 1953).

GLUECK, GRACE. Review. *Art in America* 55, no. 5 (September–October, 1967).

HAHN, OTTO. "Lettre de Paris: Le Peinture Méchanique." *Art International* 9, no. 6 (September, 1965).

———. "Roy Lichtenstein." *Art International* 10, no. 6 (Summer, 1966).

HAMILTON RICHARD. "Roy Lichtenstein." *Studio International,* January, 1968.

HUNTER, SAM. "Neorealismo, Assemblage, Pop Art in America." *L'Arte Moderna* 13, no. 112 (1969).

IRWIN, DAVID. "Pop Art and Surrealism." *Studio International* 171, no. 977 (May, 1966).

JOHNSON, ELLEN H. "The Image Duplicators—Lichtenstein, Rauschenberg, Warhol." *Canadian Art* 23, no. 1 (January, 1966).

———. "Lichtenstein: The Printed Image at Venice." *Art & Artists* 1, no. 3 (June, 1966).

———. "The Lichtenstein Paradox." *Art & Artists* 2, no. 10 (January, 1968).

J[OHNSTON], J[ILL]. "Roy Lichtenstein." *Art News* 63, no. 8 (December, 1964).

JOUFFROY, ALAIN. "Une Révision Moderne du Sacre." *XXe Siècle,* December, 1964.

JUDD, DONALD. "Roy Lichtenstein." *Arts Magazine* 36, no. 7 (April, 1962).

———. "Six Painters and the Object at the Guggenheim." *Arts Magazine* 37, no. 9 (May–June, 1963).

———. Review. *Arts Magazine* 38, no. 2 (November, 1963).

———. "Castelli." *Arts Magazine* 39, no. 3 (December, 1964).

KARP, IVAN. "Anti-Sensibility Painting." *Artforum* 2, no. 3 (September, 1963).

KOZLOFF, MAX. " 'Pop Culture,' Metaphysical Disgust and the New Vulgarians." *Art International* 6, no. 2 (March, 1962).

———. "Art." *Nation* 197, no. 14 (November 2, 1963).

———. "Art and the New York Avant-Garde." *Partisan Review* 31, no. 4 (Fall, 1964).

———. "Art: Dissimulated Pop." *Nation,* November 30, 1964.

———. "Modern Art and the Virtues of Decadence." *Studio International,* November, 1967.

———. "Lichtenstein at the Guggenheim." *Artforum* 8, no. 3 (November, 1969).

LANGSNER, JULES. "West Coast Letter." *Art International* 6, no. 9 (September, 1962).

LIPPARD, LUCY R. "New York Letter." *Art International* 10, no. 1 (January, 1966).

LIVINGSTON, JANE. Review. *Artforum* 6, no. 10 (Summer, 1968).

LORAN, EARL. "Cézanne and Lichtenstein: Problems of Transformation." *Artforum* 2, no. 3 (September, 1963).

———. "Pop Artists or Copy Cats?" *Art News* 62, no. 5 (September, 1963).

LYNTON, NORBERT. "Venice 1966." *Art International* 10, no. 7 (September, 1966).

McCLELLAN, DOUG. Review. *Artforum* 2, no. 1 (July, 1963).

MARMER, NANCY. Review. *Art International* 9, no. 1 (February, 1965).

MEIER, KURT VON. "Los Angeles Letter." *Art International* 11, no. 8 (October, 1967).

MELVILLE, ROBERT. "The New Classicism." *Architectural Review* 139, no. 828 (February, 1966).

———. "Battlepieces and Girls." *Architectural Review* 141, no. 842 (April, 1967).

MONNIER, JACQUES. "Roy Lichtenstein." *Tribune de Lausanne,* March 17, 1968.

"Painting: Kidding Everybody." *Time,* June 23, 1967.

PICARD, LIL. "New School of New York." *Das Kunstwerk* 18, no. 6 (December, 1964).

PINCUS-WITTEN, ROBERT. Review. *Artforum* 9, no. 9 (May, 1971).

PLAGENS, PETER. "Present-Day Styles and Ready-Made Criticism." *Artforum* 5, no. 4 (December, 1966).

————. "Los Angeles Letter." *Artforum* 10, no. 2 (October, 1971).

"Pop Art—Cult of the Commonplace." *Time,* May 3, 1963. ·

"Pops or Robbers? The Big Question." *Newsweek,* September 16, 1963.

P[ORTER], F[AIRFIELD]. "Roy Lichtenstein." *Art News* 50, no. 19 (January, 1952).

————. "Roy Lichtenstein." *Art News* 51, no. 10 (February, 1953).

————. "Lichtenstein's Adult Primer." *Art News* 53, no. 1 (March, 1954).

READ, HERBERT. "The Disintegration of Form in Modern Art." *Studio International* 169, no. 864 (April, 1965).

RESTANY, PIERRE. "Le Nouveau Réalisme à la Conquête de New York." *Art International* 7, no. 1 (January, 1963).

————. "Le Pop Art: Un Nouvel Humanisme Américain." *Aujourd'hui U.S.A.,* nos. 55–56 (December, 1966–January, 1967).

ROSE, BARBARA. "Dada Then and Now." *Art International* 7, no. 1 (January, 1963).

————. "Pop Art at the Guggenheim." *Art International* 7, no. 5 (May, 1963).

————. Review. *Art International* 7, no. 10 (December, 1964).

————. "Pop in Perspective." *Encounter* 25, no. 2 (August, 1965).

R[OSENBLUM], R[OBERT]. "Roy F. Lichtenstein." *Art Digest,* February 15, 1954.

————. "Roy Lichtenstein and the Realist Revolt." *Metro,* no. 8 (April, 1963).

————. "Pop and Non-Pop: An Essay in Distinction." *Canadian Art* 23, no. 1 (January, 1966).

RUSSELL, JOHN. "Pop Reappraised." *Art in America* 57, no. 4 (July–August, 1969).

————. "Art Moderne: Roy Lichtenstein, Pop No. 1." *Connaissance des Arts* (October, 1969).

SAARINEN, ALINE B. *"Explosion of Pop Art." Vogue,* April 15, 1963.

SANDLER, IRVING. "The New Cool-Art." *Art in America* 53, no. 1 (February, 1965).

SAWIN, MARTICA. Review. *Arts Magazine* 31, no. 4 (January, 1957).

SCHLANGER, JEFF. "Ceramics and Pop." *Craft Horizons* 26, no. 1 (January–February, 1966).

SCHJELDAHL, PETER. "The Artist for Whom 'Style' Is All." *New York Times,* March 21, 1971.

S[CHUYLER], J[AMES]. "Roy F. Lichtenstein." *Art News* 55, no. 10 (February, 1957).

SECKLER, DOROTHY GEES. "Folklore of the Banal." *Art in America* 50, no. 4 (Winter, 1962).

SEIBERLING, DOROTHY. "Is He the Worst Artist in the U.S.?" *Life,* January 31, 1964.

SELZ, PETER. "A Symposium on Pop Art." *Arts Magazine* 37, no. 7 (April, 1963).

SHIREY, DAVID. Review. *New York Times,* November 13, 1971.

SOLOMON, ALAN. "The New American Art." *Art International* 7, no. 2 (March, 1964).

———. "American Art Between the Two Biennales." *Metro,* no. 11 (1966).

"Something New Is Cooking." *Life,* June 15, 1962.

SORRENTINO, GILBERT. "Kitsch into Art: The New Realism." *Kulcher* 2, no. 8 (Winter, 1962).

"The Story of Pop." *Newsweek,* April 25, 1966.

SWENSON, G. R. "The New American 'Sign Painters.' " *Art News* 61, no. 5 (September, 1962).

SYLVESTER, DAVID. "Art in a Coke Climate." *The Sunday Times Colour Magazine* (London), January 16, 1964.

T[ILLIM], S[IDNEY]. "Roy Lichtenstein and the Hudson River School." *Arts Magazine* 37, no. 1 (October, 1962).

———. "The New Realists." *Arts Magazine* 37, no. 7 (December, 1962).

———. "Towards a Literary Revival?" *Arts Magazine* 29, no. 9 (May–June, 1965).

———. "Lichtenstein's Sculptures." *Artforum* 6, no. 5 (January, 1968).

T[UTEN], F[REDERIC]. Review. *Arts Magazine* 42, no. 1 (September–October, 1967).

WALDMAN, DIANE. "Remarkable Commonplace." *Art News,* October, 1967.

Exhibitions and Exhibition Catalogues

AMSTERDAM: Stedelijk Museum. *American Pop Art* (June–July, 1964). Catalogue essay by Alan Solomon; *Roy Lichtenstein* (November–December, 1967). Catalogue foreword by E. de Wilde, essay by W. A. L. Beeren.

ANDOVER, MASS.: Addison Gallery of American Art, Phillips Academy. *Signs of the Times* (February–March, 1964). Catalogue text by Thomas S. Tibbs.

BERLIN: Akademie der Kunst. *Neue Realisten und Pop Art* (November, 1964–January, 1965). Catalogue essay by Werner Hofmann.

Kunstverein. *Sammlung 1968 Karl Stroher* (March–April, 1969). Catalogue essay by Hans Strelow.

BERN: Kornfeld und Klipstein. *1¢ Life* (February–March, 1965). Catalogue introduction by E. W. Kornfeld, poems by Walasse Ting.

Kunsthalle. *Roy Lichtenstein* (February–March, 1968). Catalogue essays by Jean-Christophe Amman, W. A. L. Beeren.

BOSTON: Institute of Contemporary Art. *As Found* (March–April, 1966). Booklet statement by Ulfert Wilke; *American Painting Now* (December, 1967–January, 1968). Catalogue text by Alan Solomon. Exhibition held at Horticultural Hall, Boston.

BROOKLYN, N.Y.: Brooklyn Museum of Art. *16th National Print Exhibition: Two Decades of American Prints: 1947–1968* (October, 1968–January, 1969). Catalogue introduction by Una E. Johnson.

BRUSSELS: Palais des Beaux Arts. *Pop Art, Nouveau Réalisme, etc.* (February–March, 1965). Catalogue preface by Jean Dypreau, essay by Pierre Restany.

BUFFALO: Albright-Knox Art Gallery. *Mixed Media & Pop Art* (November–December, 1963). Catalogue foreword by Gordon Smith.

CHICAGO: The Art Institute of Chicago. *66th American Annual Exhibition* (January–February, 1963). Catalogue foreword by James Speyer.
Museum of Contemporary Art. *Violence in Recent American Art* (November, 1968–January, 1969). Catalogue introduction by Jan van der Marck, text by Robert Glauber.

CINCINNATI: The Contemporary Arts Center. *An American Viewpoint, 1963* (December, 1963). Catalogue statement by Allon T. Schoener; *Roy Lichtenstein* (December, 1967). Catalogue introduction by Lawrence Alloway.

CLEVELAND: The Cleveland Museum of Art. *Roy Lichtenstein* (December, 1966). Leaflet essay by Edward B. Henning.

DALLAS: The Dallas Museum for Contemporary Arts. *1961* (April–May, 1962). Catalogue introduction by Douglas MacAgy.

DARMSTADT: Kunsthalle. *Menschenbilder* (September–November, 1968). Catalogue texts by Arnold Gehlen, Werner Haftmann, Wieland Schmied, Rolf-Günter Dienst.

FLUSHING MEADOWS, N.Y.: New York State Building. New York World's Fair (April–October, 1964).

FORT WORTH: Fort Worth Art Center Museum. *Master Drawings from Degas to Roy Lichtenstein* (June, 1965).

FRANKFURT: Frankfurter Kunstverein. *Kompass New York* (December, 1967–February, 1968). Catalogue text by Jean Leering.

THE HAGUE: Gemeentemuseum. *Nieuwe Realisten* (June–August, 1964). Catalogue texts by Jasia Reichardt, L. J. F. Wijksenbeek, Pierre Restany.

HANNOVER: Kestner-Gesellschaft. *Roy Lichtenstein* (April–May, 1968). Catalogue essay by Wieland Schmied.

HARTFORD, CONN.: The Wadsworth Atheneum. *Black, White & Grey* (January–February, 1964). Exhibition by Samuel Wagstaff, Jr.

HELSINKI: Art Museum Athenaeum. *Ars '69 Helsinki* (March–April, 1968).

HOUSTON: Contemporary Arts Museum. *Pop Goes! The Easel* (April, 1963). Catalogue essay by Douglas MacAgy.
University of St. Thomas. *Mixed Masters* (May–September, 1967). Catalogue text by Kurt von Meier.

HUNTINGTON, N.Y.: Heckscher Museum. *Pop, Pop Whence Pop?* (February–March, 1965).

IRVINE, CALIF.: University of California Art Galleries. *New York: The Second Breakthrough 1959–1964* (March–April, 1969). Catalogue essay by Alan Solomon.

KANSAS CITY, MO.: William Rockhill Nelson Gallery of Art, Atkins

Museum of Fine Arts. *Popular Art* (April–May, 1963). Catalogue text by Ralph T. Coe.

KASSEL: Galerie an der Schonen Aussicht, Museum Fridericianum, Orangerie im Auepark. *Documenta IV* (June–October, 1968). Catalogue texts by Max Imdahl, Jean Leering, Gunther Gercken, Werner Spies.

LONDON: Hayward Gallery. *Pop Art* (July–August, 1969). Catalogue essays by John Russell, Suzi Gablik.

Institute of Contemporary Art. *The Popular Image* (October–November, 1963). Catalogue text by Alan Solomon; *Study for an Exhibition of Violence in Contemporary Art* (February–March, 1964). Catalogue preface by Roland Penrose; *Painting and Sculpture of a Decade, 54/64* (April–June, 1964). Exhibition sponsored by the Calouste Gulbenkian Foundation. Catalogue notes by Alan Bowness, Lawrence Gowing, Philip James.

Tate Gallery. *Roy Lichtenstein* (January–February, 1968). Essay by Richard Morphet.

LOS ANGELES: Irving Blum Gallery. *Roy Lichtenstein* (April, 1968); *Roy Lichtenstein* (February, 1969); *Roy Lichtenstein* (April–May, 1971).

Dwan Gallery. *My Country 'Tis of Thee* (November–December, 1962). Catalogue introduction by Gerald Nordland; *Arena of Love* (January–February, 1965).

Ferus Gallery. *Roy Lichtenstein* (April, 1963); *Roy Lichtenstein* (November–December, 1964).

Gemini G.E.L. *Lichtenstein at Gemini* (1969). Catalogue introduction and interview by Frederic Tuten.

MILAN: Galleria Apollinaire. *Roy Lichtenstein* (November–December, 1965).

Galleria Sperone. *Warhol, Lichtenstein, Dine, Rosenquist* (April–May, 1966).

MILWAUKEE: Milwaukee Art Center. *Pop Art and the American Tradition* (April–May, 1965). Catalogue essay by Tracy Atkinson.

MINNEAPOLIS: Walker Art Center. *Roy Lichtenstein* (June–July, 1967). Catalogue essay by John Coplans. Exhibition in collaboration with Pasadena Museum.

MONTREAL: United States Pavilion. *Expo '67* (April–October, 1967).

NEW BRUNSWICK, N.J.: Douglass College Art Gallery. *Roy Lichtenstein* (January, 1961).

NEW YORK: Bianchini Gallery. *The American Supermarket* (October, 1964); *Warhol, Oldenburg, Lichtenstein* (April, 1965); *10 from Rutgers University* (December, 1965–January, 1966). Catalogue text by Allan Kaprow; *Master Drawings: Pissarro to Lichtenstein* (January–February, 1966). Catalogue text by William Leonard. Exhibition in collaboration with Contemporary Arts Center, Cincinnati.

Carlebach Gallery. *Roy Lichtenstein* (April–May, 1951); *Roy Lichtenstein* (December, 1951–January, 1952). Brochure introduction by Hoyt Sherman.

Leo Castelli Gallery. *Roy Lichtenstein* (February–March, 1962); *Drawings* (May–June, 1962); *Group Show* (April, 1963); *Drawings* (May–

June, 1963); *Roy Lichtenstein* (September–October, 1963); [*Roy Lichtenstein*]—*Landscapes* (October–November, 1964); *Roy Lichtenstein* (November–December, 1965); [*Roy Lichtenstein*] (October–November, 1967); [*Roy Lichtenstein*] (March–April, 1971); *Roy Lichtenstein Drawings* (January–February, 1972).

Finch College Museum of Art. *Art in Process: The Visual Development of a Painting* (February–March, 1965); *Art in Process: The Visual Development of a Collage* (March–April, 1967); *The Dominant Woman* (December, 1968–January, 1969). Catalogue foreword by Elayne H. Varian, text by Walter Gutman.

The Solomon R. Guggenheim Museum. *Six Painters and the Object* (March–June, 1963). Catalogue text by Lawrence Alloway; *American Drawings* (September–October, 1964). Catalogue text by Lawrence Alloway; *Word and Image* (December, 1965). Brochure introduction by Lawrence Alloway; *Roy Lichtenstein* (September–November, 1969). Catalogue text by Diane Waldman. The last-named exhibition traveled to Chicago; Columbus, Ohio; Kansas City, Missouri; and Seattle.

John Heller Gallery. *Roy Lichtenstein* (January–February, 1953); *Roy Lichtenstein* (March, 1954); *Roy Lichtenstein* (January–February, 1957).

Sidney Janis Gallery. *The New Realists* (October–December, 1962). Catalogue text by John Ashbery, Pierre Restany, Sidney Janis; *A Selection of 20th Century Art of Three Generations* (November–December, 1964); *Pop and Op* (December, 1965).

Mi Chou Gallery. *The Hudson River School and Roy Lichtenstein* (August, 1962).

The Museum of Modern Art International Council. *Two Decades of American Painting* (1966–1967). Catalogue texts by Lucy Lippard, Irving Sandler, G. R. Swenson.

The Museum of Modern Art. *Art in the Mirror* (November, 1966–February, 1967); *The 1960's: Painting & Sculpture from the Museum Collections* (June–September, 1967). Catalogue introduction by Dorothy C. Miller; *Technics and Creativity Gemini G.E.L.* (May–July, 1971). Essay by Riva Castelman, catalogue raisonné of Gemini graphics and objects.

Public Education Association. *Seven Decades: 1895–1965: Crosscurrents in Modern Art* (April–May, 1966). Catalogue text by Peter Selz.

Condon Riley Gallery. *Roy Lichtenstein* (June, 1959).

Charles E. Slatkin, Inc. *American Tapestries* (October–November, 1968). Catalogue introduction by Mildred Constantine, notes by Irma B. Jaffe.

Visual Arts Gallery, School of Visual Arts. *Drawings by Roy Lichtenstein* (November–December, 1971). Exhibition by Diane Waldman.

The Whitney Museum of American Art. *1965 Annual Exhibition of Contemporary American Painting* (December, 1965–January, 1966); *1967 Annual Exhibition of Contemporary American Painting* (December, 1967–January, 1968); *The 1968 Annual Exhibition of American Sculpture* (December, 1968–February, 1969).

OAKLAND, CALIF.: Oakland Art Museum. *Pop Art U.S.A.* (September, 1963). Catalogue text by John Coplans.

PARIS: Musée d'Art Moderne de la Ville de Paris. *XXe Salon de Mai* (May–June, 1964). Catalogue foreword by Gaston Diehl, essay by Yvon Tillandier.

Galerie Ileana Sonnabend. *Roy Lichtenstein* (June, 1963). Catalogue essays by Alain Jouffroy, Ellen H. Johnson, Robert Rosenblum; *Group Show* (May, 1965); *Roy Lichtenstein* (June, 1965). Catalogue with interview by G. R. Swenson; *Roy Lichtenstein* (April, 1970).

PASADENA: Pasadena Art Museum. *The New Paintings of Common Objects* (September–October, 1962). Catalogue introduction by John Coplans; *Roy Lichtenstein* (April–May, 1967). Text by John Coplans.

PHILADELPHIA: Arts Council of YM/YWHA. *Art 1963—A New Vocabulary* (October–November, 1962).

Institute of Contemporary Art, University of Pennsylvania. *The Other Tradition* (January–March, 1966). Catalogue text by G. R. Swenson.

PITTSBURGH: Carnegie Institute. *The 1967 Pittsburgh International Exhibition of Contemporary Painting & Sculpture* (October, 1967–January, 1968). Catalogue foreword by Gustav von Groschwitz.

PROVIDENCE: Rhode Island School of Design Museum. *Recent Still Life* (February–April, 1966). Catalogue text by Daniel Robbins.

ROCHESTER, N.Y.: Memorial Art Gallery, University of Rochester. *In Focus: A Look at Realism in Art* (November, 1964–January, 1965). Catalogue text by Harris K. Prior.

SAINT JOHN, CANADA: The New Brunswick Museum. *Eleven Pop Artists: The New Image* (January, 1967). Catalogue text by Max Kozloff.

SAINT PAUL DE VENCE: Foundation Maeght. *L'Art Vivant: 1965–1968* (April–June, 1968). Catalogue introduction by François Wehrlin.

SAN FRANCISCO: San Francisco Museum of Art. *The Current Moment in Art. Exhibition: East* (April–May, 1966); *Untitled 1968* (November–December, 1968). Catalogue foreword by Gerald Nordland, introduction by Wesley Chamberlain.

SÃO PAULO: Museum of Modern Art. *9th Biennial* (September, 1967–January, 1968). Catalogue text by William C. Seitz.

SPOLETO: Palacio Collicula, Festival of Two Worlds. *Recent Landscapes by Nine Americans* (June–July, 1965).

STOCKHOLM: Moderna Museet. *Amerikansk Pop-Konst* (February–April, 1969). Catalogue foreword by K. G. Hultén.

TURIN: Galleria Civica d'Arte Moderna. *New-Dada e Pop Art New Yorkesi* (April–May, 1969). Catalogue introduction by Luigi Malle.

Il Punto Gallery. *Roy Lichtenstein* (1964).

VANCOUVER: Vancouver Art Gallery. *New York/13* (January–February, 1969). Catalogue introduction by Doris Shadbolt, text by Lucy Lippard.

VENICE: Galleria l'Elephanta. *Dine, Lichtenstein, Oldenburg, Rosenquist, Warhol, Wesselmann* (May–July, 1966).

Palazzo Grassi. *Mostra Internazionale d'Arte Contemporanea* (July–October, 1967).

United States Pavilion. *23rd International Biennial Exhibition of Art* (June–October, 1966). Catalogue texts by Henry Geldzahler, Robert Rosenblum.

VIENNA: Museum des 20 Jahrhunderts. *Pop etc.* (September–October, 1964). Catalogue essays by Werner Hofmann, Otto Graf.

WALTHAM, MASS.: Rose Art Museum, Brandeis University. *New Directions in American Painting* (December, 1963–January, 1964). Catalogue introduction by Sam Hunter; *Recent American Drawings* (April–May, 1964). Catalogue essay by Thomas Garver.

WASHINGTON, D.C.: Corcoran Gallery of Art. *The 20th Biennial Exhibition of Contemporary American Painting* (February–April, 1965). Catalogue text by Herman Warner Williams, Jr.

WORCESTER, MASS.: Worcester Art Museum. *The New American Realism* (February–April, 1965). Catalogue text by Martin Carey.

index